A TOWER IN TUSCANY

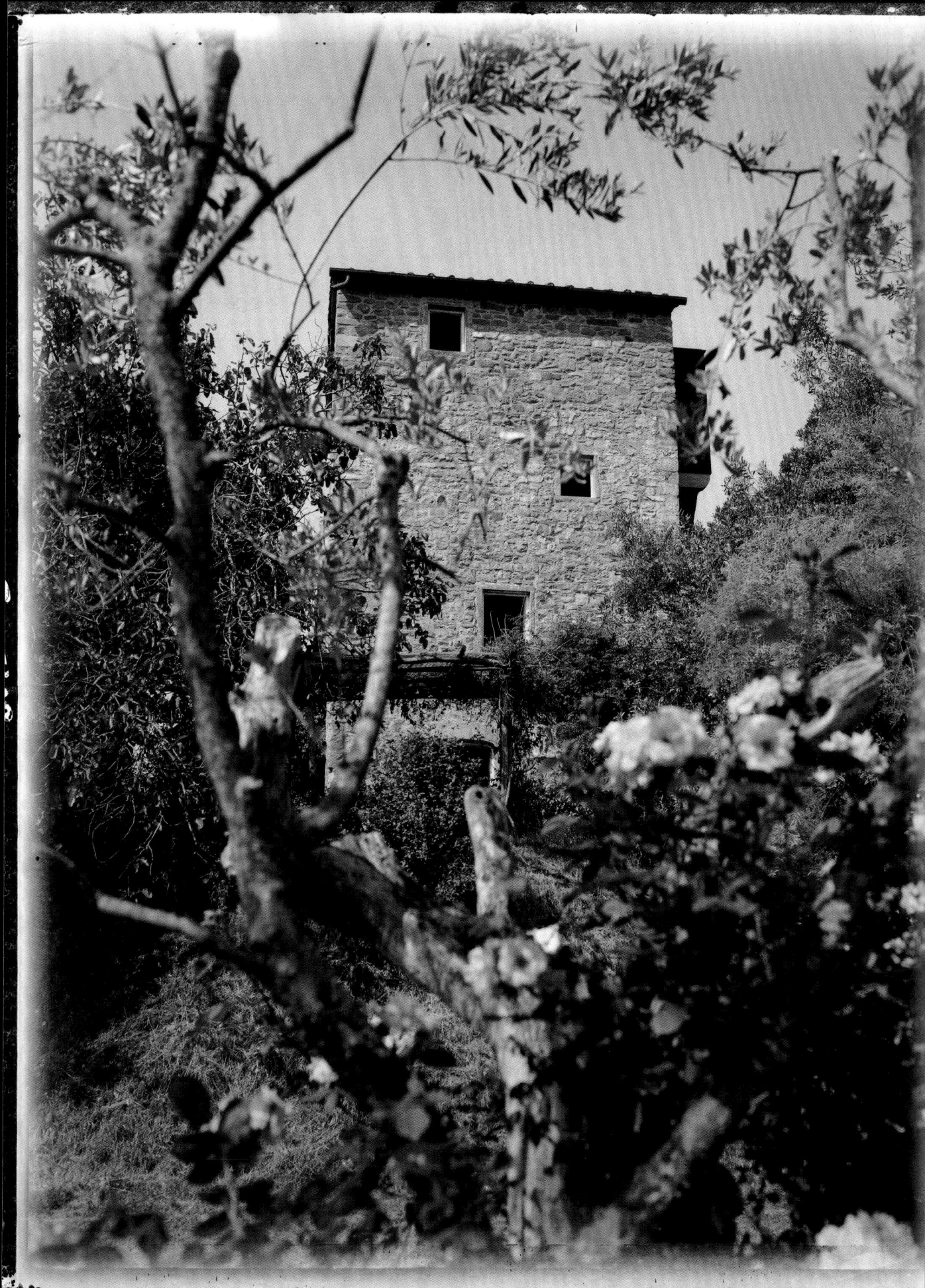

A TOWER IN TUSCANY

OR A HOME FOR MY WRITERS
AND OTHER ANIMALS

COLLECTED BY **BEATRICE MONTI DELLA CORTE**

PHOTOGRAPHY BY **FRANÇOIS HALARD**

EDITED BY **MICHAEL CUNNINGHAM**

Our house in Tuscany stands on a rib of land between two ravines in the furrowed landscape of the Arno Valley. I can watch the earth crumbling away on either side. The only thing that seems firmly rooted is the tower atop its cone of earth. I haven't bothered to investigate the tower's history. Presumably it's part of the cordon built by Florentines as a line of defense against Siena and Pisa. (Is history even imaginable without acts of violence?) In any case all such structures are monuments to power.

—Anecdotage, *Gregor von Rezzori*

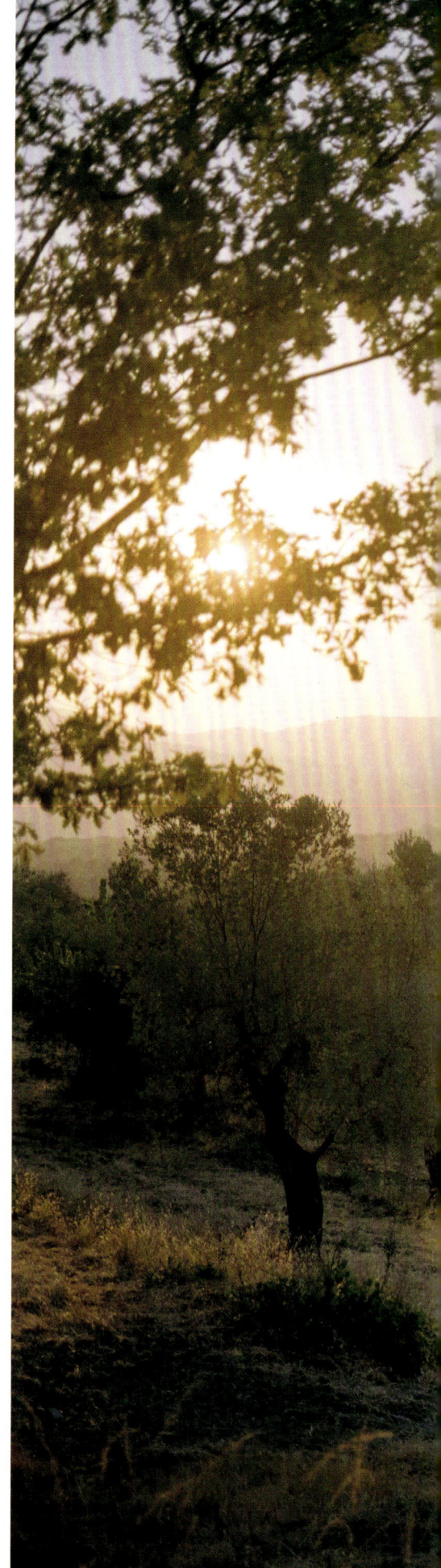

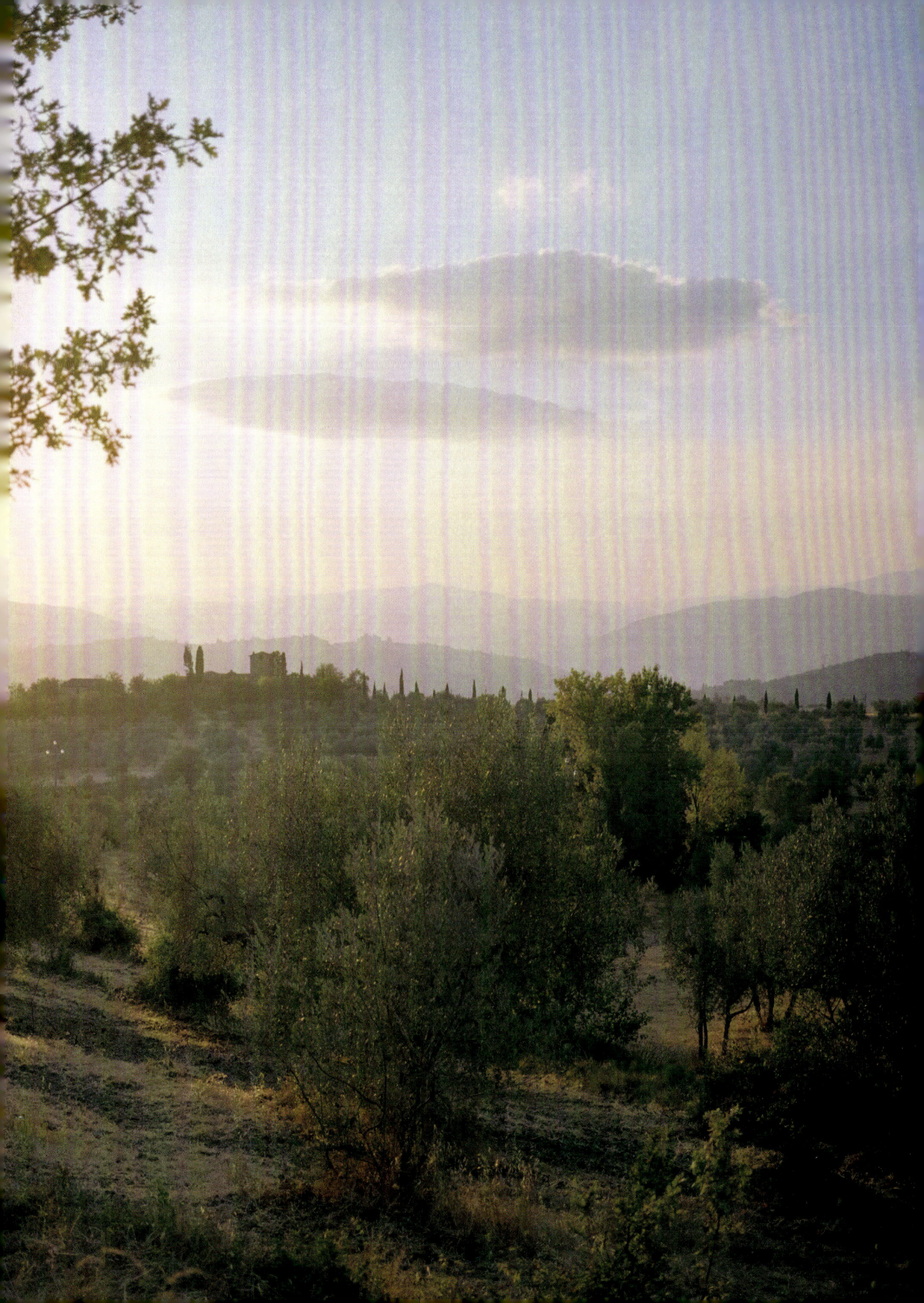

Among my friends there isn't a one who doesn't envy me for living here. I conduct every visitor to the highest room in the tower. The view there is stupendous. Undeveloped countryside all around; a scant handful of houses scattered in the direction of the Arno Valley the closest one a half hour's march distant. To the south are only two buildings a dozen or more miles away as the crow flies: the farcical Moorish palace of Sammezzano tucked brick-red into the evergreen obscurity of its park like a comb in the hair of an Andalusian woman; one leap farther is the Torre del Castellano simple as a child's drawing of a knight's castle tiny smoke-blue silhouette in the airy pigeon blue that the Pratomagno paints on the sky's seam.

—Anecdotage, *Gregor von Rezzori*

The region is mountainous hilly furrowed lengthwise with deep ravines where the earth has subsided into crevasses in which slender rivulets cut into the rock. The red clay walls are as steep as the cliffs of a coastline. They are what have saved the countryside for miles around from the construction craze that has taken over Italy's fresh-out-of-the-oven industrial society.

—Anecdotage, *Gregor von Rezzori*

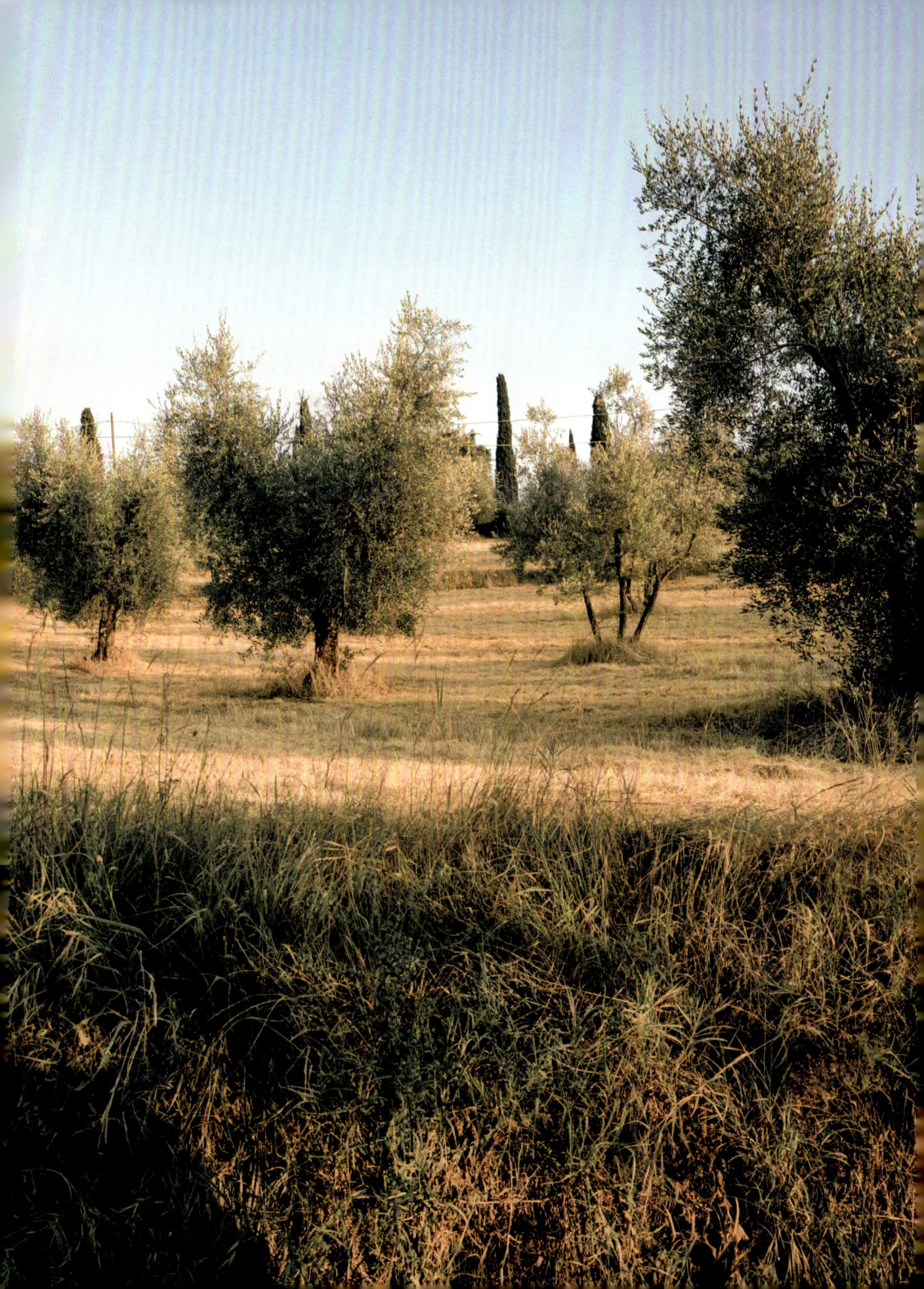

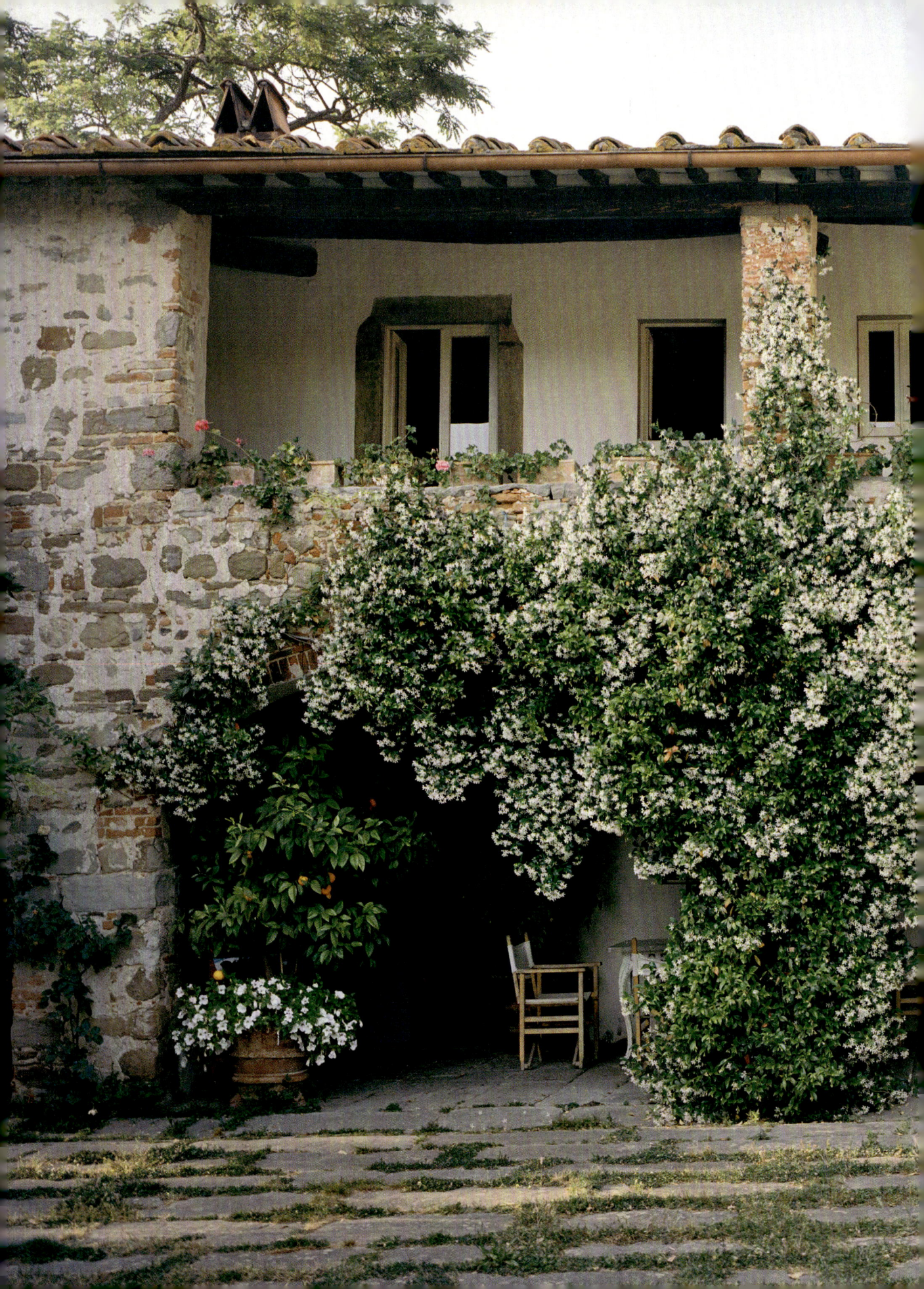

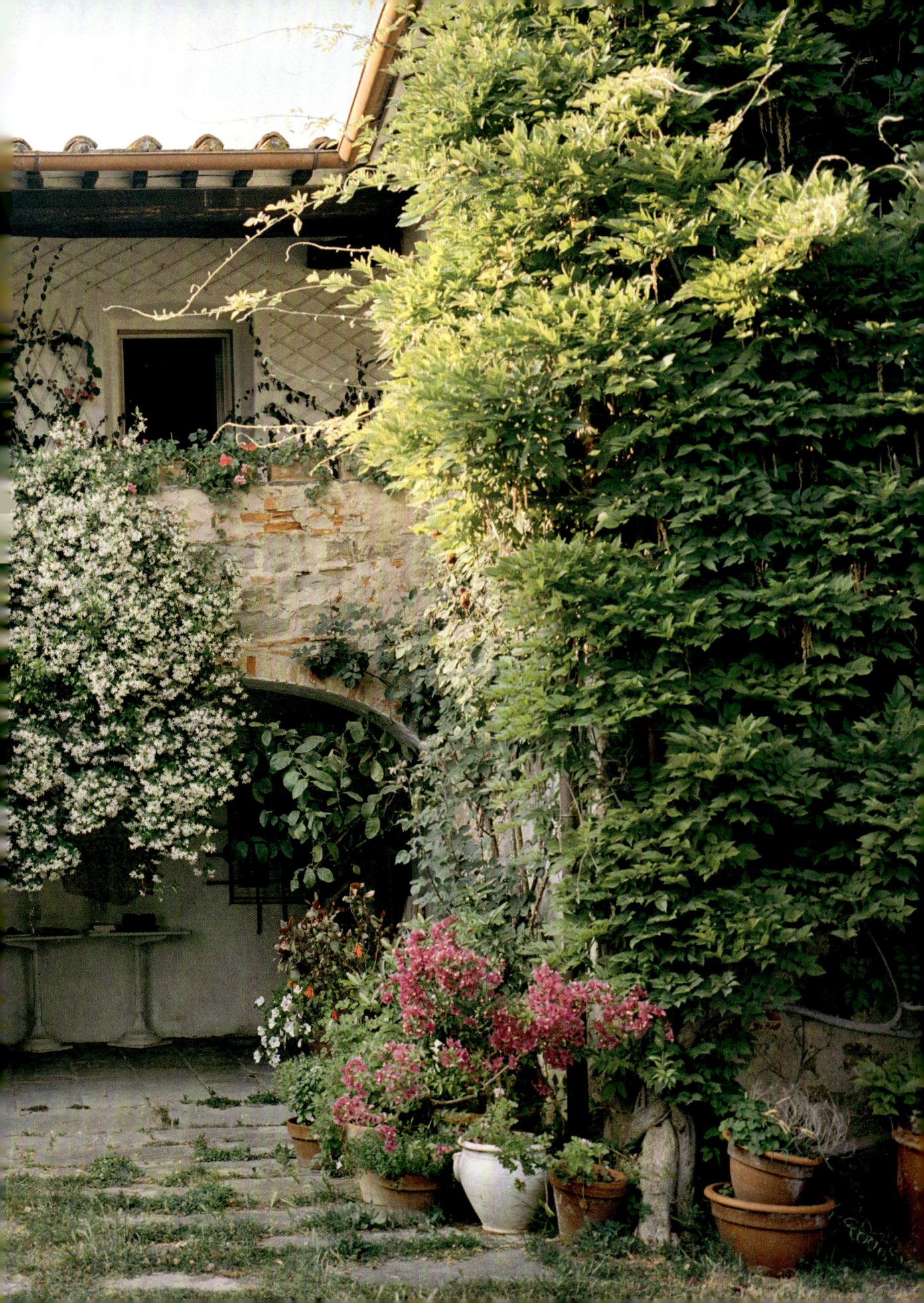

Like many others of its type the so-called case coloniche *being the homes of tenant farmers dating back to the period of Tuscany's settlement in the fourteenth sixteenth and eighteenth centuries it was originally devised for two families who lived cozily with all their livestock beneath a single roof. It was half caved in when we took it over twenty-five years ago: bedded in knee-high meadow grass beneath a snow of acacia blossoms. Swallows that had encrusted the roof with their nests swarmed about the house (as the bees had once swarmed about their hollow trunk). By the time we got it back in shape the nests had been destroyed and the swallows were gone leaving us with a maze of stables rooms hallways closets whose functions and furnishings are still under discussion. No sooner has perfection been achieved in one corner than something in the next is in need of repair and the mere thought of some necessary operation is enough to get B.'s aesthetic juices flowing. I keep toting my things from one niche to the other: the paradox of a domestic nomad. The swallows never turned.*

—Anecdotage, *Gregor von Rezzori*

We live in the tower. Supposedly just for the time being. Though it's beginning to feel permanent. For my optical gymnastics it's just the thing. Each window offers a splendid view. The days are glorious: skies blue after gray weeks in which a wintry spring dabbed the countryside with stingy bits of green. Not what one expects of Italy.

—Anecdotage, *Gregor von Rezzori*

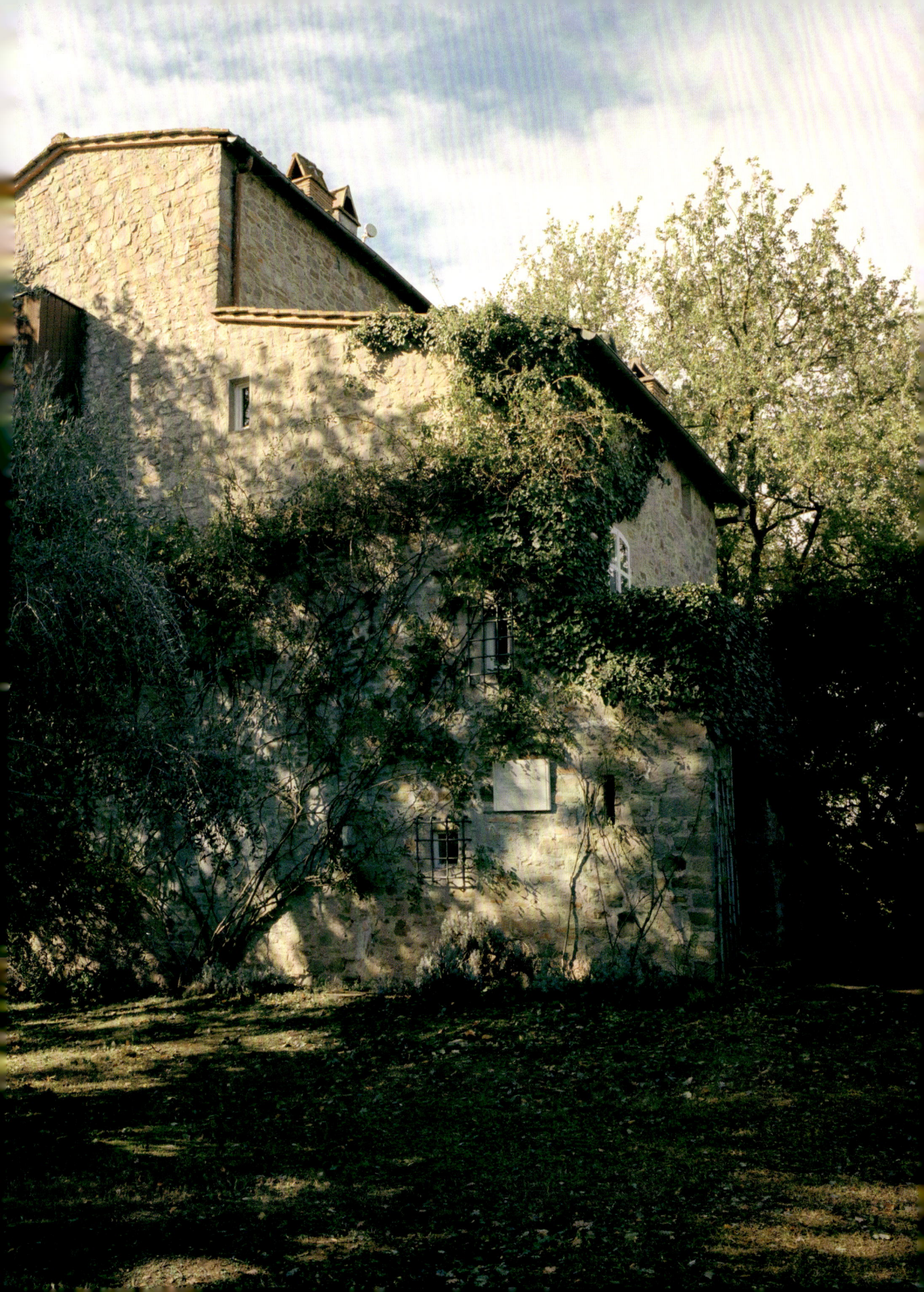

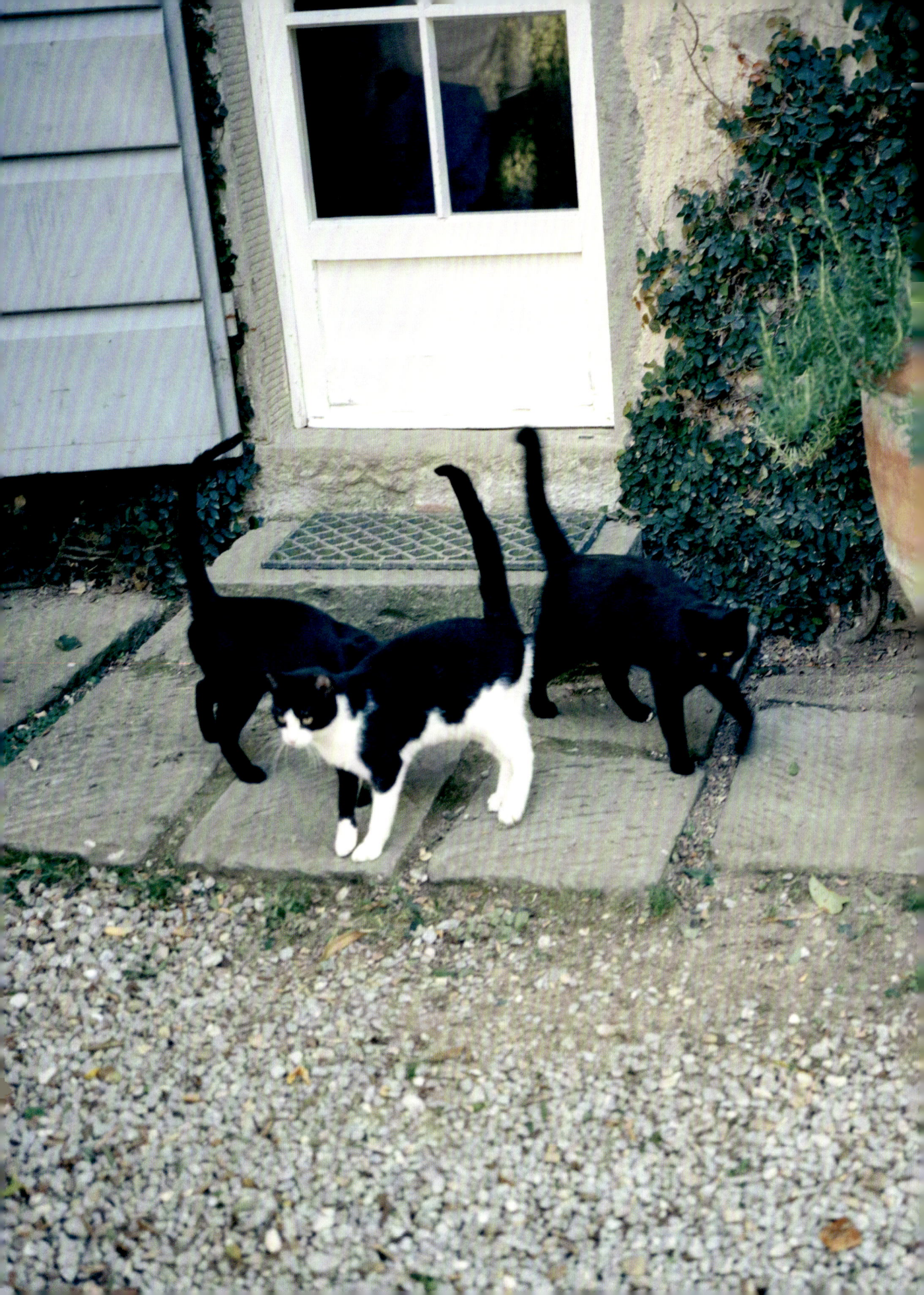

And here in my Tuscan tower I am beset by the question: What am I doing here? The shadows are sharp as silhouettes cut from black paper. The summer its own skeleton. The sky is blue like a whetstone. The sun sharpens its knives on it. The cypresses are black torches flanking the sacrificial altar of the stony earth. The grape leaves are thickly coated with dust: the thirsty find no succor here.

—Anecdotage, *Gregor von Rezzori*

This page: *Neighborhood cats who like to visit Santa Maddalena.*
Following page: *My beloved companions Paride and Giulietta at rest on the couch.*

CONTENTS

24 **Ralph Fiennes**
On the Way to Santa Maddalena

27 **Beatrice Monti della Corte**
A Few Notes About My House

36 **Stefan Merrill Block**
The Courtyard: A Convocation

48 **Colm Tóibín**
This Way of Seeing

57 **Juan Gabriel Vásquez**
The Art of (Not) Playing Billiards

62 **Edmund White**
Dining

68 **Emmanuel Carrère**
Giulietta

76 **Elif Batuman**
The White Room

81 **Henry C. Krempels**
Your Room

86 **Hisham Matar**
A Portrait of a Marriage

96 **Adam Foulds**
Where the World Gets In

101	**Andrew Sean Greer** *An Extra Bit of Luck*	164	**Tash Aw** *A Retreat Within a Retreat*
110	**Kamila Shamsie** *The Heart*	170	**Dany Laferrière** *La Visite de Legba*
115	**Deborah Eisenberg** *Waiting for Ramin*	176	**Michael Cunningham** *A Bat*
124	**Beatrice Monti della Corte** *(Un)Still Life*	182	**Gary Shteyngart** *A Trip Atop an Ottoman: A Conversation*
131	**John Banville** *Wanderers, At Home*	195	**Robin Robertson** *A Bestiary*
136	**Zadie Smith** *Happiness is a Warm Pug*	201	**Terry Tempest Williams** *The Geometry of an Olive Grove*
140	**Adam Thirlwell** *The Sweetness of Living*	206	**Sean Borodale** *Key to a Legend*
144	**Michael Ondaatje** *A Nomad's Grave: A Song of Grisha*		
147	**Maylis de Kerangal** *Genius Loci*	220	About Santa Maddalena
150	**Francisco Goldman** *A Bench*	222	About the Authors
160	**Andrew Miller** *Nothing Important Needs to Happen Here*	224	Contributors
		231	Acknowledgments

Right: *Approaching Santa Maddalena.*

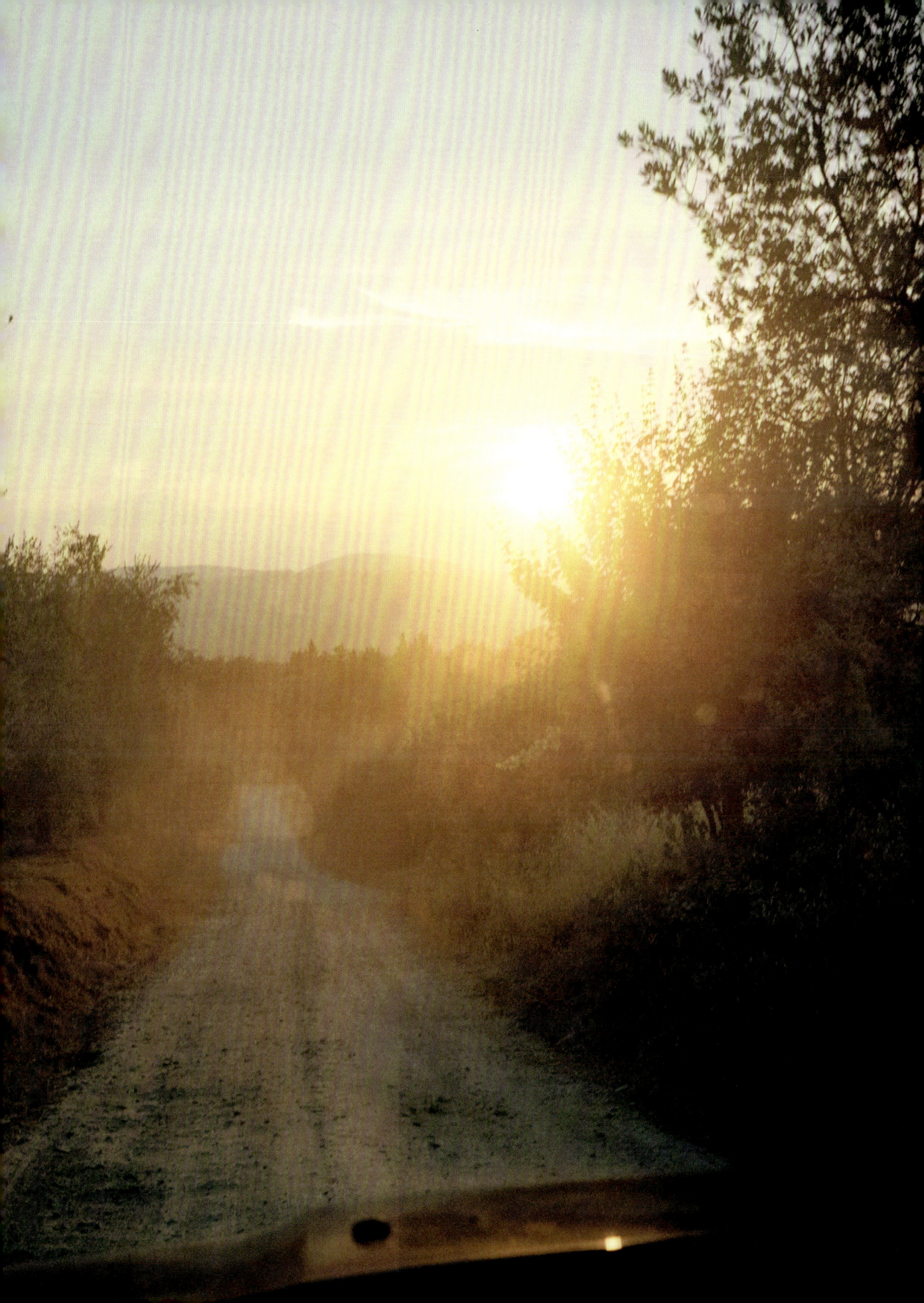

ON THE WAY TO SANTA MADDALENA

Ralph Fiennes

You turn off the road, having passed through the village of Donnini. And you're on the track.

First visit. 1995.

Michael Ondaatje, Saul Zaentz, Paul Zaentz, Anthony Minghella, Kristin Scott Thomas, and me. Saul drives all the way from Viareggio with his turn signal on. Deliberately, I realize. Swervy, speedy Italian traffic. I remember rain.

Then Incisa in Val d'Arno. Then Sant'Ellero. Then Donnini. Then turn off to the track.

The track seems to go on forever. Open bits and then shaded bits. The track begins in open ground, feeling high up; then you continue going downhill, and the track gets rougher, bumpier. As the track descends, passing some farm buildings and wooden fences, the density of the foliage increases. Finally you arrive almost abruptly at a leafy wall, and you realize you are outside a house.

We pull up and two elegant figures emerge. Grisha—handsome, smiling, long legs, gray hair—with a kerchief around his neck. Beatrice—strikingly beautiful, elegant, eyes alert with humor—taking us all in. I remember they were holding pugs.

Since that first visit I have driven myself down that track often. It has an atmosphere of mystery every time. If I think I know what part of the track comes next, there's always another stretch I've forgotten. Sometimes when I arrive, dusty and sweaty, I let myself into the kitchen calling Beatrice's name.

The top of the track feels uncovered by trees, but as you continue they close in, their branches cocooning you as you approach the house. When you're leaving, the trees embrace you as you depart. If I'm staying with Beatrice, I might run up the track or walk it. I think I'll get to know it better that way, but it's elusive somehow. The track is dusty in summer; damp, soft chalk in winter.

The greater context of all this is Florentine Tuscany. High, green, magisterial hills, almost mountains. Usually I drive up from Umbria, skirting Arezzo, then take the A1 highway heading north toward Florence for about forty minutes before the turnoff at Incisa. I always remember the name "Incisa" because it was the main junction that Saul kept looking out for the first time we drove to Donnini. *The English Patient* team.

The track to Donnini is full of memories, but it is also full of new expectations, nostalgia, and future dreams all rolled into one. I'm tempted to say there are spirits there. I must walk it again—as that is the only way to know it, to feel it.

Strada Bianca.

Donnini.

Beatrice.

Grisha.

Traveling hopefully.

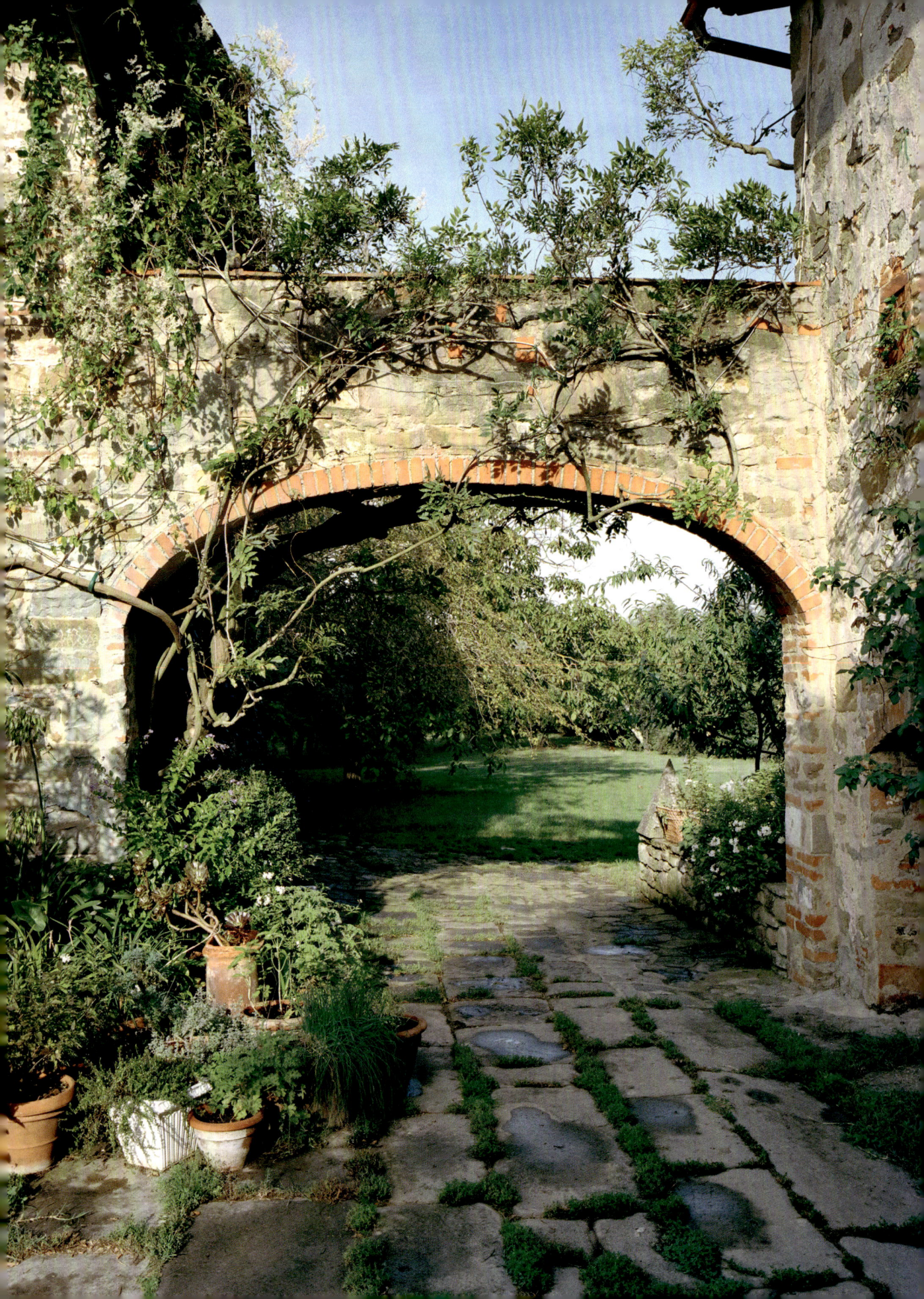

A FEW NOTES ABOUT MY HOUSE

Beatrice Monti della Corte

We know that love affairs—apart from pleasure, a swiftly beating heart, and occasional moments of pure exaltation—can also give us anxiety, depression, sometimes even rage. I have received all that from my house as well, through the long years that our lives have been intertwined. Ours is a love affair that started in 1967, when my husband, Grisha, and I saw it for the first time.

It was more or less a ruin, on high ground in the Valdarno, difficult to find. You could reach it from the north side, crossing woods, deserted olive groves, and destitute fields, the crooked lines of vines still visible beneath the brambles. The south side of the house was a marvel: woods almost lapping the walls, and green valleys immersed in deep forest stretching up to the far ridge of hills. Nothing to disturb the view. On the other side of the valley, atop the opposite ridge, was only the bizarre Moorish Castle of Sammezzano. The castle's elaborate folly heightened the fairy-tale aspect of the landscape.

The farmhouse had been inhabited by two families, then abandoned for about thirty years. It was full of rubble and chicken droppings. The stables that had occupied much of the ground floor were still ornamented by desiccated manure. But the house was full of promise as well. The spaces were vast and labyrinthine. The large barn, positioned at a right angle to the main house, contained the farm's yard, which was still paved with old, rough flagstones. Two hundred meters east of the house, perched stalwartly on a little mound, stood a small, dilapidated tower from the fifteenth century.

It was love at first sight. My husband was a writer of Austrian origin. His family had been transplanted to Romania, where he grew up in the wilds of the Bukovinian forest; since he left his wooded homeland, he had lived like a nomad. It was evident to me that in this place he could put down some roots.

We bought it. And we rolled up our sleeves.

For me it was a huge challenge, traveling for hours every weekend from my work in Milan, searching out the old, true bones of the place. But every day of work brought a reward. The house cleaned up. Old windows reopened. The space was widened by the demolition of some useless walls. The house began to breathe again, and live.

Finally the day arrived to place furniture in the rooms and make it livable.

"Decoration" is a word I don't love. It suggests rules. I think that if there is a sort of complicity between those who occupy a house and the house itself, its walls, and its spaces, in the end the house will dictate what it needs.

It was evident that we should only plaster and whitewash the walls, making no attempt to cover over all the traces left by the centuries. Therefore my walls are far from being straight or smooth; the stone steps are uneven and still bear the footprints of previous inhabitants; and the small windows have not been enlarged, but each one of them frames a landscape that could be an Impressionist painting.

As for the choice of furniture: here too, the decisions were dictated by the house. Of course, it was necessary to consider the tastes and the needs of its two newest occupants. Many ceiling-high shelves appeared, practically in every room, to hold my husband's books, spaces that he subtracted from the spaces allotted to the paintings that were an integral part of my life. With a bit of elbow pushing, they both found their places. I would call it a kind of brotherhood. The concept of a family relationship between the furniture, objects, books, and lights is a very subtle one, even secretive. But for me it is evident; it links together everything my house contains. It is not a question of style.

As an example: In the room where I am making these notes, it is extremely cool (it was a black hole inhabited by sheep when we first saw it). I have taken refuge here since the summer is scorching outside. Everything seems whiter in the heat. There are white-and-green Neapolitan tiles on the floor; a big, silver Sicilian marriage bed with amorous

symbols; some Viennese pieces of furniture from 1910, designed by Orly, lacquered in white; and some Kajar paintings—one of which depicts a thief being given a bastinado by a group of soldiers, elegant in their red uniform, in front of a small, joyful, blue mosque; all the characters are smiling, including the thief. Some family portraits: my very elegant Italian grandfather wearing a pale blue–and–white striped tennis jacket; my other Armenian grandfather has an imposing look under his fez. Nearby there is a voluptuous odalisque gratified by the presence of a silver chandelier near her, various sultans, and several piles of books on every surface. All this is dominated by the blue, slightly cloudy sky painted on the ceiling.

 I realize that this might sound like a list of bric-a-brac, but it is not. Everything has its own place, its proximity to each other and to my life, and if just one of these elements was missing, a warm intimacy would be lost. This room is very often lived in now by writers (as are the others since I have turned Santa Maddalena into a working retreat for writers, who come from all parts of the world; they often tell me that the slightly absurd atmosphere, which is not lacking in tenderness, helps their work).

 Every room has its character and also its mystery. The old barn became the place where Grisha worked for thirty years, an open space dominated by a huge library table. The light in that room filters through open brickwork, the bricks arranged like a child's game. Depending on the hour, the light hits the table in different ways, forming patterns like mysterious writing, still to be deciphered. There Grisha hammered away at his Olivetti typewriter with great zest, coming out of his barn to approve or disapprove of work on the house that had been done during the day. Those were happy times.

 The restoration of the tower was less of a challenge. I had learned a lot from the work in the house, where we were living by then, enjoying it enormously. I had a magnificent friend, the famous architect Marco Zanuso, who was able to turn my dreams into reality. First of all, we made the important decision to put back one of the missing floors.

Some of the original stones were scattered around the fields. I managed to be there when the job was done, and I am proud to say that I chose, along with the chief mason, every stone that was put in place—again a matter of finding the intimate associations that brought the stones together once more.

Zanuso had the brilliant idea of creating a wooden structure attached to the exterior wall of the tower to contain the staircase connecting the top two floors—a device used in medieval times, which leaves intact the spaces of the two square rooms. A little wing was added. The tower was beginning to turn into a small but very desirable residence.

During those years some members of my Armenian family died, leaving me more Ottoman remains that had survived the great naufrage that swept over them in the 1920s, forcing them to flee their beloved Bosphorus for their lives. Among other items were a few precious things: beautiful silver objects, Iznik tiles, many Koranic inscriptions and calligraphy, and mother-of-pearl inlaid pieces of furniture. All of them tokens of another existence.

For some miraculous reason, they fit perfectly in the tower. Those few Ottoman touches dictated the exotic atmosphere of the place, which is certainly nostalgic but also serene.

Sunset hits the upper floors in a spectacular way: the rooms are pervaded by a red and golden light, which reminds me of other glorious sunsets that I have enjoyed in Istanbul. Everything glows. It is easy for me to think that instead of the deep green of the forest at our feet, there is the crimson satin of water running nervously under our windows.

 These are the fantasies I sometimes share with the writers in residence in the tower. I know it confirms in their mind the eccentricity of their hostess, but it also makes them wonder. And in each room, the intimate relationship among the objects there ends up also drawing in and involving the person who is living in it. At Santa Maddalena, the writers remain for long periods of work. Therefore they, too, have time to develop a connection with whatever is around them. Often they come back for another sojourn, maybe after a long absence, and it is a great comfort for them to find the same singular family they know so well. After all, they are part of it.

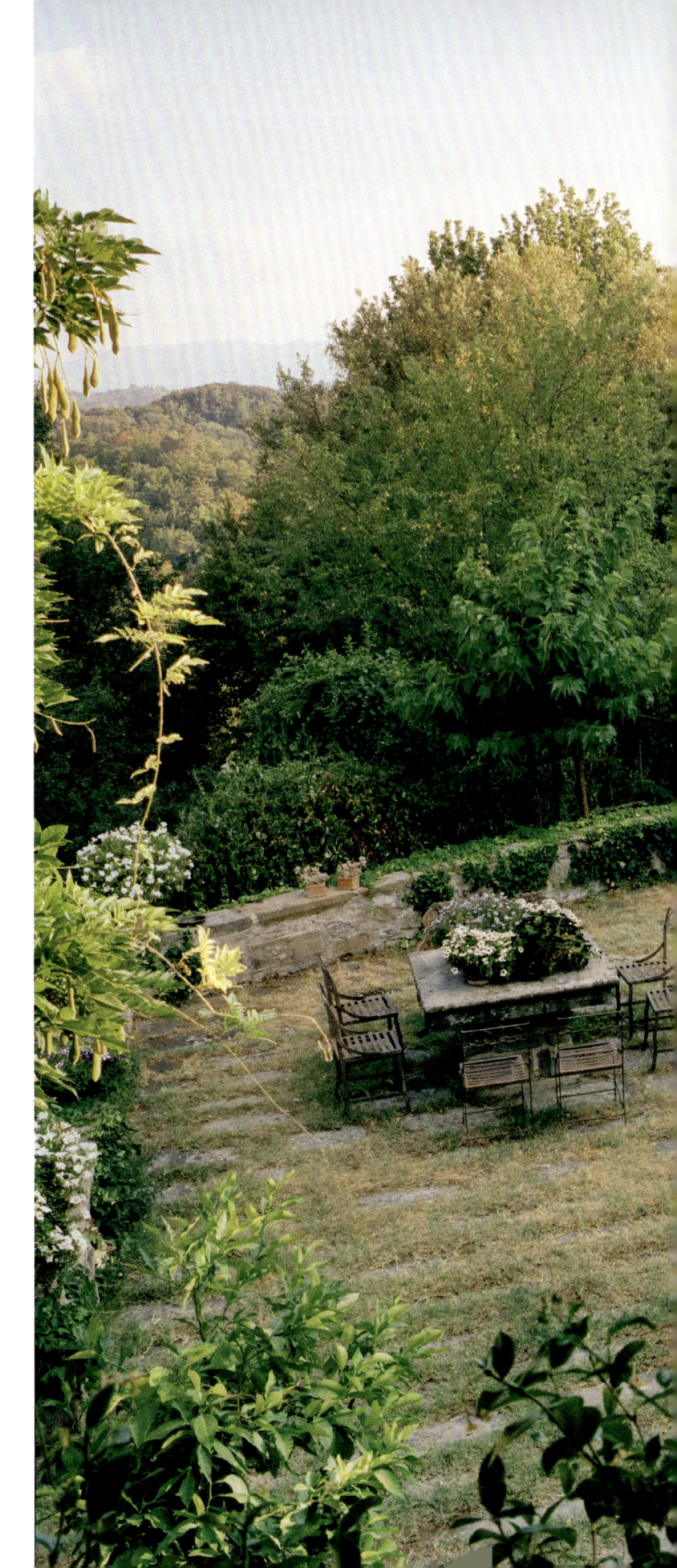

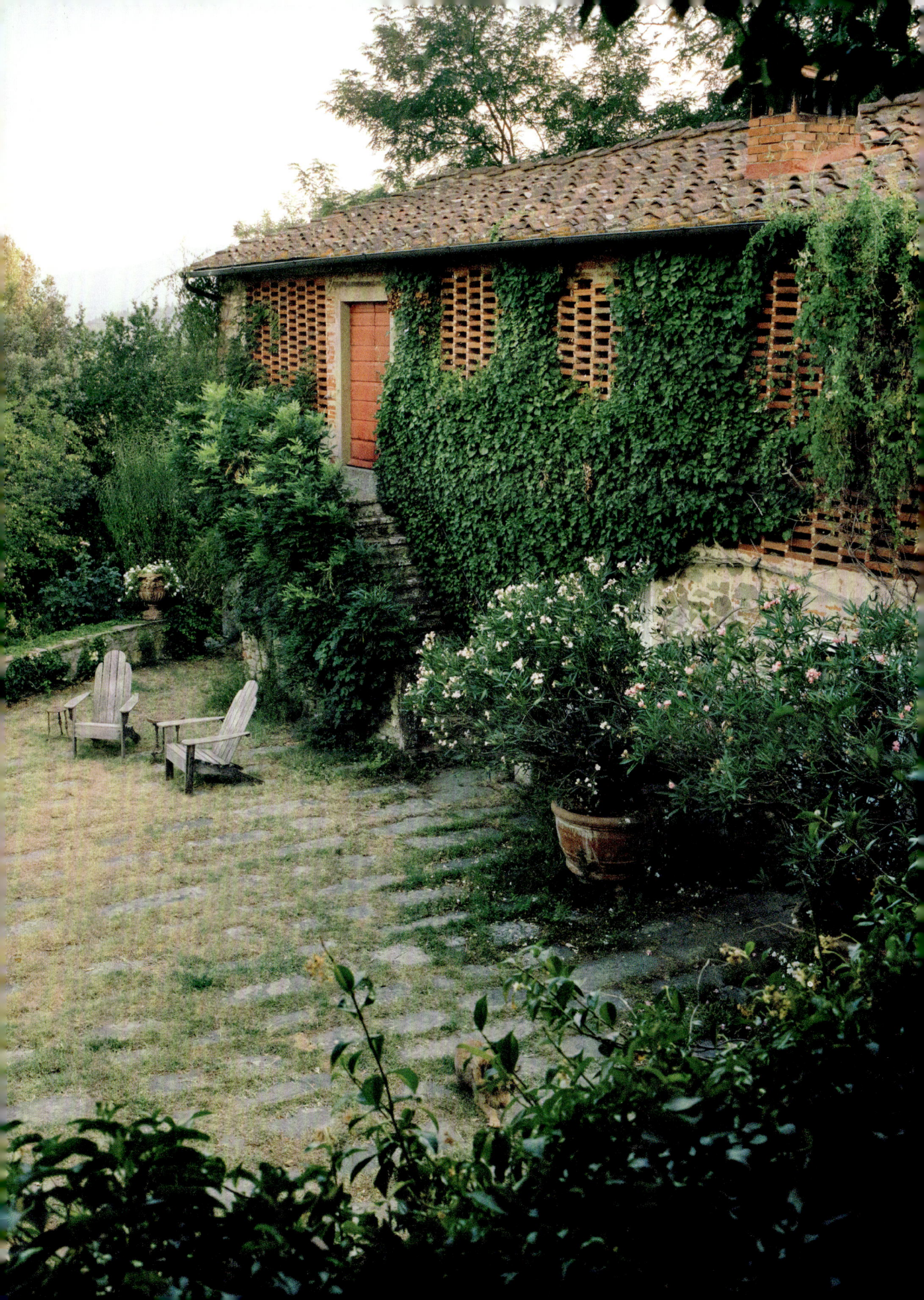

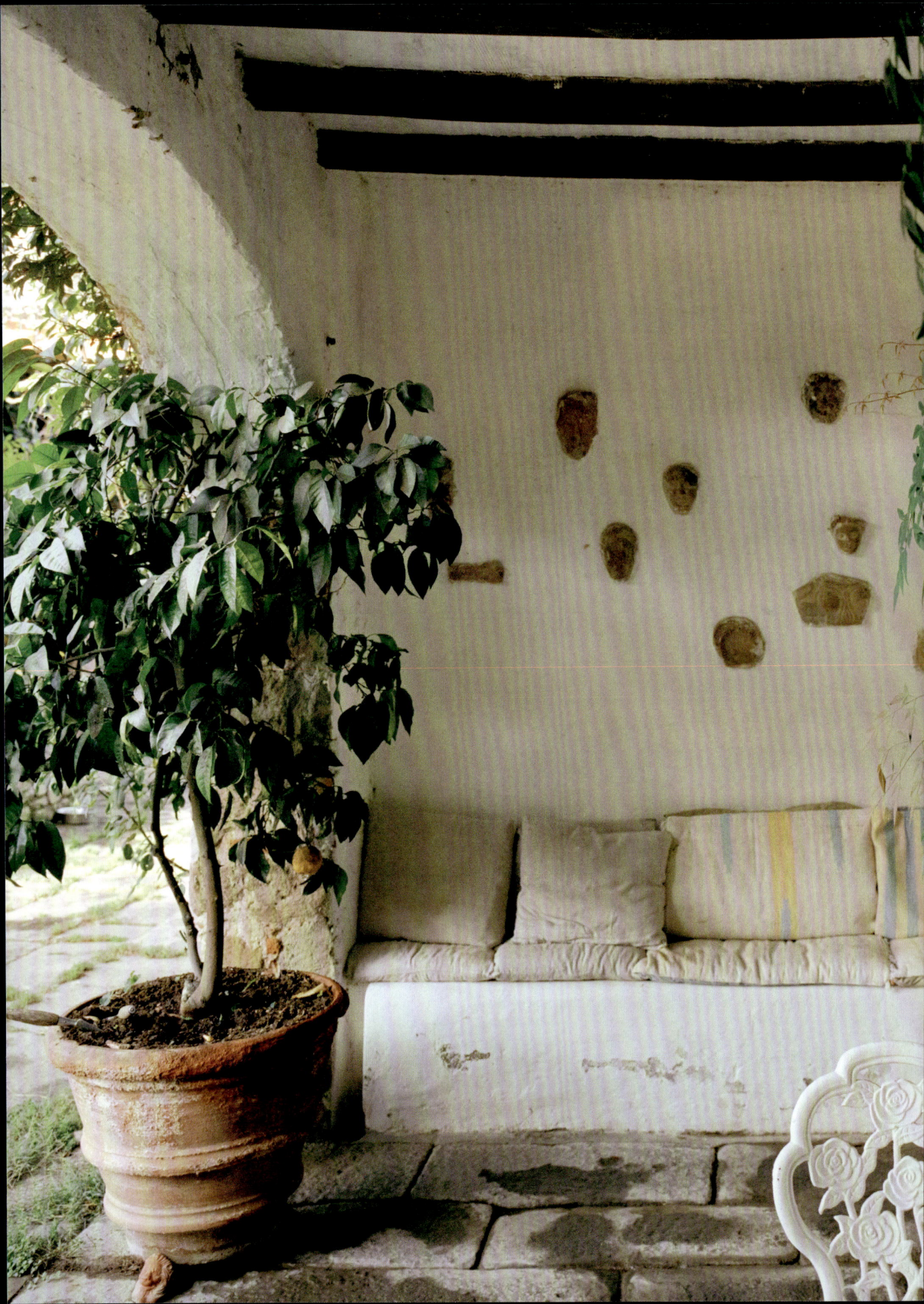

THE COURTYARD: A CONVOCATION

Stefan Merrill Block

To humans, the courtyard is the idyllic heart of Santa Maddalena, a place of measurable dimensions. Its six hundred square feet are paved with stone slabs, between which bright green grasses grow in vaguely geometric islands; from above, its floor looks like the map of an imaginary kingdom, the frontispiece of a fantasy novel. The courtyard is bounded on one side by a fieldstone barn, with its walls of red-tipped ivy. On another side stands the house, its long portico and upstairs balcony lending the courtyard a theatrical aspect. At night, when the moon is high, the space seems to be awaiting some antiquated drama, a duel perhaps. At its far end, the courtyard opens to wilderness, the jungle density of the forest, and the cool blue mountains beyond. On a nice afternoon, writers sip their coffee at the stone table, where the sun shines.

But the courtyard doesn't really belong to humans. The courtyard, Beatrice likes to quip, is "the salon of the dogs," the place where Santa Maddalena's esteemed pack passes its days. They are a motley crew, and a constant source of visitors' conversation. "My goodness, look at his eyes," a writer says, rubbing the ears of a hound named Paride, "they look so wise, so *human*." "What do you think has gotten into Giulietta?" a poet wonders, as she leans over the disheveled, red-haired mutt who is unwilling to put her snout to a hand, even when it offers a morsel of chicken. "Poor thing must have had a bad owner, once upon a time." Even as the humans wonder over the dogs' pasts, they do not suspect the truth: the dogs' stories are written right under their feet.

J.R. Ackerley once observed, "Dogs read the world through their noses and write their history in urine." And look: even as the foundation's writers take a break from their own scribblings to lounge in the sun, the dogs are still at work, sniffing each other's memoirs, lifting a leg to a stone wall and jotting down a new chapter. In fact, the courtyard is not really a courtyard at all. It is a secret library of urine, whose books are updated many times a day by the foundation's other stable of authors.

THE BOOK OF PARIDE
An aging truffle hound with a coat as thick as a sheep's and those disquietingly human eyes, Paride writes in a businesslike way. Squatting against a wall, he commits his story in a fast, unceremonious stream then moves on. The reader, coming upon Paride's work, might not at first recognize its tragic content. The dominant tone is one of obdurate stoicism—his piss has a grassy, plodding smell. But if the reader lingers, they will discover, in Paride's subtle urinary undertones, a story of considerable woe.

Beneath the ordinary bitterness of urea and creatinine is a faint but pervasive aroma, a smell like peat and blood, in which the reader can discover a vivid description of the rich earth of Paride's early years, mingling with the rancid hormones of a sudden, drastic loss: Paride was once the son to a famous pack of truffle hounds, all of whom were murdered by a rival truffle hunter one moonless night, when Paride was only one year old. After the slaughter, Paride wandered the countryside, and in his story the reader can detect the ranging valley scents of Paride's orphanhood: primrose and cypress, rosemary and boar meat, the ketones of his worst wintertime hunger. And yet, the reader also finds a conclusive note of redemption: the heady musk that all Santa Maddalena dogs have in common, which tells the story of his adoption into the foundation's walls.

Paride relates his story without any trace of sentimentality. A kind of dog Hemingway, Paride writes in language with the visceral, complex bluntness of life itself.

THE BOOK OF CARLOTTA
Sadly, the susurrating old pug Carlotta is not fully literate. She spurts out her narrative in poor phrasings of drips and drabs across the flagstone floor, and the reader must scrape together their meaning. And yet, the dogs of Santa Maddalena read those scraps with great interest. Among the spayed and neutered dogs of Santa Maddalena,

Carlotta's story is salacious, like a tell-all memoir of an aging prostitute. Her urine is eccentric with the yeasty funk of estrogen: a long rambling account of her years spent in a puppy mill, turning out litter after litter. The reader will also discover a hint of iron, from the time she was strafed with buckshot during an attempted jailbreak. Mingled into every dashed line is a strong, acrid presence of acetylcholine, the hormone of loss, which relates the endless sorrow of a long-suffering mother, her puppies sold away from her again and again. A sad story, not especially well told, but Carlotta occasionally evinces a sort of accidental and subversive poetry, writing her accounts of this abject life on little marble plaques, abandoned dinner plates, or a cashmere sweater someone dropped on the ground.

THE BOOK OF GIAMAICA

Giamaica, a four-year-old half-breed, is one of the foundation's most prolific authors, writing her story with that telltale mix of exuberance and amateurishness that marks a very young writer. Like many untested authors, Giamaica is perhaps too proud of her callow work, leaving it in places of prominence for others to read, like under the table or over the ivy on the portico. Sometimes, if the mood strikes her, she'll even sneak inside to write a passage across the kitchen floor. As for the content of Giamaica's memoir? It is not an especially introspective text. For the most part, it is just a showy account of Santa Maddalena's wonders: the minerals of the river-fed swimming pool, the tang of olives dropped from the grove, the purloined cheese, and the rubber of the ball forever in her slobbering mouth. But Giamaica is not satisfied to report each of these joyful smells without elaboration; to each she adds the exclamation point of pure dopamine, the hormone of happiness itself. Pausing to peruse Giamaica's latest offering, the other dogs harrumph about the flashiness and awkwardness of youth, but the truth is they often find themselves rereading her work many times over. Studying Giamaica's story, they can feel the vanished spring in their joints, the lost glee of an unending game of fetch. Whatever Giamaica's literary shortcomings, to read her is to become young again, if only for a moment.

THE BOOK OF GIULIETTA

Giulietta is a gaunt, lumbering, bearded mutt who lurks far from dogs and humans alike, out where the courtyard abuts the forest, and she is the most philosophical of her cohort. Giulietta's own particular brand of metaphysics tends toward a sort of existentialist nihilism; her text is not much but an account of whatever she supped

that day, and it warns the reader off the attempt to locate any deeper meaning. *Why try to make any sense or tell any story*, her round, spreading puddle asks, *when life is just one senseless thing after another?* Her readers, of course, can assume that whatever her true history might be, it is not a very happy one. And yet, despite all of Giulietta's gloom, the reader can't help but detect a faint serotonin in her texts: the dark pleasure that Giulietta takes in the grumpy role she has chosen for herself in a home of many pleasures.

THE BOOK OF ROSINE

No one can deny that the *Book of Rosine* is the courtyard's most celebrated text. Though the other dogs like to imagine that their own books might someday prove more meaningful, though they like to sniff Rosine's history and offer their envious critiques of her coddled life, they all know that their own work will never echo as resoundingly. Like a queen offering the peasants alms, Rosine plods out in the courtyard and leaves her story right there at the center, where it belongs. Rosine is an aristocratic pug, the latest scion of the long line of Santa Maddalena's pugs that have preceded her. Her urine is fragrant with privilege: her many chicken suppers, the perfume of the human laps on which she spends her days. And the mysterious scents of faraway places: the fatty goodness of her evenings spent in human cafés, the smoky residue of her winters in New York. And in that richness, a dog can read also the story of her pug forebears. Tom Boy, who snuffled at the feet of Robert Rauschenberg and Jasper Johns in the galleries of Milan; Lazlo, the Venice-born pug prince, who was the pride and joy of Beatrice's late husband, Gregor von Rezzori; and Alice, who helped oversee the foundation's early years while always taking time to summer with Beatrice at a seaside house on the Isle of Rhodes.

The tone of Rosine's literary voice is uncommon in these troubled times. It is the smell of civility and culture, of history and continuance. Rosine's story is told simply, austerely in scents any dog could read, and yet there remains something playful and enigmatic. A familiar but unplaceable zest, like a question unanswered. And that is precisely the quality that gives her work a brilliance the others will never achieve. It is the lesson of generations of Santa Maddalena's dogs past, an awareness into which each of the foundation's noble pugs is born: to always remember, amid the telling of their tales, that there should be an uncertain mystery, that there will always be scents that exist just beyond translation, in that ineffable realm whose qualities we can only describe secondhand through the strange shapes of our stories and our grasping languages that will never quite suffice.

Previous pages and left: *The two nude ladies smoothly dancing away in the living room are by Michelangelo Pistoletto.*

Right: *Facing the two ladies from the previous page is a demure Venetian courtesan from the seventeenth century. The marble sculpture is by Andrea Cascella.*

THIS WAY OF SEEING

Colm Tóibín

Upstairs at night, she dreams of the rooms below. The spirit of the years that are gone now lives, she thinks, in how shadows fall, how vistas and interior spaces are configured. She sees the past in pictures and in pieces of sculpture, in objects that she found on her travels: a table she had restored, a chair that she noticed and bought, and rugs that she carried home from some long trip.

It is hard to know how to feel about time. When she wakes, she remembers something for a moment, or on occasions it seems like more than a moment. It is as though what she sees now had actually just happened. Grisha's birthday party in Lindos, for example. She can name who was there with absolute ease, remember how each one traveled, how long they stayed, where they lodged, what they wore, and who sat next to whom. She can remember who took photographs and who smiled, and she can almost hear shouting and chatter, the familiar voices.

Then, as she notices in her mind someone coming up the steps, the picture fades, or shifts. Instead of the people at that party in the shimmering light of Lindos, she sees her mother in a photograph, and that image gives way, in turn, to an image of her sister, whose face becomes a face in another photograph and then a real face moving and smiling now as the scene is interrupted by a dog barking outside and someone shouting below the window.

It is morning in Donnini; it is time to inhabit the present. She has never, it strikes her, had any difficulty with the present. Now, as she moves around the bedroom and goes into the bathroom, choosing the clothes she will wear, she is already beginning to think about the two phone calls she will make as soon as she arrives downstairs.

She is sure, as she gets ready for the day, that the past is shadow and that things remembered are over. This moment, on the other hand, the sheer solidity of now, matters more than anything, or seems to.

This, she smiles at the thought, is called life, and she has every intention of getting on with it.

It is strange, she thinks, how much beauty matters—the way the stairwell curves, the depth in the whiteness of the paint, and the worn texture of the tiles. Each room in this house was imagined by her first, each object chosen by her; this is her creation.

Then, in those years when she lived in Milan during the week, she would often let her mind wander through these spaces she had decorated with such care. She would imagine the fall of light and shadow. She would see the pictures and the furniture, the table with books and magazines, the other shinier table, ready for guests who would come on the weekends, and the table outside where she would have her breakfast and read the newspapers on Saturday morning when she returned.

The house could, she thought, have so easily become a house full of ghosts, filled with odd echoes and fading glimpses of parties and dinners and days of ease that are gone. A place filled with memories, old fading photographs. But now, there are new voices, new presences, fresh echoes being created.

She attends for a moment to the noise of morning in a house where there are people. The noise, in all its domestic softness, satisfies her.

For the moment, however, she sits alone with Rosine, the pug, outside and flicks some more through the pages of the newspaper, pondering on the differences between writers and painters. How physical and raw and uneasy painters are, almost awkward, and needy and strangely ambitious! No amount of studio space would work for most of them! They would need any number of assistants! And they would, if the notion took them, sleep all morning and work through the night. Then they would require new materials, or a truck would have to come to deliver stretchers or take the work away. Having painters around, she thought, would be like living close to a factory.

Nonetheless, it strikes her, she has liked painters in the past. She has enjoyed their presence at parties and openings. It has amused her how closely and dartingly the painters watched everything, how much on the move they were. And the work itself interested her. She knew how good her eye was, not just for the work, but for something in the spirit of the artist that made its way into the work.

She could see when that spirit was not there; maybe that skill was just as important—the ability to detect a fraud, someone who had no style, who was trying too hard. She could see that too in a room or in a garden space, she thought. It was what made her different from other people—this way of seeing.

In a house like this, she thought, writers had a way of moving that was almost elegant. They did not seem to need to make a great deal of noise. No one talked much about their work, what they were doing in the silence of their rooms. They took an interest in the world, or at least they did when they were not working.

Her way of reading a novel, she knew, was close to how, in the old days, she would study a body of work by a painter or a sculptor. Her own sense of style, her own original response to the world would have to be matched before she would be engaged. In order for her to be satisfied, there would have to be something—a light. She would know when this happened. Recognizing it was, she supposed, a sort of instinct.

She had no interest in dullness or things that conformed. Eccentricity interested her, a tone in things that was unusual, which has a charm that seemed both natural and cultivated. She liked managing things, talking on the phone, writing and getting emails, making plans, looking for further adventures, searching through her address book, and thinking of people she would need to contact.

The past, now, is a kind of adventure. Her mind can wander through the great bazaar of what occurred like an expert shopper and collector. She can pick up and

examine something her father said, for example, or a trip on a boat with Grisha, or even imagine a time before all that, a time she had not personally lived, which belonged to her grandparents. What is delightful is how easy she can leave these images. It is enough for her that she has inspected them and held them.

She looks out at the morning and then stands up, hearing the sounds of voices and visitors. She will, she knows, be busy all day. She will soon venture into the house to find out what is going on. Nothing escapes her.

The two rooms downstairs between the dining room and the garden are signs of plans fulfilled, of dreams that made their way into living spaces. They were once stables, abandoned for thirty years, filled with chicken shit when she came here in 1967, at a time when there were sixty thousand abandoned farmhouses in Tuscany. And she set about converting them, taking the flagstones up to put in underfloor heating and then putting them back, creating an arch with the same sweep as an arch in her house in Lindos, and making the sitting space at the back of one of the rooms with concrete and plaster, like a space in a Turkish house, filled with cushions and comfort. The plan was to open up these spaces, but not too much. No big windows, for example. Instead, shadowy light flows in through small openings, making these rooms perfect for the summer or rooms to use at night. The two rooms have an Eastern feel, like spaces in some outpost of the Ottoman Empire, reflecting the heritage of her mother, whose family were Armenians living in Istanbul.

She laughs, as she looks around the rooms, at how many of the objects in these rooms bought on trips abroad were carried rather than shipped, from a drinks cabinet found in Marrakesh to cushions brought from Tangier, to rugs from Kabul and other objects bought in India, to a Sicilian mirror and a table bought in Turkey. On the wall behind the sofa, there is a piece of embroidery that was bought in a town on the border between Afghanistan and Kahmir. Other things in these rooms were picked up at local

antique shops and flea markets. Some other things came from members of her family, including a couch from the house where she was raised, in Nigoline, in the north of Italy.

On the right of the door that leads to the garden is a painting by Michelangelo Pistoletto of two dancing women, both naked, one with a big bottom. There are also works using canvas and plaster by Piero Manzoni, the artist who supposedly shat into a tin can and sealed and sold it as *Artist's Shit*, as you might sell a can of beans or as you might sell a masterpiece. No one was sure which.

Manzoni was one of the artists that she displayed in her gallery in Milan—the gallery that she ran between 1955 and 1982, which caused her father to remark, "We spent so much time educating this girl, and now she's selling the shit of artists."

On a small raised area between the two rooms, there is a piece of sculpture in white marble by Andrea Cascella that suggests a woman's private parts. Like Manzoni, Cascella was a friend. Although she was careful not to get romantically involved with the artists she represented, there is a rumor that she made an exception for Cascella, and a further rumor that Cascella used her, or a part of her, as a model for this piece, which was a gift from the artist.

The two most striking paintings in the room are by Enrico Castellani. They are done in white, with undulations, and there is something very pure about them. Despite their minimalism, they have an architectural grandeur and a sense of presence. She remembers that Castellani looked like a priest and was a very nice and correct person even though he was on the far left, indeed someone in whom the police took an interest. There is a rumor that he hid in this very house when he was on the run.

She looks around the two rooms, taking in a piece by the English artist Stephen Buckley and a piece of pre-Columbian art that she got in Los Angeles. Going back over the years in her mind, she thinks of the artists she showed: Francis Bacon, Joan Miró, David Hockney, Antonio Saura, Antoni Tàpies, Anthony Caro, and Robert

Rauschenberg, to name a few. Looking around again, she goes back over the journeys she went on, the years that have passed, and the things that belonged to her father or to older generations. It makes her sad for a moment that time has moved on.

But the sadness does not last. The house is here now. There will be more people coming soon, younger writers who were not even born when these rooms were put in shape, and there will be evenings and conversations that will add to the atmosphere she so carefully and lovingly created. These rooms belong to the future as much as to the past. And she has plans for the future, for the rest of the day, for next week, next year. So she is tired of talking about the past. It is time to make phone calls, send emails, work out what is happening at this very moment in the garden, to which she will make her way briskly before sitting at the table in that garden outside these rooms and checking the day's happenings in the newspapers that have just arrived, starting to read a new novel by one of the young writers who will come soon to stay in this house.

Pour Beatrice,
la plus belle amie
souvenir très a[ffectueux]

Left: *At the entrance, there is an oversize guest book full of mementos. The page in the photo recalls the visit of Antonio Tàpies, the great Spanish artist. He was one of the first to exhibit in the Galleria dell'Ariete in its early years.*

THE ART OF (NOT) PLAYING BILLIARDS

Juan Gabriel Vásquez

I owe a lot to the library, which I don't call the library, but the Billiards Room. The nature of this debt is difficult to establish. It is made up of emotions and anxieties and that most unassailable entity: wasted time. But I will give it a try.

When I arrived at Santa Maddalena, in the summer of 2008, two things were happening in my life. Or, rather, one was happening and the other, conspicuously, was not. My twin daughters had been born less than three years before: that was happening. Since then, since that day in late 2005 when I managed to finish a novel while they recovered from a difficult birth in their incubators, I had not been able to write one single page of fiction. This, as you may have guessed, is what was not happening.

So I came to Beatrice's legendary retreat with a sense of mission: I was to begin a new novel here or die trying. For six weeks—six long, childless weeks in which uninterrupted sleep was not a luxury—I followed the same stubborn routine, broken only by a weekend in Spain and a day trip to see Piero della Francesca's marvels in Arezzo. I woke up early in my room in the tower (the one with the twin double beds), had coffee and bread with Nadeem Aslam, my fellow tower dweller, and went to work. Shortly before lunch I would walk down to the office, where Edmund White would be sitting with Nabokov's *Lectures on Russian Literature*. I would speak to my family on Skype, have lunch in great company, and go back to my reading and brooding and my obsessive note-taking until dinner. Little by little, as the days went by, images started coming to me: a man being shot in downtown Bogotá, at a corner that smells of burnt cooking oil, or a pilot flying over a river in the middle of the night, relying on luck and skill to reach the Mojave Desert with his cargo of marijuana. I moved absently from building to building, from room to room, thinking about a distant place and trying to fill it with distant characters.

Even if it's true that every room at Santa Maddalena is linked in my memory to those weeks of discovery and liberation, one of them lit up in my mind when I was asked

to write for this book. The library, aka the Billiards Room, was not a place where people stayed but somewhere they walked through. People came down the stairs from the second floor to the corridor, crossing the library to reach the main door; they moved around in the kitchen, talked about everything and nothing at the forged iron table, and socialized in the living room under the white, threatening-looking canvases. But no one ever stayed in the library. Books might be taken from the shelves or put back onto them, newspaper clippings or magazines arranged on the surface of the billiards table, and then the room was empty again. To me, the library soon became the place to spend time by myself, between worlds: between, for instance, my several hours of frustrating work at the tower and being called *à table*.

In the library, browsing the books of those who had preceded me at Santa Maddalena, I decompressed; I got ready for social life again. They were precious minutes, improbably stimulating, peculiarly effective at quieting down my stressed-out brain and getting me ready to enjoy the food and the wine and the conversation.

But there was something else as well. Those moments spent clandestinely with the books of others were a kind of promise, and also a challenge. Shelves full of accomplished books—books written by men and women who have stood where you stand, who have worked in the rooms where you work—convey a sense of belonging, a remedy for loneliness, and a source of good-natured ambition. *This is what can be done*, you say to yourself, *with what I have now*. After a difficult morning at the desk, just a couple of minutes in the library, haphazardly grabbing volumes by known and unknown fellow toilers, were enough for me to recover my drive. Spying on the way other writers wrote—listening to the music of an opening sentence, measuring the lengths of paragraphs—became a necessary ritual, a prayer before going back into battle.

And there was the billiards table. There were no ivory balls, no cues or racks hanging from the walls, but that table, covered with the news of the day, became a favorite

spot of mine. Billiards tables, you see, are extraordinary reading places. At eighty centimeters (or nearly three feet) tall, their bed—we players call it the bed—stands at just the right height to allow the reader to place their hands firmly on the table's surface and lean into the open pages of a newspaper or a magazine. I discovered this as a young man, many years ago, when I began skipping class at law school to spend my time in the billiards clubs that surrounded my university like dens for thieves. I drank beer with my friends and discussed politics and interrupted someone's inspired series of billiards shots to spread a literary magazine on the green cloth and point out, with admiration or envy, a poem or a short story.

At Santa Maddalena I would go down to the vestibule where, on a square table, two sculpted frogs guarded a collection of the *New York Review of Books*. After some minutes under the frogs' heavy gaze, I would choose one or two newspapers, probably that day's *La Repubblica*, and climb the five steps back up to the library, to open them under the big lamp and get lost in an essay by Colm Tóibín or Joyce Carol Oates until I was called to order.

One afternoon in early July, just minutes after we'd left the white forged iron table where the spoils of lunch were still visible, I went to the library. I had been thinking about my days as a law student, about the billiards clubs and the people I met there, and those memories stayed with me while I performed my little ritual. I can't remember which books I absentmindedly chose: Michael Ondaatje? *The Death of My Brother Abel*? An anthology on memory edited by A. S. Byatt, in which I had found a line by Samuel Johnson that had become unaccountably haunting? At some point, after ten or fifteen minutes walking around the table, I realized I had it: I knew the beginning of my novel. I rushed to find Beatrice and said to her,

"I have the first page in my head, and I would like to write it on Grisha's desk."

It still seems astonishing that she took me seriously.

DINING

Edmund White

There can be many chance meetings at Santa Maddelena—at the pool, along the miles of footpaths, between the watch tower and the house, or beside the olive trees threaded with white roses—but there is one sure place to find Beatrice, the other writers, and visitors: around the dining table at dinner time.

For Americans, there's a touch of formality—no shorts, twelve high-backed chairs in impeccable white linen slipcovers, wine in decanters, candles in old silver candelabras, and the meal served in courses by the cook. For some Americans, a shared, sit-down dinner is already sort of unusual.

But the crackling fire in the giant fireplace, the bright light pouring down from the overhead chandeliers, the ever-circulating, tongue-loosening wine, the attentiveness and wit of the hostess, and the fact that the kitchen is just a red-tiled step down—these are all informal, farmhouse touches. The cuisine is Tuscan and is based on the produce of the large, bounteous garden across the road and home-grown and home-pressed olive oil, just as it is drawn from the Tuscan cookbooks that fill a shelf of the breakfront.

The writers have that slightly extraterrestrial, electrocuted look of warriors who've been battling angels all day—and winning or temporarily losing. After some comforting gnocchi and chicken Marengo, say, and a few glasses of wine, they slowly thaw out and become human again, even voluble. They seldom discuss their work; they're more likely to talk about the strange bits of information that their Google "research" rendered that day or their strange youth in Alabama or Latvia.

Of course there are famous guests, such as Isabella Rossellini or Ralph Fiennes, but there are also "friends of the family," such as Tonino the doctor, for whom the French word *espiègle* (full of mischief) was invented (it's a French mispronunciation of Till Eulenspiegel, the merry prankster). Tonino doesn't play jokes, but he always looks as if he's in on one. Then there is the recently departed Max—kind, cultivated, and curious—with his gift for friendship and his effortless chic. There are always various princes and countesses with their exquisite manners so subtle they look like kindness and their

slightly bewildered expressions as they mingle with all these exciting, unfamiliar writers. They're invariably introduced as a psychiatrist or a cookbook writer or someone who makes sculptures out of glass, but they have rich, blood-soaked Renaissance titles one learns of only later.

But I find Beatrice herself the most fascinating person around. She's not a born narrator of her own life, but other people's remarks or the mention of a name will touch off a fleeting memory. "You're from Ethiopia? How wonderful! My happiest memories are from there. My father was stationed there. We often traveled by horse. I had my own horse. My father restored the famous monolithic churches of Lalibela, one of the treasures of Ethiopia." Or Beatrice would tell us about how she was the *présidente du comité de l'épée* for Dany Laferrière, who became an Immortal of the Académie Française. Like one of the older women Balzac relied on for his plots, Beatrice remembers everything—her mother's Armenian family, that time she traveled by boat down the Amazon alone, her visits with Curzio Malaparte on Capri, where she spent her childhood and adolescence, or with Cy Twombly in Gaeta or with Patrick Leigh Fermor in Mani, in a remote part of the Peloponnese, where she arrived by helicopter. Or she'd show me pictures of the family *yali*, a waterside residence, on the Bosphorus or Giuseppe Garibaldi's handwritten letter to her great-great-grandfather. She is the golden spider in the midst of a vast, fluttering web of memories.

Something miraculous happens around that table: we all become a family, which is so important to Beatrice, who lost her mother when she was still a child and was sent off to a convent school at an early age. As the two oldest people at the table, we are like the parents. All these extraordinary young writers are our children or grandchildren or nephews and nieces. Perhaps that association would offend some young people. In any event, Beatrice and I are definitely "family" by virtue of our experience, languages, culture, and references—and in the light of our deep friendship.

Previous page: *My living room on the upper floor, where only the most intimate friends are invited.*
Left: *A photo of Alice, one of my most beloved pugs, rests in front of a painting by Tancredi Parmeggiani from the 1960s.*

GIULIETTA

Emmanuel Carrère

This little text was written but untitled until just now, when I realized, without hesitation, that I would call it "Giulietta," for it was thanks to her that, from my very first steps into Santa Maddalena, I managed to win Beatrice's esteem.

It was spring 2013. I took a taxi from Florence Airport. After the village of Donnini, we continued along a road shaded by a canopy of foliage that kept the sunlight out—an enchantingly broken road, one I have driven through so many times since. As wonderfully beautiful as the landscape was, I was nonetheless slightly anxious. First of all, the section of the book that I promised myself to write during my sojourn was clearly going to be difficult. I had been thinking about it for several months, always postponing the actual moment of starting it; but now I knew the time had come, and frankly, I was worried. Secondly, it was the first time I was going to stay in a residence for writers—or rather, a residence for writers and *botanists*—and I had heard contradictory rumors about the Baronessa who reigned over it: some adored her, others were intimidated. I had no time to prepare properly for the meeting; as soon as I arrived, I was shown upstairs, then taken to a large room, half of which—opening onto a loggia—was filled with sunlight, while the other half was shrouded in semidarkness, as though floating in amniotic fluid. Two people were in this darker, yin part of the room from which a dog emerged suddenly, rushing toward me. If you consider that a love of dogs *or* a love of cats is one of the distinguishing features separating human beings into two groups—like a preference for Voltaire over Rousseau, for a bathtub as opposed to a shower, for the sea or the mountains, tea or coffee, the *Iliad* or the *Odyssey*, one side or its opposite—I would rather be a dog person. The candid spontaneity of dogs moves me more than the disdainful reserve of cats. But in fact I have never owned a dog, and I can barely distinguish a dachshund from a spaniel, so it was with slightly self-conscious embarrassment that I stroked the head of the animal that had just jumped up on my legs and whose mistress had called imperiously to order, "Giulietta!" Politely I said,

"Bonjour, Giulietta," as I kept stroking her head, as she licked my hand in response. At that, the two people sitting at the back of the room approached me as well. One of them was Beatrice, the other was Max Rabino. Beatrice told me later: "It was extraordinary. Normally Giulietta is . . . not a misogynist, no, I don't know how you say that, those women who cannot bear to be touched by a man. It's rare, but it does exist. And you—she let you touch her, she licked your hand. She must have realized that you were an *homme bien*." Beatrice holds Giulietta's opinions in high esteem, as Eckermann held Goethe's; that's why we did not need any lengthy preliminaries to become great friends.

I do not want to leave this sitting room without a tribute to Max, who was visiting Beatrice when I first met her. Max was one of her dearest friends: an amateur in the original sense, an enlightened art lover who was beloved by all the Santa Maddalena regulars, and for whom I fell instantly. It was friendship at first sight. I am also indebted to him for an absolute revelation. We were visiting Palazzo Medici Riccardi in Florence together, observing the chapel where all four walls are decorated with frescoes by Benozzo Gozzoli, depicting the procession of the Magi coming to worship the Christ Child. Max made me notice the following: Among the dozens, perhaps hundreds, of characters in the frescoes, some are famous figures from the Medici court, others are merely passersby—people one would have come across in the streets of Florence around 1460. But there can be no doubt that all of them, aristocrats and plebeians, were based on life models. Even though we do not know who the painter's models were, it is certain that these are portraits of living people, whereas the angels, saints, and celestial legions, which grow more and more numerous as they get closer to the manger, all have more regular features, more idealized faces. What they gain in spirituality, they lose in expression, in individuality, in realism; we can be absolutely sure that these are no longer real people. I am not a great art connoisseur and certainly not an art critic, but the idea that one can, instinctively, feel whether a portrait is of someone who really

existed or a figure created by the artist's imagination—I do not think I had ever read that or heard it from anyone other than Max Rabino, and I found it truly enlightening. Further, it helped to illuminate the subject of the book I had come to Santa Maddalena to work on, especially the most difficult part. The book, called *The Kingdom*, was about the birth of the Gospel according to Luke, and in it I was addressing a never-ending question: is there an internal, organic, intuitive criterion enabling us to distinguish between true and false, to distinguish an episode that really took place from one imagined by an author in order to provide a story that will be satisfying to an audience?

A large number of unquestionably real characters occupy that sitting room where Giulietta introduced Beatrice and me. They gradually took up residence here over the years, starting in 1967, when Grisha and Beatrice fell in love with this ruin. It had been abandoned for thirty years, used by the local peasants as a stable and as a chicken coop, entirely covered by the droppings of generations of birds. Everything at Santa Maddalena clearly shows the combined touch of Grisha and Beatrice. There isn't a room, or even a corner in one of the rooms, or a piece of furniture, a photograph, a secluded alcove, or nook in the garden that does not evoke their history. But their touch is recognizable in differing degrees. The second floor of the main building, which houses the sitting room I've described, adjacent to their bedroom, is the absolute sanctum sanctorum, the most private and intimate part of the house, where visitors and writers and botanists in residence only enter if expressly invited. Grisha would work in the sitting room almost as much as he worked in his magnificent studio. He and Beatrice would sit here together reading, watching television, and falling asleep next to each other, lulled on winter evenings by the surrounding silence and the embers in the fireplace. The household spirits who kept watch over their lives—and today protect Beatrice—are works of art, such as the door created for them by Enrico Castellani and the large red painting, almost a tribute to James Ensor, made by the painter Tancredi. Beatrice had been his art dealer, supporting him until he committed suicide, the way she supported so many wandering souls who had found at Santa Maddalena a safe harbor. I really love these works of art, precious objects bearing witness to friendship, but I still prefer the photos and portraits of her ancestors. They remind me of those of my mother's family, straight out of the Russian Empire, with their uniforms, their sideburns, their grand crosses on necklets, and their crinolines: Countess Panine and Count Komarowski, who fascinated me as a child, because there he was, on horseback in the Boer War, he who would die being thrown down a well by the Reds. At least two

empires inhabit the thick stone walls protecting Beatrice, in what she calls "an enormous family shashlik": the Austro-Hungarian Empire in which Grisha grew up and the last throes of the Ottoman Empire that her grandparents lived through. There are photographs of wedding scenes with bearded men who are clearly Armenian priests. There is Ohannes Pasha, Beatrice's maternal great-uncle, who was the last mutasarrif of Mount Lebanon. What is left of his library, some of which is in Latin, is aligned on the shelves. There is an enormous, magnificent silver teapot, from which iced tea was once poured on picnics on the Bosphorus.

There is Beatrice's great-great-grandfather Pasqaule Stanislao Mancini, a great, longtime legislator who abolished capital punishment in Italy (a century and a half before the rest of Europe: bravo!), who corresponded with Tocqueville and got his friend Garibaldi out of a seemingly inextricable marital mishap by procuring an annulment, which was nearly impossible at the time and which took twenty years of effort. This is proven by a letter half-hidden under a drawing, in which Garibaldi thanks him for having "saved more than my life, the honor of my family, which is why we will forever remain attached."

And here is the brother-in-arms of my heroic, though unlucky, ancestor Count Komarowski, in the form of the no-less-heroic Baron Alessandro Monti, who became a colonel at the age of twenty-six and, in 1848, single-handedly recruited an Italian legion of a thousand men to fight alongside Lajos Kossuth for Hungarian independence. He looks as though he has just stepped out of the film *Senso*, and—as I write about him—I realize that had anyone ever wanted to produce a biopic about Beatrice, Alida Valli would not have been a bad choice in the title role.

Another thing I realize, as I come to the end of this short text, is that I don't even know what breed Giulietta is. Apologizing for my canine ignorance, I asked Beatrice in an email. She replied:

"Giulietta is 75% a kind of Spinone italiano. We looked this up in the dog dictionary: in France they are called Italian Griffons. The remaining 25% of Giulietta is mistrustful, passionate, thieving, voluptuous, independent, but with an insatiable need of tenderness.

Like almost all of us, right?"

THE WHITE ROOM

Elif Batuman

In the summer of 2015, I had the good fortune to spend several weeks in the White Room. The White Room is also known as the Turkish Room. Even in July, it's cool and dim. Shadows shift on the floor tiles, which are white with a pattern of green vines. The windows overlook a bamboo forest, planted by Beatrice, I think with the idea of seeing whether bamboo would grow in Tuscany.

One of the most eye-catching artworks in the White Room is a painting of some soulful-eyed soldiers in red jackets and tall dark hats, beating a man on the soles of his feet. The victim's vacant shoes, abandoned in the foreground, appear to be contemplating their escape.

No matter what you may be doing in the White Room—reclining on the silver Sicilian marriage bed, writing at the table with its rose-festooned cloth—you have a fine view of the foot beating. Having gazed at it for long periods, I have often had occasion to regret that I can't read the inscription in the Arabic script. Turkish was written with Arabic letters until the alphabet reform of 1928. Most Turkish people today can't read anything that was written before the 1930s. The illegibility of early twentieth-century documents has had many effects on the national historical consciousness.

As it turns out, the foot-beating painting isn't Turkish but Persian. Beatrice likes it because everyone seems to be having a good time, "including the one who has his feet beaten." Indeed, the expressions of all the participants are wonderfully tranquil.

The reason Santa Maddalena has a Turkish Room is that Beatrice's mother, Jacqueline Keuchè-Oglou, lived in Istanbul until she was a teenager. Her family, like most of the city's remaining Armenian population, left in 1922. (It was the French ambassador who advised the Keuchè-Oglous to leave and arranged for their passage on a warship.) Between 1915 and 1922, 1.5 million Armenians disappeared from the Ottoman Empire.

This disappearance was not spoken of in the new Turkish Republic.

"I always feel close with people from the Levant," Beatrice told me, the first time I met her. I was so moved by her warmth, which seemed to extend not just to Istanbul but also, more miraculously, to Turkish writers.

In her photographs, Jacqueline is always young and unspeakably lovely: a little girl in a hat in front of a wooden Ottoman mansion; a beauty posing in queenly regalia in an Italian photography studio, her diamonds retouched with white paint. In a later portrait, taken with tiny Beatrice, mother and daughter have matching hairstyles—that was the bribe for Beatrice to sit for the photograph.

In the White Room hangs a portrait of Jacqueline's grandfather Agop Keuchè-Oglou, a person I have spent many hours googling; his surname also appears as Keutchoglou, Guetcheyan, Köçeyan, Köçeoğlu, Köçekoğlu, and Göçeoğlu. Well-dressed, he sports a finely turned handlebar mustache. Dark curls escape from the bottom of his fez.

A banker and official money changer of the Ottoman court, Agop was one of a number of French-speaking Armenians belonging to Istanbul's liberal intelligentsia. He supported the Young Ottomans, a secret society established in 1865, with the goal of both preserving and Westernizing the Ottoman Empire. In 1876, the Young Ottomans drew up the first Ottoman Constitution. One of the constitution's writers, a French-educated Armenian named Krikor Odian, had also coauthored the Armenian National Constitution in 1863. Those were the days when you could be an Armenian nationalist *and* an Ottoman patriot.

Among Agop's many Istanbul properties was a hunting lodge in Acibadem, on the Asian side of the Bosphorus, where he and his good friend Sultan Abdülaziz would hunt together. The sultan's nephew Prince Murad used to come over to play the piano with Agop's daughter. Those were the days when you could be a constitutionalist and the sultan's hunting buddy. On your right when you enter the White Room, you will notice an illustrated family tree of the sultans. Upstairs Beatrice has a signed photograph of Abdülaziz's son Abdülmecid II. An avid lepidopterist who regularly read the *Revue des Deux Mondes*, Abdülmecid II was the last Ottoman caliph.

I am always happy to find any connection between the Istanbul known to Beatrice and the Istanbul known to me. These tenuous, elusive connections remind me of the threads between waking life and a dream.

Although Agop's Bosphorus mansion was destroyed in 1941, to make way for a highway, I have visited its decorated vaulted ceiling, which was transferred to the royal stables in the Topkapi Palace Museum. I went to those stables in 2014 while reporting a story about a soap opera set in Sultan Süleyman's harem.

Agop's parquetry was transferred to another great house: the Count Ostroróg Mansion, named after Count Leon Ostroróg, a legal consultant to Sultan Abdülhamid II.

The last time I talked to Beatrice on the phone, I asked about the parquetry. "He was my uncle," Beatrice said patiently.

"Count Ostroróg was your uncle?"

"Of course. He was helping to adapt the Napoleonic Code to the Ottoman law."

The Count Ostroróg Mansion now belongs to the Koç family, who founded Koç University, where I was a writer in residence for three years. They actually had a faculty dinner once at the Ostroróg Mansion. Beatrice, too, has visited the house as a guest of the Koçs. Over lunch, one of the sons made a remark to the effect of who would ever leave a place as beautiful as this?

Naturally, the White Room has a painting of an odalisque. She's wearing a pale gold robe, reclining on a rich gold cushion. The minute I saw her, I thought, *That woman writes something or other*.

The odalisque was painted by Hippolyte-Dominique Berteaux, who spent much of the 1870s in Istanbul, where he became friends with Agop. When Agop had a winter palace built for himself and his family on the Grande Rue de Péra (now İstiklal Caddesi), he commissioned Berteaux to decorate it. Berteaux painted two ceiling murals: one featuring the personifications, mostly female and nude, of Water, Fire, Earth, Air, Spring, and Summer; the other represents Science and Literature, also as topless women. Literature is leaning on her elbow, absently writing something, staring at the sky from under her laurel crown. If Berteaux's Literature can't be in the White Room, the odalisque is a worthy placeholder.

When I lived in Istanbul, I was a frequent visitor at Agop's palace, though I didn't realize it at the time: since the mid-twentieth-century, the complex has been known as the Atlas Passage and has housed the Atlas Cinema. I saw *Avatar* there in 2009. I had no idea that I would someday be friends with the great-granddaughter of the person who constructed the building.

In 1876, Sultan Abdülaziz was deposed by his ministers. His nephew Prince Murad, the Francophile Freemason who had once played the piano with Agop's daughter, assumed the throne. Before he had time to adopt the Young Ottomans' constitution,

he was dethroned on grounds of insanity. Later in 1876, the new sultan, Abdülhamid II, implemented the constitution but only until 1878: after the Russo-Turkish War, feeling himself betrayed by all of Europe, the sultan disbanded the parliament, founded a secret police force, and turned to Pan-Turkism. The first wave of Ottoman massacres of Armenians, whom he considered to be enemies of state, started in 1894.

Some historians have posited a link between Abdülhamid II's paranoia and his love of detective fiction. In 1907, Sir Arthur Conan Doyle and his wife visited Istanbul, and Abdülhamid presented them both with medals. Conan Doyle was particularly gratified that his wife, who "ever since she set foot in Constantinople had been endeavoring to feed the horde of starving dogs," had been granted an Order of Compassion. "No gift could have been more appropriate," Conan Doyle wrote in his memoir. This story made me think of Beatrice, so full of compassion for stray dogs, and for writers, too.

In Istanbul in 1911, the Armenian satirist and translator Yervant Odian published an 832-page novel called *Abdülhamid and Sherlock Holmes*. In this novel the sultan hires Sherlock Holmes to solve the murders of three agents of the secret police. The investigation leads Sherlock Holmes to critique the sultan's anti-Armenian policies. I find it so moving that an Armenian Istanbulite took the time to try to explain humanity in a language that Abdülhamid could understand.

Yervant Odian was the nephew of Krikor Odian, the Young Ottoman who cowrote the 1876 constitution, with the support of Beatrice's great-grandfather Agop. In 1915, Yervant was deported to the Syrian desert, an experience he later wrote about in a memoir titled *Accursed Years*. Nonetheless, in 1919, he returned to Istanbul. He came back. That's how much he believed in his uncle's constitution, which was again in effect. He left for good, like Jacqueline's family, only in 1922.

Where are you when you're in the White Room? You're in a world where history took a different course—where the ethnic nation-state didn't win. You're not in a museum but in a living world. (I once found a lizard in the bathtub.) What if democratization had come not from nationalism but from enlightened multiculturalism? The White Room is a place where nationalisms are absorbed, seamlessly, naturally, almost inevitably, into cosmopolitanism. At the time of writing, the disasters of the twentieth century are still yielding rich dividends, and nationalism is triumphing in Turkey, the United States, and Italy. Spending any amount of time in the White Room is a great gift—not just a respite from the present but a glimpse of a possible future.

YOUR ROOM

Henry C. Krempels

1.
At the heart of the house, looking out onto the courtyard, next to the dogs and below *i casieri*, there is the small room with the metal-framed single bed. This is the bed that squawks when you roll around in thin, cotton sheets, in the heat of a late August night. Your British body will, eventually, acclimate to the long, hot nights, but for now you're lying there veiled in your own sweat, looking up at the blue-hued ceiling that's subtly painted with clouds. Remaining still for a moment, your gaze drops to the doorway, to the heavy curtains of a deeper, but not dissimilar, tone that are always drawn together; during the day to keep out the heat and at night as the last frontier between you and the moths and the mosquitoes.

 You eventually fall asleep that night, lying at the center of this old new world, in the only room in the house that doesn't have a name. You will, while you're here, simply hear it called "your room," and you suspect it is the same for the other assistants, past and future.

2.
Giamaica is born miraculously and under great suspicion. Last week the vet said there was no chance that Carlotta, her pug mother, who is now in her late teens with a hamper full of puppies already to her name, could be pregnant again. He'd even done an ultrasound to be sure, and nope, there was nothing. Probably just gas. But today Giamaica entered the world in rather straightforward fashion, surprising everyone. Perhaps most of all, her own mother.

 Some days, you will lie on your bed with her tucked down your sweater, an empty plate of *stellette*—for her, not you (okay, sometimes for you)—by your side. You will read to her out loud from the books you find on the undersized bookshelf, hung

not-quite-above the bed. This modest library first began as a small collection of Romanian literature on three painted shelves and has since become a mixture of the tastes and styles of the room's various occupants. The first one you notice is *Il servitore di due padroni* left by a former assistant. This is an excellent joke, you think.

3.

You talk to Giamaica in simple Italian, the only kind you have, as you slowly teach her, among other things, the difference between inside and outside. It's not a concept that comes easily to her, unlike, say, how to fetch a stick or what happens if she rolls over and shows you her belly.

She has begun to wake you up each morning by scratching on the glass panel of your door: pushing it open, two quick steps in, she cocks her left ear and drops the object—a nut, a ball, a leaf—on your floor.

Don't look at me like that, she'd say, probably. Just throw the thing.

4.

In winter, the house is as empty as the trees. Beatrice is in New York, and there are no writers, no housekeepers, not even occasional passersby. The plants sit under covers, the furniture is draped with white cloth, and the stone walls stay cold. This house, with its pale grays, low, dense mist, and damp exterior, seems to suffer in the silence. But it's an expressive sort of melancholy, as if it had read the hundreds of novels contained within it and learned how to appropriately respond to solitude.

You spend most of the season in the tower and your room, at the low, square desk by the door, handcrafted by a Romanian artisan. You sit there consuming hot drinks and books from your ever-expanding library. You've added dozens: books you found on tables, books you aspired to read, and books you've never heard of.

You think your room has stopped making sense with no one else around it. After all, you can't be at the center of something if there's nothing in the orbit.

5.

You realize you have been sharing this space with Beatrice's great-grandmother, Eliza Glavany. A large and austere portrait of her, partially covered by objects, is (or should be) the first thing you see when you walk through the door. But you hadn't noticed it properly until this moment. And now you can't stop looking at her.

In Beatrice's room there's a smaller, more extravagant portrait of the same woman, which you'd noticed much earlier while performing the nightly ritual of carrying her pug Rosina up to bed. Drawn only a few years before, it shows the socialite of the Bosphorus

poised in her ball gown and jeweled coronet, with a refined smile that leaves you in no doubt about why this particular portrait was drawn at this particular time.

Now you stand in front of this larger one, in this room, and you realize you can't remember ever getting here.

6.

At the end of your time at the house, you leave some clothes in the wardrobe, a book on the bookshelf (bottom shelf, third from the right), and a half-chewed ball in the corner by the door. You scan the room, past the Karagiozis—a peculiar Turkish marionette gifted to Beatrice by Saul Steinberg—and settle on the tattered old eye, oil on canvas. Facing out, world-weary and perhaps a little ashamed by now (what with all the watching of young, single men in their room), its fabric has begun folding in on itself. It almost seems to be trying to close its eyelids, little by little, night after night. You think about helping it along—a final gesture that the playwright in you might be proud of. But of course, you don't. Instead, you nod at it, grateful, and you close the curtains behind you.

Soon you learn that this was not the end of your time at the house.

7.

B. on the phone. She tells you Giamaica now wakes up whoever's in that room. The space itself—the walls, the curtains, and the door—have become her mistress. The occupant, without exception, must fulfill their simple duties:

Wake.
Bend.
Grab.
Lift.
Throw.
Pat.
Repeat.

8.

You are picked up at the station by the new "you," and everything seems as it always was except you're on the other side. In the car you ask Nico about Beatrice and about the house and about which writers are currently occupying which rooms. You stop for coffee at the café. You wave toward the baker whose face you knew so well, but she doesn't see you, does she? You think everything is smaller than you remember.

When Nico puts your bags down in the courtyard, you call Giamaica. A moment or two, then a small, recognizable sniff as she pokes her head out of the curtains in "her room."

A PORTRAIT OF A MARRIAGE

Hisham Matar

Perhaps each one of us carries, along with everything that has happened to us, a private genealogy of rooms. Somewhere, there is a library of dining tables, a long line of beds, an assembly of chairs, and countless doors we had opened and shut behind us. And if gathered in some imaginary museum, such a catalogue of personal architecture might present a compelling portrait of a life.

I'm thinking of this idea when I am with my friend B. in the most private of rooms: her bathroom. She is sitting in a chair draped with fabric. Beside her is the counter with the sink. It is strewn with makeup and perfume. Straddling it are two windows looking out into trees. Their leaves are moving gently, changing the afternoon light.

B. is ninety-two years old. This has been her bathroom for well over half of her life. It sits on the first floor of an old Tuscan farmhouse that she had converted. I am lying in the daybed in the corner across the room from her. Between us are two white bathtubs sunk into the middle of the floor. They look like conspiring seashells. The rest of the floor is carpeted in old kilims that B. and her late husband had bought years ago from Kabul and Turkey.

"He used to believe," she tells me, smiling, "that the secret to a good marriage is to never share a bathroom. Maybe to share a bedroom, that is a good idea, but never a bathroom.'"

I tell her I agree, and this makes her laugh.

"So it was a bit complicated, you know," she says, opening her hand, pointing to the fact that although this is a bathroom, it is also a space in between, one that leads from the corridor to her bedroom and also to her late husband's dressing room where, although he departed nearly twenty years ago, everything remains as it was: his shoes, his belts, his silk handkerchiefs.

"First of all, I thought I was going to have . . ." she says and stops. Her expression changes a little. "Well, I was pregnant. So I thought I would put a child in the room on the

other side of the corridor. And it came very naturally that if we could not each have our own bathroom because of the space, then at least we would have our own bathtub. It was his idea. He said, 'Can you imagine how nice it would be to have a discussion like that?' So we built them facing each other. You can even have a fight or whatever you want."

We both laugh. "And you don't have to negotiate the temperature," I say. "Exactly," she says. "At least you can regulate your own water. The things you have to worry about at the beginning of a marriage." After a short silence she adds, "It is a very civilized way to be. The idea was to preserve the sanity of a married life."

"You never told me about the baby," I say.

"I lost it when it was eight months already. There's nothing to say about it. It was just sad. And he already had three children, but he wanted another, out of curiosity, because the other ones were German—the mother was German—and he and she didn't get along at all, there were problems. He wanted very much to have an Italian child with Armenian blood. He thought it would be very interesting to see what would be the product of all that. But it didn't happen."

I tried to imagine the life of this child. I became strangely and vividly aware of its absence. It bled into all that I knew about my friend, as though now, beside everything else, there was this child's shadow. Such moments when B. lets me into a dark place are rare. They move me and not only for the obvious reasons. B. is not, and this is one of the things I admire most about her, interested in emptiness. She does not have a taste for absence. It is always clear with her that the present is more superior. Given the nature of the world, where all is passing, I find such disposition heroic.

"The other strange thing about this bathroom," she continues, "is that you have to walk through it to go see me in my bedroom, to visit me or to bring me . . ." she looks at her dog, a pug, who is beside her chair and looking up at her keenly. "*Vieni*," she tells it. Then, to me, "She wants to come up to my lap."

It's not laziness as much as my wish to hold on to this moment that I don't get up to help lift the dog.

"*Vieni, Rosina*," B. says again using the dog's Italian name. The pug looks up. "I have to pull her because I don't think she can . . . she's like me, you see, she has a bad spine." But the dog takes a step back. "Well, you want to stay there or you want to come, Rosina? She just wants attention," B. finally tells me, which makes me feel more permitted in remaining stretched on the daybed. "Look at her," she says. "I've never seen a dog sit like that. She's like a human being." Sweetly, as though speaking to a child, she says, "*Rosina la pallina, ma non posso continuare*. We are having an important conversation here." B. eventually picks the dog up and seats her in her lap.

"You know," she tells me, "I have had these dogs for a long time. I adore them. They have something very special, very human. The first one I had when I was twenty-five. And I've had many since. And every time I think my heart has gone with them, but . . ."

I have known at least three of her pugs. In my memory they have all become one and the same.

"B., weren't you born in Rome?" I ask.

"Yes, to society people, let's call them that, or aristocrats or whatever you want to call them. They usually had some land here and there. It was very Italian, people could remain 'aristocrats' even if they lost all their money, even if the women had only one gown to wear to parties. My family would go to Rome because Rome was the capital, the king was there."

I remember this from previous conversations, but I am enjoying hearing her recount the details again and watching her across the room, with the twin baths between us, and she sitting and the gentle light seeping through the two windows on either side and to one side her wardrobe, with its doors flung open, as she is yet to decide what to wear for the evening.

"There was an architect who invented a sort of a Moresque pastiche in the 1920s," she continues. "He was called Gino Coppedè. And Coppedè built a strange quarter in Rome, and the houses there were, at the time, very fashionable."

I remembered my father walking me through the district on one of our visits to Rome when I was a child and him pointing out the Arab influence and how good it made me feel. But I don't tell her this.

"My grandfather," she continues, "bought a big apartment in one of those houses. At the time children were born at home, so I was born there. And they had a house and another house, and, of course, all along we kept the house in Lombardy, with an enormous library, near Brescia, in a place where they make a very good wine called Franciacorta. Do you want a glass of wine?"

"Not now, thank you." I want her to keep talking. "That was the family home, the one in Brescia, right?"

"Yes, for five hundred years, but my mother died when I was six, and my father remarried. I then lived with my Italian grandfather, who was half English. So on that side there is English blood, and on my mother's side Armenian and French. The only good thing that happened when my father remarried—the woman was very complicated, neurotic, difficult, etc.—was that she had a house in Capri, a beautiful house. So they started taking me along, and I grew up there, between Capri and the old house in Lombardy, which was more severe, you know, more austere, but Capri was fantastic. It opened my eyes when I was eight, the first time I went there. I thought it was the most beautiful place on earth, and beauty was my religion. I have to live somewhere beautiful. I have to be surrounded by beauty. But I was coming and going; it was a second home. And my father went to Ethiopia during the war. He went as a *volontario*. He then remained in Africa for years and years, as he was held prisoner. I visited, but continued to live between Capri and Rome, where I went to a convent school. But in the middle of

the war, Italy was divided in two, and at that moment we were in Lombardy. The house was occupied by the Germans. Everything was thrown out. A complicated time. When it was over, I went back to Capri."

"At what moment did you become independent?" I ask.

"I was twenty. At twenty I was able to make money." To the pug, who is dozing in her lap, she says, "Yes, we made some money." Then to me she says, "But before this, at sixteen, I became friends with Alberto Moravia—he lived in Capri—and Elsa Morante, who admired me much more. All those people. Graham Greene was living there, Norman Douglas too, and, you know, it was a free and exciting life. I was curious. It was bizarre. And it went on after the war. Those were the people I liked the most. I was reading a lot. I had the big library in Lombardy, and it became easy. In Milan—but that's a long story—where I had the gallery, I became a great friend of Curzio Malaparte. Are you comfortable there?"

"Yes, very," I say. "I can lie on this daybed all day." I look up at the picture hanging above me: Michelangelo Pistoletto's *Il bagno turco*. It's a silkscreen on polished stainless steel of a woman playing the guitar. She has her back to us. Her flesh is warmly colored. The two dimples at her lower back are sweetly erotic. Her shape suggests antiquity, yet she is pulsing with the hot life of flesh and blood. You can glimpse the top of her left thigh, covered in an off-white stocking that might be that color from lack of washing, and that is the only part of her that is clothed. She could be from any century except for her left wrist and hand, which grips the neck of the guitar as her unseen fingers play some unknown chord. I am not sure what it is about her wrist and hand that look contemporary. They are delicate and slender and therefore perhaps spoiled by the ease of modern utensils. But they are also sociable—a wrist and hand used to wielding and dealing and drawing fancy shapes in the air. Her head is turned in the opposite direction perhaps because she is unsure of the effects of her music or worried about being overheard. Her left breast presses against the guitar's back. I wonder if the polished wood felt cold at first. Either way, it must have been quickly warmed by her touch.

"It's a very friendly space," B. says about her bathroom. I smile at her. "I also like the daybed," she says. "It's very important to have a daybed in the bathroom, don't you think? It's Asian."

"Absolutely," I respond.

"It was also for us what the English call the angry room; if we had a little discussion and one of us wanted to get away, we could come here. Or if one of us had a cold and was sneezing. It gave us that sort of independent togetherness."

She pauses and for a moment seems self-conscious. Although she had told me much of these details before, it was always in fragments. I know how much she fears sentimentality. We both do.

"Oh, but I can't tell you my life in three words," she suddenly says. "It's too long. You'll have to invent it. I would very much like an invented life."

"Me too," I say.

"And what about my dogs?" she says, looking at Rosine. "A dog is wonderful because she doesn't know when you are getting old. Doesn't know you are getting ugly. She thinks you are the best thing in the world."

We sit in the silence that follows, then I ask her if she and he used the bathroom as they had initially imagined.

She answers immediately, "Not really," and laughs. "But it was an amusing idea. It was symbolic. We were independent, but we needed each other very much."

I picture them bathing face-to-face, separate but together, in the bathtubs that are recessed in the ground, so that the bather's eye level is not much higher than a pug's, but they are still able to look up and see more sky through the windows. Two figures who have arrived here through countless other bathrooms. A childless couple with the ghost of the child that was nearly theirs hovering somewhere in the house, the same house where it was meant to be born. Perhaps a marriage is like a child, I suddenly think, contained in white till it grows.

"The thing I hated so much when I started selling paintings was the Americans saying, 'We like; we this; we that.' My God, you are two people, why do you speak for your wife? Why do you say 'we?' Sometimes it is 'we,' but sometimes it is 'I like; he likes.'"

This page and next pages: *This room in fact doesn't look like a busy office where more than three people work hard at running Santa Maddalena. The paintings on the wall are beautiful vistas of sixteenth century Naples, and the futuristic Russian sailor from the 1920s was found at the Arezzo flea market.*

WHERE THE WORLD GETS IN

Adam Foulds

This is the room where the world gets in, where communications are sent, and business is done. In this room the festival is organized, the fellowships administrated, and often one enters to find an atmosphere of convivial, even joyful crisis, licensed perhaps by Beatrice's uncanny powers of persuasion and arrangement that seem able, in the end, to solve any problem. It seems fitting that the room's most conspicuous artworks are fine eighteenth-century paintings of Naples, that raucously productive trading city, its waters crossed by beautiful laboring ships. This spirit of work and seafaring is shared by another painting, more recently arrived in the room—a Russian work produced at the Vkhutemas school, a kind of Soviet Bauhaus of the 1920s. The painting, a robust abstraction that fuses man, wharf, and ship in bright, vital Malevich colors, found its way to the antiques market in Arezzo, where Beatrice discovered it in a heap of canvases, saw its quality, and brought it home. This too is how the world gets into this room, the accumulation of art and objects that Beatrice calls a "mishmash." There is a mother-of-pearl decorated chest of drawers bought in Baghdad; a desk by Giuseppe Maggiolini in his later Empire style, inlaid with a mythological scene, that had belonged to Beatrice's father; a stone fireplace from Brescia; an ancient wooden plaque carved with a verse of the Koran, its position over the door decided by Bruce Chatwin; and a cushion decorated with a naïve image of a tiger and bought in Savannah, Georgia, with a friend of Beatrice and Grisha, the civil rights leader W. W. Law, that sits on a large sofa covered with a blue striped fabric from Marrakesh. Things of great or purely sentimental value come together here in unlikely but convincing harmonies. They seem entirely natural, these associations—the creations of Beatrice's unique eye. They remind one that this was Beatrice's own office for years of art dealing, a room for the business of beauty and enjoyment.

Books are here too, some of the best in the house, on shelves painted an Adriatic white and blue: art books and travel books, novels by von Rezzori, Nabokov, Ondaatje. And there are dogs also, of course, who have followed the humans inside. They like the sofas and chairs where they repose with an aristocratic indifference to the work being done at the desks. Sometimes a cat will come in alone and settle in the warm circle of itself on a cushion to sleep, until the people and dogs are too much for its delicate sensibility.

Writers come to the office to send emails or speak to loved ones. They come from their work, glazed with concentration, and become social again when the distant faces appear on laptop screens. Often they enter through the garden door, out of the different seasons of Santa Maddalena: the winter rain, the summer heat, the flowers and fireflies. The garden breathes gently into the room. Its colors stand in the doorway. Beneath whatever frantic work that may go on at the house, the ringing phones and chattering keyboards, there is always that peace and constant growth outside, that invitation to flourish.

AN EXTRA BIT OF LUCK

Andrew Sean Greer

I don't call it "my room," though it is the room I stayed in when I first came to Santa Maddalena in 2005, the room I have returned to many times, and the room I have lived in as director for almost two years; I call it *la Camera Rosa*. The Pink Room. So much of the main house is whitewashed—the *imbianchino* comes every year to touch it up—but this room is pink. Pink is, in fact, a more traditional color for these old houses because it recalls a common disinfectant paint. Its floor is also traditional, set at the original level (the lowest of the upper rooms); in fact, it is the only room on the property that has not been significantly changed. The structure is just as it was when Beatrice and Grisha found the property; it has been left slightly imperfect and simply painted so you can feel the stones. Even the bed is from another age: not just the seventeenth-century Genovese frame, in silvered brass with images of birds (and a giant acorn?), but the mattress itself, of horsehair. Once, I mentioned that it had become very flat, so a woman was called in, a practitioner of a lost art, who, with a medieval device akin to a delicate pitchfork, worked over every inch until it was revived to twice its previous size. All of this makes the room feel much like the old *casa* it used to be. One window looks out upon a cypress, which an ambitious wisteria has climbed and overcome; rashly, it turns out, for it will, one day, all have to be taken down. But when it blooms, twice a year, it blooms almost into the room. The window has no screen and has to be closed at night, not only to keep out insects but also curious cats and a stone marten (a relative of the weasel) who one time stared at me and put one horrible paw into the room before I screamed.

The door to the Pink Room, of course, holds a special power for me; it is through this door that I have heard news of all sorts about life and death at Santa Maddalena. I have answered the door to hear Beatrice tell me of the death of our dear friend Max Rabino; it was here I overheard Zadie Smith's message on our answering machine with the news that Bob Silvers had died. I have been awakened by knocks on this door to news of an errant bat, a missing dog, a leaking wall, and, once, to terrible news about

Page 100: *The two paintings of animals reading the Bible are by Jasmin Joseph, the famous Haitian painter. Grisha and I bought them in Haiti in the 1960s (on our honeymoon).*

the septic system. This was in my first weeks at the foundation, when my knowledge of such systems and of Italian were at an all-time low. It was before dawn when the caretaker, Sampat, knocked on my door and communicated something to me about *fosso biologico*, which I dutifully wrote down in my blue book, understanding nothing. In darkness, he led me to the garage, and I could immediately smell the problem: the septic tank was full. Wanting to solve the problem without bothering Beatrice, I phoned all of our neighbors for advice, but none had any, and when at last Beatrice asked me what was preoccupying me and I told her, she announced, "I love solving problems like these." She called someone in Naples who said he had two men who could help us; one was alive, and one was dead. "We prefer the living one," she informed him. Soon there was a truck pumping out what our friend Nayla called "the most famous literary refuse in the world" when Beatrice recalled a second septic tank. Surely it should be emptied as well. But no one could remember where it was. Blueprints were consulted, and we went about the property with long iron rods, thrusting them into the turf in search of concrete. No luck. It was later that night, when returning for bed, that I told Beatrice of my disappointment that we had not found it. Turning to face me, in the doorway of the Pink Room, she said, "Don't worry. One day, it will find us."

 Like so many writers who come to Santa Maddalena, I am amazed every day by some new discovery in my bedroom: a painting, an object I had not noticed before or, more often, a *story* about a painting or object I had never known. How many times did I stare at the clock on my dresser, assuming it was an antique meant for a mantelpiece, only to discover, when I asked Beatrice about it, that, in fact, it belonged to an old colonel and was not a clock but a *pocket watch*, sitting on its elaborate nighttime stand? And while, of course, I knew instantly that the kachina dolls standing on a little shelf in the corner were from the American Southwest, it took me a long time to learn that

they had come from Arizona's Canyon de Chelly, another place I thought Beatrice had invented (my doubts are always wrong). She described it, one evening over dinner, as a kind of Shangri-la where when all was winter on the land above, the canyon below would be in spring. Impossible. Last February, I found myself driving an RV through Arizona and, after camping overnight in deep snow, made my way to the Canyon de Chelly. The canyon floor can only be visited accompanied by a member of the Navajo Nation and only by one who lives in the canyon. My guide, Delbert, a bull rider, took me in his Jeep along the snow and down a rutted path to where the canyon began, and there, water rushing everywhere, it was indeed spring. On an island in all this water, his aunt sat outside her house weaving in the open air; we waved to her as we splashed by. On the shelf, beside those dolls, are other talismans—African fetishes, Cambodian Buddha heads—some saintly, some "not so saintly" as Beatrice puts it. An unpracticed eye such as mine (let us admit it: an American eye) cannot tell the difference.

There is much to draw the attention of any writer or insomniac. I have considered them all, and I have gotten everything wrong. What I took to be an antique Russian icon I am told is "a fantasy." What I took to be a painting of Spanish boats arriving on American shores, seen from the point of view of the Caribbean people, turns out to be *Paul et Virginie*, based on an eighteenth-century novel of which I am shamefully ignorant. The heavy horned animal head on the dresser that I considered to be a ram's head paperweight, and used as such, is, in fact, an African goat fetish. The painting of a woman on glass that I assumed to be an Italian antique, of course is not antique or Italian but made by "a crazy Russian lady" in the 1970s and is not a woman at all: it's Jesus. I have never asked about the painting of a masturbating guitar, but surely I have that wrong too. Or do I?

The piece that I have stared at most often, however, not only because it is

enormous but because it is across from the bed, is the two-panel painting of animals. There is a lion standing, mouth open, over a rabbit; both have books in their paws. In the other a bear stands, mouth open, over another reading rabbit; the bear has a child's hula hoop on its arm. It is the last thing I see before I close my eyes and the first when I wake up in the morning. It is a lion and a bear singing to some very bored, and bookish, rabbits, of course. That's what I've always thought. "Singing?" Beatrice says to me, astonished as we walk along the orchard, throwing a ball for Rosine, her pug, to catch. The olive trees are bare of fruit; they have all been picked and pressed into oil, which sits in vats in our basement; it's November. "They're not singing. They're reading the Bible," Beatrice explains. Wrong again. Once again I feel unworthy of living in a room that I so thoroughly misunderstand.

 Perhaps, in a way, it *is* my room. After all, who knows better than I how to work the little hook inside the painted wardrobe, unlocking the left door so it can be opened to reveal all of my thrift store purchases? Or how to shift the mattress without pushing the heavy bed off its little glass cups, put there to keep it from rolling? Or which switch works all the lights, and which works just the eighteenth-century lamp on the dresser, with its pleated pink shade? How to make the bed in seconds, how to arrange the pillows embroidered with leaping animals? How to place the pink-striped bolster so it does not fall behind the birds (and the acorn?) of the bed frame? How to open the drawers of the dresser, a transplant from Beatrice's childhood home, which has been propped on wooden stands to stabilize it on the uneven floor, without pulling the whole thing disastrously off-kilter? How to do the same with the nightstand? How to walk, in darkness, into the corridor and up three steps into the bathroom? How to walk back? How to dry socks on the radiator? How to keep the stone martens out?

"With all these fetishes in this bedroom, Andy," Beatrice tells me on our walk among the olive trees, "one should have an extra amount of luck!" I blush, of course. I ask if luck is the theme of the room, though I know there is no theme; the objects simply "call" to one another. But Beatrice considers this carefully. Rosine sits below us, staring indignantly at the ball right there in Beatrice's hand. "I suppose the room is spiritual or, no," she stops herself. She turns to me; she has found the word she wants. Or, perhaps, the word she knows *I* want: "Magic."

next pages, left: *A photo of my first pug, Tomboy. He is also in the drawing by Barry Flanagan.*
next pages, right: *Giamaica waiting for a writer to take her for a walk.*

THE NEW YORKER

THE HEART

Kamila Shamsie

The first time I took in the details of the library, I was sitting on an armchair at one end of the room, waiting for a dog's heart to burst while I held her in my arms. Giamaica's heart was beating so fast, and had been doing so for so long, that I could see no other possible outcome. Half-pug, half-mystery, Giamaica had a heart too large for her chest, I decided—in the way that the much-mourned Alice's tongue was too big for her mouth (pugs were crossbred from dogs of different sizes, Beatrice explained to me years ago; the pugs ended up with the mouth of the smaller dog and the tongue of the larger dog). So there was Giamaica with her large-dog heart hammering against her small-dog rib cage while I enveloped her in my arms.

 Just a couple of feet away, Beatrice sat at her "machine," the laptop, playing Spider Solitaire. With her profound knowledge of dogs' hearts, she knew there was nothing to worry about, and eventually her calm certainty transmitted itself to Giamaica and me and slowed both our heartbeats to a regular rhythm. In more than a dozen years of coming to the library, it was the first time I had sat in the armchair, which is clearly meant for reading in solitude rather than conversing. My usual position was at one of the two chairs pulled up to the two desks, where B. would dictate emails. and I would write them. The first time we did this I was so intent on writing every word as B. uttered it, knowing the delight with which her friends around the world receive her unforgettable turns of phrase, that when she declared "*punto*" I typed out P-U-N-T-O, to be rewarded with a rap on my shoulder that was composed in equal parts of humor, affection, and reprimand. Ever since, when I finish writing a particularly emphatic sentence, I think of the punctuation mark that ends it as a *punto* rather than an anodyne full stop or period. (B., having read my version of our interactions in the library, insists I have it wrong. She does not dictate while I type. Rather, "here I have many crises, and you solve them by typing." I leave both versions here, and the reader may decide who is being factual, who generous.) But that afternoon of Giamaica's heart was an occasion when

the library was not the place to be part of B.'s email correspondence but, instead, a place to sit in a corner and, once the canine drama had ended, observe the particular, peaceful charms of the library, which is, as B. once said, "the core of the house." When B. and Grisha first moved in, the house—which had been two adjoining houses—was marked by blockages with multiple entrances and exits; with the architect they set about giving it the fluidity that now characterizes it while still maintaining the spirit of the original farmhouses. This flow is evident in the library, which can be entered in three distinct ways—via the balcony, via the sitting room, and, most intimately, via Grisha's dressing room—but it still retains its character as a place apart from the talk and interactions of the rest of the house. You understand this aspect of its character as soon as you come to know that the library is where Grisha wrote during the winter when the studio in the converted barn was too cold (it was also his first writing room, before that studio was built).

Because it was to be his writing room, this is the only room in the house that Grisha planned, so it is his sense of humor you see when you enter it and notice the bookshelves, which decrease in width along the length of the room, creating a forced perspective. It was inspired by Palazzo Spada in Rome, but the inspiration was laced with a sense of the ridiculous because the room is so small compared to the great perspective of Palazzo Spada. When B. started the foundation and realized there would have to be an office for people assisting her, she vacated the studio downstairs that had long been her study and moved up into Grisha's winter writing room. She has largely left the library as it was when he worked here, so it is mostly Grisha's Germanic books that line the shelves, except for a modest corner, which has files of Beatrice's correspondence regarding the Santa Maddalena Foundation and a section devoted to books written by Grisha that were placed there by Beatrice. At some point in his life Grisha whittled down his library to the essentials, and in the spaces that opened up he placed

encyclopedias in many languages. Whether you sit at the desk or in the armchair, your eye is drawn to the massive set of beautifully bound encyclopedias, a facsimile of Denis Diderot's *Encyclopédie*, which was one of B.'s gifts to Grisha. "All that was known in the world at the time is in there," B. says. When you lift the great weight of one of its volumes out of its casing and turn the exquisitely illustrated pages, it's easy to understand why Grisha was so happy, "like a child," to receive them.

In many ways this is a solitary—rather than lonely—place, as writers' writing rooms generally are. "I was permitted to enter, but it wasn't a place for me," B. says. But there is also a feeling of life and living to it. Much of that today has to do with the presence of Beatrice and an assortment of dogs at her feet, but it also comes from the books, the artwork, and the objects with personal meaning that are everywhere you turn to look, though never in a cluttered way.

On the shelves and along the walls you find medieval manuscript pages bought in Bruce Chatwin's company, a pen carved by Saul Steinberg dedicated to Beatrice, and photographs and paintings. The most charming pairing is the photograph of Tom Boy, the first of B.'s pugs, facing us as we face him; beneath, a line drawing by Barry Flanagan of Tom Boy with his back turned to us. This combination has always led me to imagine Tom Boy as both friendly and independent. Also among the artworks on the wall are watercolors of Morocco by Grisha's father. "They are sort of charming; he pretended to be a painter. He was many things, mainly a great hunter; he also experimented with poison," B. says.

The largest canvas, at the far end as you enter, is of an Armenian lady who may or may not have been Beatrice's aunt and mistress to the sultan. She looks remarkably like a photograph of that very aunt, so when B. encountered her (it is never "the painting," always "her" or "she" when B. talks about it) in a gallery in Istanbul, she had to bring her home. But the incorrect packing by the seller meant that she arrived in Italy with a broken nose. B. sent her to a woman who restores paintings, and the Armenian aunt was returned with a completely new nose, one bearing a great resemblance to the restorer's brother, a Neapolitan prince. "*Un naso borbonico*," B. says. This has become part of her story. Most things that other people might regard as minor disasters B. incorporates into amusing anecdotes. If something can be made interesting or entertaining, it is forgivable.

B. fails to see any beauty in her that would explain why she ended up as a mistress to the sultan, but concedes that she has elegance and authority, and perhaps she was witty. "She's not ugly," I say, and B.'s response is not a question but a verdict: "You think

not." Ugly or not, she is certainly interesting, not only in face but in composition. There is a shade-giving tree behind her, and beyond is a particular bend in the Bosphorus that is recognizable to anyone who knows the riverside architecture. One ungloved hand is touching the wrist of the other gloved hand. B. likes the elegance of this gesture. "She is putting her gloves on," she says. For once I think B. is completely wrong about a painting. Perhaps once upon a time, she really was putting her gloves on. But she has lived a long time at Santa Maddalena now, and this is a place that changes people's relationship to clothes and bodies. I know this from both observation and experience. Here, brows unknit, limbs loosen, torsos turn louche draped in newly acquired linen, trouser legs widen, and necklines plunge. This is not a place for constriction, literal or metaphorical. Of course she is taking her gloves off.

B. may have been permitted rather than welcomed in this room, but it is clear Grisha liked her presence around him at all times when he worked. On his desk, a little black-and-white photograph of her, all softness and introspection. On the wall, a painting of her, bare of shoulders and long of neck, as elegant and authoritative as the Armenian aunt on the opposite wall (here the resemblance ends). She watches the writer at his desk, nonintrusive but never unaware.

One mystery remains before I take my leave of the room. What was it that made Giamaica's heart pound so dramatically that it terrified someone who had been living for over a month with the everyday shakes and dramas of that little body? Perhaps just before I found her, she had finally opened herself up to that faculty of the imagination, which is an almost tangible presence at Santa Maddalena. Perhaps, for the first time in her self-involved young life, she stopped to consider all the dogs' lives being lived in the world, and the tumult of images, good and bad, ended in this single thought:

And I, Giamaica, live at Santa Maddalena.
PUNTO.

WAITING FOR RAMIN

Deborah Eisenberg

This is how I remember it:

Grisha was away and the repercussions were many. First, a change of focus. Grisha was not technically a god, but he certainly resembled one in most respects: his power of observation, his beautiful appearance, his magnetism, his endless appetite for displays of human folly, his mischievous unpredictability and inventiveness, his outsize intelligence, his glamour, his alternations between cool irony and urgent passions, and his casual magnificence. But abruptly all of that had been whisked away by a German television company, which had hired Grisha to be filmed, as I remember, hosting elderly ladies on a cruise ship.

Beatrice, who shares many of Grisha's godlike characteristics in feminine variation—not even slightly subdued but veiled, as one might put it, or oblique—incarnates one presumed godlike characteristic that Grisha lacked: a pronounced inaptitude for cooking. Grisha, in contrast, was a marvelous cook and had a flair for producing dinners fit both for food writers and food photographers, and this he did, maybe not always with perfect calm, but always with a decidedly theatrical insouciance.

By chance, while Grisha was off charming elderly ladies at sea, the woman who usually cooked for the household happened to be on holiday. And also by chance, there was only one visitor, myself, at the house—a very rare occurrence, as the inexhaustibly gregarious Beatrice has a shocking volume of friends, who visit at the drop of a hat to relax, to write, to go on little excursions orchestrated by Beatrice, to be amused, to stroll through the Tuscan countryside, and to eat.

The entire house has a somewhat apparition-like quality, very faintly oscillating in the dappled light, as if it were the representation of its visitors' deep and unconscious longings for worldly and spiritual comforts. It is largely the creation of Beatrice, who has been knocked around a bit by history, for Grisha, who was knocked around considerably by history (though he knocked it around right back in his writing). It has welcomed

writers and friends, some very down on their luck, and for amazingly long periods of time. One guest stayed for about a year, and Grisha refused to expel him, though he looted the fridge every night, wreaking havoc on preparations for the next day's meals.

If one examines specific elements of the harmonious whole, one notes not only bona fide treasures but also items that Beatrice has plucked from flea markets and who knows what from all over the world, which in another context might well be considered junk. Grisha once said to me, beaming modestly, "Yes, my wife has an eye for attractive trash."

In Grisha's absence, a becalmed hush fell over the place. I was staying, as I always have when I visited, in what is called the White Room, though I think of it as the Green Room, maybe because although one simply opens a door to it and enters, it feels more like an enchanted grotto than a room exactly. Its climate is unique in the house—somewhat damp and vegetal—and a second small door leads, surprisingly, outside. For a time, a dainty mouse shared the room with me, though I doubt it actually, as in my memory, wore a coronet.

This so-called room is dominated on the one hand by a silver Sicilian marriage bed, whose frame is ornamented with amorous doves and faces wearing love's blindfolds, and on the other hand by matching, more or less life-size, Qajar depictions of one man and one woman—possibly imaginary people—both in splendid dress, both with magnificent, black Persian eyebrows that meet fiercely over their noses.

There are also clusters of delicately colored miniatures—Persian? Indian?—in which groups of people go about their business, picnicking, frolicking, waging war, and joining processions, and other small pictures, including an arresting photograph of Beatrice's Italian uncle on horseback at an angle almost exactly perpendicular to the implied ground and a photograph of Beatrice's Armenian great-grandfather, the sultan's banker, wearing a fez. Another relative, Beatrice's half-English, half-Italian grandfather, wearing a jaunty blue-and-white striped tennis jacket, is present in a painting that hangs above a little table.

Nightfall activates the images. As one drifts off to sleep, the solemn, voluptuous, clamorous activities are unleashed, and one can almost understand fragments of things said in languages vaguely remembered by someone not exactly oneself. In the morning when the pictures settle back down, one can wash in the eccentric little bathroom's eccentric little tub, one section of oneself at a time.

What did we eat, Beatrice and I, that first morning on our own, or on the mornings that followed? I don't remember. I do remember leaving the muted whisperings of my

dreams behind as I padded across one room after another, through shifts of light and shadow and the scent of polished stone and wood, past inviting sofas and shelves of books, past velvety heaps of snoozing dogs, wending my way to the bright kitchen.

A fantasy kitchen for a cook! All the space, the capacious refrigerators, the shelves, the gleaming vessels, the sleek European appliances, the ceramics inviting to the touch, the surfaces on which to chop and prepare, and the magisterial stove . . .

There must have been a loaf of bread, at least, that first morning—delicious Tuscan bread. And butter, probably, and maybe some sort of preserves. I suppose Beatrice must have made coffee, though Grisha, as she told me, always instructed her to stay away from the kitchen; whether for her sake or the kitchen's, I don't know.

But it was certainly not I who would have made coffee. I can't make coffee. Maybe we boiled some water and stuck teabags into a pot.

"Are you hungry?" Beatrice asked me later. "Would you like to make yourself something to eat?"

"Hungry?" I said. *Make myself something to eat?* "Oh, no, thanks. I'm not hungry at all."

It was Beatrice's bad luck that her only guest that day was probably the one person in Italy who was just as uncomfortable in a kitchen as she was.

"What about something to eat?" she asked me in the evening. "Wouldn't you like a bite of something?"

"Oh, not at all," I said. After all, I could hardly demand that Beatrice make me dinner. "What about you?" I added hopefully.

"Am I hungry?" she said. We looked at each other. "Not really, no."

It was spring, far too early for the marvelous tomatoes that grow in the garden, and as I remember, the garden wasn't offering up anything else edible, either.

"Don't worry," she said the next morning. "My friend Ramin is on his way here, and he's a marvelous cook. He always cooks wonderful things for us when he visits."

"Really," I said, as if it were a matter of minor scientific interest. "And where might he be coming from?"

There was a short silence. "Tehran," she said.

The sun went down, the moon rose, we sat at the little table, listening, and eventually we both went off to bed.

It must have been the next afternoon when Beatrice got a call. Her friend Ramin was delayed. He'd been headed to Rome, but somehow the road had gone the wrong way. "You must be getting rather hungry," Beatrice suggested. "Oh, no," I said lightly.

Were there a few eggs in the fridge? We might have boiled a couple of eggs.

Was it the next day that Beatrice and I went into the village? How would we have gotten there? By sheer coincidence the man who usually drove was, like the woman who usually cooked, on vacation, or maybe he was unwell or maybe he had disappeared, as apparently he did from time to time. It's in no one's best interest for Beatrice to drive, and I can't drive. Maybe we walked.

In the village, did we shop for food? I don't remember. Why would we have shopped for food? Neither of us knew how to cook. But back at the house, whether we had bought it in the village or it had been in the freezer, there was a package of gnocchi, and that package of frozen gnocchi I remember vividly, in great detail. There was some Parmesan—excellent Parmesan—and somehow some butter and some sage, which maybe the garden had managed to grow after all.

And for all her talk about not being able to cook, Beatrice boiled some water, dropped the gnocchi into it, grated some cheese, and put that grated cheese and some butter and some sage on the gnocchi after she retrieved them from the water. I helped. And I can honestly say that the meal that Beatrice and I made was a very fine meal.

But then it was the next day. "What's happening with your friend Ramin, do you think?" I asked casually. "Oh, I don't know. I expect he'll show up in a few hours," Beatrice said. I followed her gaze of abstracted disapproval to a sole, meaningless onion sitting on a counter.

We sat outside on a terrace under cascades of greenery, looking out over the hills and valleys. A wild boar lumbered rapidly along under the olive trees, toward the tower. Could I tackle the poor thing and wrestle it to the ground? And then what? I sighed, and so, as I remember, did Beatrice.

There were phone calls. "Ramin's stuck in Rome. He can't find it, the thing, you know, to drive." Excitement can sometimes make Beatrice's English unusual. "He's lost the car key?" I said. "Really?"

"That too, I think."

"What? How can he have lost his car?"

"No, no! Not his car! Claudia Ruspoli's!"

"Who's Claudia Ruspoli?" I said, not that I knew who Ramin was.

"Ah, she's, how do you say it, a lump of gold, that girl."

Beatrice is never at a loss. She always has a project, an adventure to be pursued, a plan of action—something. She has clambered up rocky mountains, trekked across deserts, and made her way through jungles. Things that make me shriek with terror

make her laugh. She is not one to give in to despair or sit passively in the face of trouble. "We will cut some broom," she said the next morning. "We will beautify the house with broom, and Ramin will come."

I didn't much feel like doing anything, but she strode out, and I followed, and there was a vast meadow that I somehow just hadn't noticed, full of broom in flower, sending out waves of fragrance.

We cut armloads and armloads of broom. The sun was near its zenith. Grisha was off, making old women swoon for the entertainment of German TV audiences, Beatrice's friend Ramin had lost the car of someone named Claudia Ruspoli, and I was sweating and exhausted and very, very hungry.

"You have enough flowers there for ten homosexuals," announced a beautiful voice—rich, vibrant, low, elegantly accented, and calm.

"Finally!" Beatrice said, as Ramin embraced her and relieved her of an armful of broom.

He was just there—how he had arrived, I don't know—and what a splendid sight he was, in black jeans and a red-and-black plaid cowboy shirt and with magnificent, black Persian eyebrows that met ferociously over his nose. Had Beatrice conjured him up with all those flowers? No, I must have; obviously he had come right off the wall of the White Room.

"We've been waiting," Beatrice said. "We're hungry."

In the kitchen Ramin rooted around, as Beatrice and I watched anxiously.

"All we've got are potatoes," Beatrice lamented.

"Potatoes," Ramin said. "Is there any olive oil?"

"Naturally," she said, maybe a little bit irritably. "Gallons."

"Potatoes! Olive oil!" Ramin exulted. "Oh, look, an *onion*! I will make a Spanish tortilla."

And although Beatrice rebuked him for using so much olive oil, I'd have to say that the Spanish tortilla Ramin put down in front of us not a half hour later might well be the single best meal I've ever had in my life.

Left: *Giulietta in front of Grisha's studio.*
Next pages: *Grisha's studio.*

(UN)STILL LIFE

Beatrice Monti della Corte

I'm now in Grisha's studio, which is agreeably tepid on this autumn day. My three dogs are here with me. They all breathe noisily but with great optimism.

Even without the clacking of his Olivetti, Grisha always fills the space. He seems to replenish the atmosphere completely, like breath into a balloon. No more, no less. It's particularly extraordinary because all of the objects in this room come from me. Thus was Grisha—always present, a master of all things.

First of all, an enormous table that runs the whole length of the room is placed very close to the four windows, which are more like one single window divided by pillars of whitewashed stone that touch the ceiling beams.

On the other side of the windows is a big valley. The valley, which is part of our property, is completely occupied by a forest, so thick with trees that only wild boars and roe deer should be able to pass. But in fact, hunters, whom I loathe, have traced the almost invisible paths all the way up to our garden, from whence they shoot shamelessly, even in the direction of our house. Some years ago, I was quietly sitting in the courtyard when a hail of little bullets grazed my hat. Some even reached the back of my pug, who is always squatting at my feet.

In the studio, the windows are covered with long white strips of linen. For Grisha, it is enough to know that the landscape is on the other side of the fabric, always at his disposal. They are removed when there's a storm—and a storm here is spectacular.

The table comes from the library of my paternal house up in the north, and whenever some visitor admires the working possibilities that such a table offers to a writer, Grisha would say with a wink, "Now you understand why I married her! I would've done anything to obtain that desk."

The windows on two sides of the room are partially screened by a grid of bricks, which let in a geometrical light, which touches every surface of the room and changes

every hour. The room has a wood floor, and the ceiling is kept in place by big wooden beams—this space that, during World War II, was the shelter for twenty refugees from Donnini when the village was occupied by Germans. This little cluster of buildings—the farm, the barn, the tower—was occupied by an English battalion. All the territory between Santa Maddalena and Donnini—about three kilometers of field and forest—were filled with land mines.

On the opposite side of the room, the objects placed in big niches that mirror the four window pillars are extremely eclectic. In the first niche, there is a bronze, spherical bowl with a beautiful verdigris patina. It is very mysterious and beautiful. A little cover, like a skullcap, completes the sphere. It wears its years—more than two thousand of them—well. Inside, brace yourself: there are traces of bones firmly attached to the bronze. My father used to say that this bowl was the very small tomb of an Etruscan baby. The bowl is flanked by a great vessel of the exact same material and provenance.

All over the house, there are many traces of that ancient civilization. They all come from my great-great-grandfather P.S. Mancini—a lawmaker, a great liberal, and a friend of Garibaldi. It was during his tenure as minister of justice that capital punishment was abolished.

Apart from these two objects, there is a nice collection of African art, which I gathered, dispersed throughout the room—some objects bought in Kenya during travels with Grisha in the 1970s. Another object is particularly precious to me: a duck decoy that I saw from a distance one day, floating in a little lake in the mountains of Afghanistan. It was in the middle of a flock of real birds. We were in a car, driving toward Mazar-i-Sharif. I stopped, and I risked my neck to go down to the lake and get the duck.

There is also a drawing by a Moroccan painter, a naïf whom I can't hesitate to call Chateaubriandesque. It's a fantastic but, at the same time, recognizable landscape around Anguilla, made using thorn as a pen and the juices of berries as ink.

All those things—a bit like the feathers that birds bring to adorn their nests—Grisha used to accept with great pleasure. One second after they were put in his space, they became completely his, forever.

Mémoires
...tisémite

Previous pages: *Grisha's desk on the left, and a happy couple in Grisha's studio.*
Following page: *On the left a bronze model of the* Endless Column *by Constantin Brancusi. It was found in Arezzo the day of Grisha's birthday some years after his death.*

WANDERERS, AT HOME

John Banville

I first met Grisha and Beatrice in Turin sometime in the late 1980s. The occasion was the awards ceremony of the Premio Grinzane Cavour. As to why I was there, I can't say since I was neither a nominee for the prize nor a member on the jury; someone just invited me, and I just went. Who would dream of refusing a free trip to Italy?

It turned out to be a curious affair, languorously disorganized, in that particular Italian way, but with an added air of furtive temporariness, which would be accounted for years later when it turned out that the man running the prize had been embezzling millions in government funding. It was the kind of story the Rezzoris, and I, greatly enjoyed.

After the ceremony a band of us spent the afternoon in the bar of the Grand Hotel Sitea, that fine old hotel in the heart of Turin, where I was staying and where, I was pleased to learn, Samuel Beckett used to stop on his way south to the sun—he confided to a friend of mine that he was very fond of Turin since it reminded him of an enormous cemetery. In those days I was youngish still and poor, and to be put up at the Sitea made me feel quite the sophisticated grandee. I remember being tremendously impressed that afternoon to learn that Grisha and Beatrice were titled; Beatrice would later casually remark to me, "How amusing, to be twice a baroness, first from my father and then from my husband!"

There are few things, even the not inconsiderable tribulations of her early life, from which Beatrice will not derive some amusement.

When I met him in Turin, Grisha must have been well into his seventies, but he was still impossibly handsome, with that sheen characteristic of the classier film stars of the day, like Vittorio De Sica, say, or Raf Vallone or Marcello Mastroianni. He was clad in tailored gray tweed, handmade shoes, and an opulent silk tie. His English was perfect—you have to know English very well indeed to be as witty in it as he was—and I suspected, rightly, that he would have command of at least half a dozen other languages of old Mitteleuropa. After all he was

born, as was the poet Paul Celan, in Bukovina, a country that no longer exists, and so he could not even claim the status of refugee. He was, rather, a wanderer.

I remember, in the Sitea that day, being greatly taken with this polished, cosmopolitan couple—she beautiful and composed, quietly observing everything, and he charming everyone, male and female, who came within the radius of his burnished presence. And if anyone had told me that one day I would stay at Beatrice's house in Tuscany and work in Grisha's studio, I would not have believed it. But life is strange, and it arranges strange conjunctions. So in 2004 I accepted Beatrice's invitation to come and be a guest for the first time at the Santa Maddalena Foundation. By that time Grisha had died, and his studio was unoccupied—but not empty.

The studio, lovingly preserved by Beatrice as it was in Grisha's time, is on the upper floor of a converted barn—in the old days, no doubt, the domestic animals were quartered downstairs—that stands at right angles to and a few paces from the main house, much of which dates back to the twelfth century.

One of the sad aspects of being a writer is that one's calling needs so few props. I enter the studio of a painter friend and am at once filled with envy of all the *stuff* he requires for his work: stacked canvases; scores of brushes bristling in jam jars; lovely, fat, heavy tubes of oozy oil paint that look as if they have been ticklishly squeezed and are doubled up with laughter—and the easel, oh, the easel! Sleek and delicate as a leaping gazelle. Whereas the extent of my necessities is a pen, some paper to write on, a keyboard, and a screen. My only recourse is to clutter my workroom with unnecessary stuff of my own, gathered over a lifetime and gathering daily a new layer of dust.

No matter that most of the things in the house were collected by Beatrice, during *her* travels, and taken possession of by Grisha, in a characteristically generous spirit of acquisitiveness. She didn't mind; what was hers was his, and he was hers.

Many of the pieces Beatrice collected are primitive carved figures, remnants of

many civilizations. I suspect Grisha relished these bare-faced fellows and ladies eyeing him as he worked—his typewriter sat on a long table-cum-desk turned away from the room toward the many windows with a view of the garden—since despite his worldly and highly cultivated sensibility, he was something of a primitive himself.

The memory of those few late-summer weeks when I worked in the studio—which by now I think of as the Studio—have lodged in my mind with a peculiar clarity. The venetian blinds rattled in the September breeze, the wasps hummed in shadowed corners under the ceiling, and sometimes I would receive a visit from Juditha, the gentlest elkhound I have ever encountered—and yes, I have encountered a few, one of them in a place in Devon, rejoicing in the name of Sheepwash.

I will not be so vulgarly sentimental as to suggest that Grisha's spirit lingered in the Studio, but certainly his things were there—his things via Beatrice—and I was at once glad of their presence and a little intimidated; how they do glare, those painted, pot-bellied, primitive wooden tribesmen!

No, better to say that in the Studio, what is present is, precisely, Grisha's absence.

HAPPINESS IS A WARM PUG

Zadie Smith

All my life I have been happiest either in water or in conversation. These are my natural elements—if someone as hopelessly urban as me can even speak of natural elements. Swimming: in lakes, streams, creeks, holes, reservoirs, the ocean, and pools, both public and private. Conversations: at tables, while walking, in bed, on sofas, amid high grass, in cars, in crowds, on stage, and on paper. At Santa Maddalena these two pleasures found their perfect combination: a pool around which conversation sparkled. For just by the pool there is a pool house, open on all sides, with many green tendrils hanging like curtains and seating for a small delegation—low, cushioned, with a Moroccan feel—and there is also a table at which perhaps six or seven can have lunch, and there are steps down to the pool, on which dogs may aesthetically arrange themselves in many different angles and attitudes, while drying their wet coats in the late afternoon sun. Sitting on these steps, wrapped in a towel, I have spoken with Gary Shteyngart about Nabokov and with Péter Esterházy about Hungarian football. I have chatted with a sun-resplendent— and blond!—Michael Cunningham about the charms of Julia Roberts, and with my host, Beatrice, about Lampedusa's *The Leopard*, the extraordinary novel I first read here, and thus I discovered Italy twice, in life and on the page. That ravishing reading experience happened on my first visit, not long after I swam in the pool during a lightning storm, revealing my very dim grasp of basic physics.

I can't remember now which writer rushed down the steep pool steps from the main house to urge me out of the water, but I'm grateful to them. It was the first private pool I had ever swum in, and it took me a while to get over the giddy thrill and the way the water, freed from the aqua-blue tiles I had always known, shimmered with the luster of the gray slate in which it is encased. No rules, no swim caps, no communal showers, no little plastic band attached to a rusty key gripping your wrist or ankle. No other people, usually. It was a quiet pool, a pool best used by one person at a time. The sort of pool you can fool yourself is yours alone for the length of time you are in it. Speaking of

length, it must be admitted that this is a pool of a certain size, fundamentally unsuited for your truly self-punishing Brit or North American, so if you insist on swimming a mile in it—as the Protestant in me was back then compelled to do, in order to "deserve" the ensuing pleasures of the day—you will have to traverse a hundred and fifty lengths. As I went back and forth in my nose-pinching goggles, in my sensible Speedo, I envied those Italian pleasure-seekers—and dogs!—who could simply dip in and swim in a dignified circle once or twice before stepping out refreshed. It must be nice to be Italian. Sometimes I would dip my Protestant head out of that fresh pool water and spot a Catholic in a lounger, reading an old copy of *Vanity Fair* and smoking a cigarette, amused by my exertions.

A hundred and fifty! Finally! Then a towel, then my own cigarette, then conversation. But being un-Italian, one tried to set oneself a limit: I will talk and eat and drink till two, and then I will go back to my desk. But two became three became four, because it was always very pleasant to speak to dear old Max about Bernini or North Africa or Katharine Hepburn or the fundamental stupidity of Labradors, and my desk was across the lawn in a high tower, and writing a novel is like swimming: a long, basically back-and-forth battle between you and your own will. Often when I am in a New York library, enacting that tedious daily battle, I think back to that pool, those lunches, the rambling conversations in the shady heat, and the delicious smell of all those wet dogs. It seems like more pleasure than a person should be permitted. And my pleasure problem has only gotten worse over the years: now I can't imagine swimming and talking away an afternoon, now every minute that is not in the library is engaged in the adult labor of work and family. But whenever I meet a stressed-out young writer at some party or another, I get their name and forward it to the Baronessa. It is some comfort to be able to pass remembered pleasures forward. And I remember it all so acutely. The texture of the towels, the crisp feel of the water, the lizards darting under the chairs, the stately entrance of a pug into the pool, paws working like a hippo, and the way her legs kept going if you lifted her out, treading the air for an extended moment like a cartoon mammal pushed suddenly from a cartoon cliff. I never wrote a word by that pool, but by the time I reluctantly made the journey back to my tower, I had an expanded view of the world, an Italianate view, in which pleasure was not a scandalous escape from life or a guilty secret buried within it, but part and parcel of life's purpose. This is not an unimportant scrap of knowledge to take to your desk each afternoon, even if you only get to that desk at, say, four forty-five. What's that you say? Dinner's at six? And then an evening swim? Oh, well—but why not! May many a stressed-out scribbler enjoy that marvelous Rezzori pool for years to come.

Right: *Happily relaxing in the pavilion by the pool.*

THE SWEETNESS OF LIVING

Adam Thirlwell

I am trying to think what the meaning of the pool pavilion is. I mean, it has an obvious meaning. It is the place to relax after swimming. You lie there, still a little damp, and let the breezes envelope you. Or it is the place to relax and talk or simply doze while *other people* swim. The pool pavilion is pastoral.

The pool pavilion only exists when there is heat. Without heat, and sunlight, the pool pavilion loses some—not all, of course—of its identity. It is a piece of architecture that requires outside elements.

But then this makes me think: the pool pavilion, like a loggia, is a hesitation between inside and outside. It is both indoors and outdoors.

Still I'm not sure this exhausts the problem of definition. There is another hesitation too, that the pool pavilion allows: a strange ambivalence between solitude and parties. Or at least this is how it always seems to me. My memories of the pool pavilion are all populated differently: sometimes large lunch arrangements, sometimes intimate conversations (I remember talking to Zadie after swimming; I remember talking to Colm while rain gathered outside), and sometimes total solitude. But what's stranger is how these can overlap. It is possible to be both alone and in company, in the pool pavilion; to be separate from and yet also part of a conversation. A room forces sociability on its occupants; the pavilion is more delicate.

I wonder if that's why it's impossible to consider the pool pavilion without also considering its soundtrack. Whenever I conjure it up, it is always on a soundstage: the Tuscan birds, soft multilingual conversations ('Thanks God," exclaims Beatrice, eternally), and the splashing, dragging sound of people moving through blue water. And all the sounds move more languorously, because they are moving through heat.

So there is another way of putting this: the pool pavilion is not the pool but is almost the pool. It requires the pool but is separate. It is the spirit of adjacency! You see the pool through a haze of leaves.

The pavilion is a charmed space. I wonder if that's why I most associate the pool pavilion with conversation—conversation that enters the afternoon, buzzing with coffee, and replaces the work one imagined one would do. It is where writing becomes conversation.

But then this only means that, in some way, it is for me a concentrated image of the entire ambiance of Santa Maddalena. In it, everything—writing, gossip, swimming, light—becomes converted into pleasure. It makes you believe there could be a *science* of pleasure—that pleasure should be treated as seriously as everything else.

In Bernardo Bertolucci's best film, *Prima della rivoluzione*, there's an epigraph attributed to Talleyrand: "He who has not lived in the years before the revolution cannot know what the sweetness of living is." There's another variant of the same epigram, where *douceur* is replaced by *plaisir*. But maybe *douceur* is closer to what I'm trying to say. I never thought I'd find myself on the side of counterrevolution. But in this era of cartoon despots and their cartoon coups-d'état, the sweetness of living that is possible in the pool pavilion suddenly acquires a kind of poignancy. I can only think about it with grave nostalgia. And maybe that, in the end, is its deepest meaning.

A NOMAD'S GRAVE: A SONG OF GRISHA

Michael Ondaatje

One dog asleep beside me as I write this. A truffle hound. Its ancestor was assassinated by her competition, somewhere near Spoleto.

 At four in the afternoon, bright sunlight competes with his name on the gravestone, as well as the smaller typefaces of birth and death, along with the false information that Grisha was born in Cernopol, a fictional town that appears in one of his books. More truthfully, the gravestone says that he died in Donnini in 1998.

 But now, at nine in the morning, there is a scattering of light through the trees onto this pyramid of rough stone, which seems at ease in this light, with its tip of red basalt. So it almost seems a part of the natural world.

 Some yards away is a small stone table as well as a metal bench for Grisha to write on in the afternoons—a small, thoughtful gift for the afterlife, for there is nowhere better to work, to rest, to take a pause from that recent afterlife and hear through the trees the splashing and see the naked swimmers in the pool, or to read a book that a friend or a writer may have left at the house. Among those swimmers are perhaps some young writers he once helped or at least inspired with Beatrice, who is a universe in her own right.

 The stone table is the right height to allow you to lean on your forearms and think of him; to think of how, after a wild life full of mockery and shadows and transformations and delights, he met Beatrice, on a beach at Lake Garda. She had been looking for the right stone to throw for her dog, she says, when he came upon her. She saw his shadow first, as she was bending down. He inquired what kind of stone exactly she was looking for and, being told, walked into the water with his good shoes in order to find that precise stone for the dog.

 When he visited her the next afternoon at her home, "he brought with him the ugliest, most interesting friend." It was, of course, another wise ploy by this man with a rake's or courtier's past. There was something, after all, almost nineteenth century

in Grisha's knowledge of how to survive and get what he wished for or needed, aware of how far to go through the darkness to the delight. (And I must note that whenever I type in the name "Grisha," my spell-check tries to correct it to "Geisha.") In any case, he met Beatrice, who was already full of her own busy life. When her boyfriend at that time said he did not like Grisha, she said, "Don't harass me, I think I am going to marry him." That happened two years later.

 Many of us met Grisha and Beatrice long after that. For many of us writers, it was in North America first, then Italy, then Tunisia. By then we had read his remarkable books. But there really are too many lives and tales to tell about the two of them. Some possibly not true, for whenever there were confused tales about his life, he didn't always bother to correct them.

 He liked to believe, for instance, that he was conceived in Egypt. So, when Beatrice thought of this beautiful and modest gravestone, 1.89 meters (over six feet) tall, she remembered the Valley of the Artisans—the smaller set of pyramids she had seen, some distance from the Valley of the Kings and the Valley of the Queens in Luxor. And there would be a small echo of that in this stone pyramid, exactly as tall as he was, which has his name and the dates of his life and the false location of his birth, with that deep red basalt top, made and given to Beatrice by the Italian sculptor Arnaldo Pomodoro.

 All those stories. All those places and evenings of talk. So it is strange, in this quiet corner of Santa Maddalena, below the tower, that now the quietness feels just right. It is the hour of the writer, collecting this and that leaf of a story that, like a memory, falls in his vicinity. Grisha steps out and glances at the women who swim, then he sits down at the stone table. It is when no one else is here. On some nights there is a storm. But now there is just the delight and shadow.

GENIUS LOCI

Maylis de Kerangal

It is a stone table, behind the tower. Between man and woods. You reach it by way of the French window, once you've traversed the salon on the ground floor, or by walking around the building or by climbing the path that leads from the pool to the hill that overlooks the forest. It is round, concrete, and tangible, a table for whoever wants to put down a glass, open a newspaper, converse, talk, remake the world, or use it as a meeting place. And what I love to begin with is that it is useful, and, in fact, I am wondering if its top isn't an old millstone. I'll have to ask Beatrice. It has braved bad weather, stone-shattering cold spells, hailstorms, pouring rain, and the wind whipping around the tower; it has endured the seasons; it is gnawed by moss, studded with mushrooms, and often adorned with scattered petals slowly rotting there. I like to think it has always been here, since the tower, since the first inhabitants of the tower, and that it will always be here, and with it the ghosts, the pacts, and the secrets.

If this table is unique in the world, it is because it creates a place. In summer, it is a leafy alcove, a stained glass light, a fresh breeze; at night, the cracks of the forest, the noises of the beasts, the distant echo of the river flowing down in the valley, and the fantastic flight of the fireflies, once believed to have disappeared. Space here takes an intelligent form, and nature has come closer, to encircle the table, to envelop it, to serve as its jewel box. The frontier between inside and out is erased to create this intimate exterior in the heart of the immense garden, and, similarly, time there is different, neither past nor future but rather always present, suspended, eternal, and fugitive— this pure present, which each of us tries to capture in the hollow of a hand, which each of us attempts to live. That's why we meet each other differently there, why we speak differently there, why we act differently there, as if each word were embedded in nature, each gesture corresponding to all that trembles, all that vibrates, all that is alive.

So I believe it is there, in this gazebo of stone and leaves, that the genie of the place takes form, this wise, wild genius loci who is ever present at Santa Maddalena.

Translated by Marcelle and Luc Clements

A BENCH

Francisco Goldman

In some of my favorite memories from my various stays at Santa Maddalena with Beatrice, rather unobtrusive objects—that is, with no history of their own that I remember being told about—play the starring role. For instance, in the cluttered vestibule between the kitchen and the stairway leading upstairs, I recall a simple wooden phone stand with a black telephone atop it, and it was there, during my first ever residence at Santa Maddalena, that I spent a long time one evening on the phone with the Peruvian cook, Marta, a doll-faced, diminutive, plumpish young woman who'd run away to her sister's in Milan. Because I spoke Spanish, Beatrice had asked me to try to convince her to come back, otherwise Santa Maddalena was going to be temporarily without a cook. I didn't succeed, ultimately, but after I'd hung up Beatrice told me that she'd especially liked it that she'd heard me enjoining Marta, that it was a question of honor, her own, that she return. I was staying in one of the rooms upstairs, and one night at about two o'clock when I came downstairs to get a glass of water or filch a banana—this was shortly before Marta left—I found her, in the darkness just outside the dining room, sitting on the lap of that carpenter from Donnini, who was always around the house, upon a plain, wooden farmhouse-style chair and making out. And there was that walking stick I treasured, fashioned out of a sturdy branch I found the first time I went out on what became known as the "Goldman Walk." I even wanted to take it back to New York somehow, until Teddy, the rambunctious black Lab, made off with it.

 This little stone bench—the *panchina*—behind the tower that I've been asked to write about is a very different kind of memory—such a sad one that I feel myself almost pulling back from revisiting it. I've already done this a lot, I tell myself, this work of somewhat publicly reliving my grief and of commemoration, of course, but you're never done with that, and isn't Santa Maddalena itself an expression of that? Of loss, undying love, and memory transformed into commemoration in the most generous and glorious, ongoing, present, and bountiful sense; in every beautiful so carefully tended

and curated room in the house and tower, in every inch of its magical gardens and orchards, and at mealtime conversations, in the dining room or outside on the patio, with dear Beatrice at the head of the table. And, of course, the writing produced in the writing studios, at Gregor von Rezzori's old desk, and in the tower is also, it seems to me, the best possible way of keeping the memory alive, in the most dynamic and meaningful way, of a beloved late spouse who was also a writer.

But I look at a photograph of that old stone bench and can only think of the sadness I felt as I sat on it one special day during the saddest time of my life. That sadness seems embedded in that stone. It's almost as if the bench itself, made of sadness, is the memory. Or as if I am that bench on that particular day: September 12, 2007. Actually I didn't even really remember, ten years later, what the bench looked like. I only remembered sitting on the bench and why I was sitting there that day and the landscape the bench looked out on. But then I received a photograph of that *panchina* and was struck by how humble looking it is, a simple rectangular slab of ancient stone, mottled black and gray, mounted on two wide concrete legs, like a bench in an old churchyard, in the shade of trees and overhanging branches with large, green leaves. The *panchina*, like everything else at Santa Maddalena, is beautiful and seems somehow perfect, which, of course, it was for what I needed it for that September 12, 2007, forty-nine days after Aura's death on July 25 in Mexico City, from neck injuries she'd sustained twenty-four hours before in the waves at Mazunte, a beach in Oaxaca.

On August 20, 2005, Aura and I got married on the rented grounds of an old hacienda in Atotonilco, a village famous for its seventeenth-century shrine and baroque church in a nearly desertlike landscape outside San Miguel de Allende, in Mexico. It was a long way to travel from Italy, but Beatrice made the trip, accompanied by Colm Tóibín. She had always been such a warm, generous friend to me, and from the first time they met, at Beatrice's apartment in Manhattan, she'd been so fond of Aura. In Mexico City,

after the wedding, we were about to leave on our honeymoon when Beatrice phoned to tell me, "Francisco,"—nobody else pronounces that name with such cheerfully florid elegance—"while Colm loses himself in the *basso fondo*, I'm going to be on my own," and she asked me for some contacts. I already knew about Beatrice's legendary and indefatigable spunk, but I was still impressed to learn later about all the people she'd met and had dinner with, and the places she'd visited, in Mexico City that week.

After Aura died, Beatrice invited me to Santa Maddalena. The residencies wouldn't be in session, I'd be alone in the tower. I remember so little of those first few months after Aura's death, so much of it lost to the devouring erasures of trauma, despair, and fear. I was wandering and reeling around Mexico City during those first weeks in a way that had my friends there saying about me, "*Frank anda al cuidado de Díos*," or "Frank is in God's hands," which is a Mexican way of saying that something bad was sure to happen. At least in the Mexico City cantinas I had company. In fact, I also found out later that my friends had secretly organized themselves so that there would always be someone to accompany me, to drink with me, to help me get home. Would it really be good for me to go off to Santa Maddalena to be with Beatrice, inevitably spending most of each day alone? I went because I love Beatrice. I went almost as if fleeing to a mother who was also a friend. I don't think any place on earth would have been "good" or "bad" for me at that moment, but who knows, maybe being at Santa Maddalena, by keeping me off the nighttime streets of a sometimes dangerous city during a very self-destructive time, did keep me out of harm's way (well, for a while, until I got back to New York, and harm did find me). Beatrice was wonderful to me, and so was her friend Max and everyone else who visited, including John Banville, who once, at a cocktail party at Beatrice's Manhattan apartment, had pointed Aura out to me across the room—he didn't know I was her boyfriend—and praised her beauty; he said that her face reminded him of the woman in the paintings of—and he pronounced an Italian name I'd never heard before,

which is to say I don't think it was a name that most people familiar with the usual, canonical names of Italian paintings would know, a name that I must have forgotten right away and that now I don't want to know. I so love to search the Italian painting galleries of museums for Aura's face.

I went on long walks, especially following the long loop, descending to the valley floor and climbing again the "Goldman Walk." It happened to be hunting season, and one afternoon, on the winding dirt trail ascending back to the house, I came across a baby boar that had just been wounded by a hunter who must have fired from some distance; entrails spilled from the flank of the lifeless little boar's smooth belly.

I lay on my bed in the tower for hours, stared out the window at the soft, green hills running to the horizon, went to Rome for a couple of days to see Colm. I remember that we stood outside the gates of the Vatican, shouting raunchy insults at the Pope and laughing. I bought a beautiful artisanal notebook in Florence, and that became my grief diary. I would write in it for years, but I wrote very little, hardly anything, in it then.

Pues nada, as they say. I don't want to make a big deal out of it. In Mexico, an Argentine psychiatrist who was also a devout Buddhist, the father of a friend, had given me Pema Chödrön's book *When Things Fall Apart*. And he'd explained to me a little bit about Buddhist beliefs regarding death and mourning and the Bardo, and I had taken from that conversation the idea, correct or not, that Aura's mind-spirit would still be among us for forty-nine days, during which she might even be able to receive my love and thoughts in a disembodied way and come to me in dreams, but on the forty-ninth day, that most extraordinary and beloved brain, and that most loving heart, would disperse into the cosmos as pure energy, as atoms. Perhaps there would be "a yellow light," I remember the psychiatrist saying, that I'd sometimes be able to find while deep in meditation. So I dreaded the forty-ninth day as yet another leave-taking, in at least some way seeming the most final, if I took the Buddhist teachings seriously, which I

suppose I really couldn't, never having practiced mindfulness or studied the religion, but grievers are irresistibly drawn to milestones and mourning rites. But I couldn't even finish reading *When Things Fall Apart*, which I'd brought with me to Santa Maddalena. Accepting that life is "groundless," and that the opposite sense is something to relinquish in order to be free, is obviously wise, but it was far beyond my capabilities. I looked for solace and understanding in the ways I knew how, by reading a lot of poetry, the love poetry of grievers especially, and I read some of the Western grief literature. Darian Leader's *The New Black: Mourning, Melancholia and Depression* was a book that engaged me and provided some insights that I would later find helpful.

On the forty-ninth day, I sat on the bench for a very long time, feeling extremely sad, trying to say goodbye in the way the psychiatrist had suggested I should on that day. And that was that. I won't pretend that I remember everything I thought and felt; I suppose anyone can at least partly imagine what I felt. And, unsurprisingly, I went on thinking about Aura, superstitiously and earnestly, sending her messages, just as I had before, and she still came to me in dreams.

The bench looked out onto that enchanting landscape of gentle, forested hills, which I suppose everyone has compared to those depicted in the backdrop of great Florentine paintings. There is even a medieval castle—or what surely resembles one—on the far horizon. Directly beneath the tower, and the *panchina*, the land drops toward a small, grassy clearing, from which the forest descends into a sort of wooded swamp before climbing again to Donnini. I had tried to explore those woods a few times, searching for a shortcut to Donnini but had always been driven back by thick, thorny underbrush and mud. But once, when I really wanted to go to Donnini to eat some pizza, I blundered onto a path and a way through those woods that I was never able to find again. I am not being hyperbolic for the sake of the tale, it's the truth. It must have been near evening, because the woods I found myself in were glowing a dark green, and

the underbrush along the floor was not too thick, in some parts the ground was even smooth, the trees seemed evenly spaced, and, most astonishingly, there were animals, as if it were a secret woods where they could hide from hunters. I saw a couple of boars scamper away from me, rabbits, and, so hauntingly, an owl flew low over my head. It really was like an enchanted woods in a children's book or a Japanese animated movie, in the latter case it would be the abode of spirits too. The climb up into Donnini was steep and muddy, I arrived pretty filthy at the pizzeria. I took the long way home, down the straight highway, the landscape hidden by darkness, and then down the vineyard-lined road to Santa Maddalena.

Right: *A memorial to some of the beloved dogs that have lived at Santa Maddalena; all were pugs except those marked with a red star.*

TOM BOY
PHILIPPINE
BABAR
CELESTINA
MINI
ROMEO
ESTHER
DESDEMONA
BRAMBLE
JAAFAR
SPIRO
ABIGAIL
ISOTTA
OMAR
FOOL

NOTHING IMPORTANT NEEDS TO HAPPEN HERE

―

Andrew Miller

Two qualities come quickly to mind: the room's light and its scent. Glass doors that in memory are always open. Which way do they face? South? Southwest? And whereas much of the rest of the tower has its carefully arranged shade and shadow, the living room opens its glass arms to the sun and fills up with light.

And the scent. A layered smell. Something from the unused fireplace, the faintest ghost of a last winter fire. Something from the dusty furnishings being warmed through by the sun like retirees at the beach. Something from the stone of the walls, the old mortar troweled on when Boccaccio was a boy. And through the heat of the day, the carried scent of that other room called the garden. Rosemary, I think. The heavy perfume of roses. A breeze from the forest.

The rooms above—even the bathrooms (especially the bathrooms)—were for dreaming, working, weeping, and writing futile love letters. They were for intensity. The living room was largely exempt from these small dramas and would have been entirely so if it were not for the phone in there—a 1980s phone, putty colored, on a little table in the corner between the wall and the fireplace. Here, having settled myself on the end of the sofa, I made my weekly calls home. A string of numbers, then a few seconds of silence, of near silence, during which I would try to close the gap, to picture who and what I had left behind, to imagine England with its small, green summer, its cloud shadows, and its drenchers. Then a voice would break in and say hello in a way that made me wonder if I had started to think in Italian or at least in Italian-English, a language that allows—encourages—a certain extravagance of speech I knew I would need to give up when I went home or be laughed at.

What else? Piles of old magazines, Condé Nast stuff with thin girls and white houses at the edge of wine-dark seas. Ads for watches of the kind I will never wear and would be ashamed to wear. Some old copies of the *New Yorker*. Sunday supplements from Italian newspapers. A paperback left open and face down on the table, next to a glass with a

half inch of iced tea in it. An ashtray—large, white—with a single cigarette butt, a single extinguished match from the box kept in the kitchen for lighting the gas stove. And there was the art, of course, for we lived—in the tower and the house—in a honeycomb of little galleries. On one wall a print by the Japanese artist Shusaku Arakawa, who thought death was immoral and could be avoided if people lived right, lived perhaps in strange houses like playpens. On another wall a painting of a Paris square, Place de Furstenberg, by Tancredi who, aged thirty-seven, drowned himself in the River Tiber, in September 1964. I have long ago learned to assume that if the person was interesting and the dates overlap, Beatrice will have a story to tell: "Oh, poor Tancredi, yes. He was Pegeen Guggenheim's lover. She killed herself too, you know."

So the doors of the room stand open to the afternoon. The place is hushed. From the ceiling a lizard, that connoisseur of air, is looking at me with infinite politeness. The room, its warmth, are making me a little sleepy. I have half a book upstairs and half to go. I seem, however, unable to make any sort of decision. I am on the cusp of some commonplace thought about the nature of reality. I am, at the same time, thinking how nice it would be if someone told me Isabella Rossellini was coming for supper. I stand there and I hardly know myself, and this not knowing, far from being problematic, seems fine. At Santa Maddalena you can hang up your old skin from the branch of an olive tree. You will not need it until you leave. A bee flies in, flies out. A moment later a butterfly, a swallowtail for sure, makes its circuit of the room, its movements like a boat in rising weather. Then it too finds the doors, drifts right, drifts left, drifts left . . . and reinvents itself as absence.

A RETREAT WITHIN A RETREAT

Tash Aw

Although I had been assigned a glorious room at the very top of the tower, with a view over the surrounding countryside, I often found myself reading and working in the kitchen on the ground floor—a dim, low-ceilinged space that felt more like home than anywhere else on the estate. The oven and the fridge dated from the late 1970s and reminded me of growing up in nondescript suburbs on the other side of the world. So too the perfunctory plates and glasses, the white tiles on the floor, and the old jars of spices and oils that lightly perfumed the air. I'd sit at the table, under the solitary pendant lamp hanging from the ancient, nearly black beams overhead, breathing in a sense of calm and belonging.

The only room at Santa Maddalena that didn't contain artwork—no paintings or sculpture or even the odd, battered treasure salvaged from a flea market—the kitchen was decorated simply with wall tiles transported from a seventeenth-century Sicilian castle. Sometimes, sitting in the half-light of the morning while I waited for the kettle to boil, my eyes still heavy from sleep, I imagined that the restrained scrolling motif of these tiles had been painted into the very walls of the tower. A silent and almost forgotten part of the house, the kitchen's isolation made me feel that it actually belonged to me.

One night, my coresidents and I decided to invite Beatrice for dinner—a simple affair, nothing fancy. Filled with the confidence of *propriétaires*, we took charge of the kitchen. We roasted a chicken with some potatoes and proudly decorated the table with sprigs of rosemary cut from a bush outside. But after two hours, the chicken was still pale, its skin flaccid, the potatoes hard. (The temperature was at max, the oven felt hot. Sort of.) Another hour, another bottle of wine. We spoke about India-Pakistan relations, the works of Jean Genet, street markets in Malaysia—anything to avoid thinking about the chicken. Beatrice remained good-humored, but by now everyone knew it was a disaster. Our attempts at hosting an elegant party had utterly failed. Four hours later, we admitted defeat and nibbled on some biscuits and cheese that we salvaged from our meager stocks. One of us produced some Swedish rice crackers, another offered half a bag of peanuts.

Late that night I took the chicken carcass from the oven—still only half-cooked—and flung it as far as I could out into the woods for the foxes to scavenge.

LA VISITE DE LEGBA

Dany Laferrière

J'étais couché dans mon lit environné par une culture à la fois à la fois proche et lointaine. Cette culture puissante et mystique qui semble témoigner d'un monde perdu se retrouve dans le vaudou et dans la peinture primitive haïtienne.

Je me réveille au milieu de la nuit en entendant un bruit familier. Les objets s'entrechoquaient. Le globe au-dessus de ma tête dansait. Je venais, il y a à peine quelques mois, de vivre un tremblement à Port-au-Prince. Je me suis recouché. Quelques minutes plus tard le bruit s'est intensifié. Je suis sorti pour réveiller ma voisine d'en-haut, une romancière d'origine indienne. Ce fut une nuit à la hauteur des vibrations produites par le fauteuil mauve.

Dany Laferrière

I was lying in my bed surrounded by a culture that was both near and far. This powerful and mystical culture, which seems to testify to a lost world, is found in voodoo and in primitive Haitian painting.

I woke up in the middle of the night hearing a familiar noise. Objects collided. The globe above my head was dancing. Just a few months ago, I had experienced an earthquake in Port-au-Prince.

I went back to bed. A few minutes later, the noise intensified. I went out to wake up my upstairs neighbor, a novelist of Indian origin. It was the night when the disturbances produced by the purple armchair reached their peak

I know I ought to describe the room I occupied in the tower, but I cannot help but mention Beatrice. It is she who has always interested me. I came to finish a book in the tower, I wrote fifty pages about her. The novel of Beatrice.

Previous pages: *Bruce Chatwin's room.*
Opposite page: *On the shelf some science fiction books collected by Michael Cunningham while writing* **Specimen Days**. *He also wrote a little note about it for the future inhabitants of his room. On top of the same shelf is a cavalry helmet which belonged to my great-grandfather. Behind it, an Islamic porcelain.*

A BAT

Michael Cunningham

When I'm at Santa Maddalena, I sleep with Bruce Chatwin.

Not, of course, the actual, corporeal Bruce Chatwin, who died in 1989 at the age of forty-eight. I sleep in his former bed, in his former room, at the top of the signal tower. His spirit still palpably inhabits the room. He laid, it seems, some profound claim on it when he was still alive, and his presence, though spectral, is the ruling one. I'm the ghost there.

It was Bruce's room whenever he came to Santa Maddalena. The room is gloriously semidecrepit and rather feminine. Its plaster walls are painted in pink-and-white stripes. Lithesome East Indian maidens, beglittered, play flutes or smile contemplatively from prints within gilded frames over the bed. The brick floor is covered with impeccably faded Oriental rugs. On the bureau top, a blue-skinned porcelain man embraces a gold-and-white porcelain woman. It is some mix of an eccentric little girl's room and a seraglio.

Bruce's devotion to the room derived, in part, from the fact that it was a perfect square. He liked squares; he liked perfection. Although there's a second room, a study meant for writing, a floor above the bedroom, Bruce preferred to write in the bedroom because, in its precise center, there is a square table. He wrote at the square within the square.

Many people have slept in the bed in which Bruce once dreamt. It would be silly, where Bruce is concerned, to imagine that one is singular. And it is, of course, impossible to imagine his dreams, but one suspects that they ran to the vivid, the elemental, and the sexy.

Bruce had been a guest at Santa Maddalena for many years, since the time when Grisha was still alive, before Beatrice turned it into a sanctuary for writers. Bruce was the first to compose sentences in the tower. He, like many of us who've come after, insisted that it was the best place in the world in which to write.

Once, when Bruce was writing *On the Black Hill* in the tower room, the maid, as Grisha writes in his memoir *Anecdotage*, "went to the tower to straighten up and returned distraught. 'How many people are staying in the tower?' Just Signor Chatwin. Why? She had overheard an entire assortment of voices: men, women, children. It was Bruce writing. Reading aloud the many-voiced chaos at a country fair in Wales."

The room inspires that kind of dramatic vitality. It is quiet but not in any way inert. Like most significant rooms, it is inhabited not only by Bruce's essence but by something benign and encouraging that must have been there the day Bruce arrived. The animas of certain rooms are a mystery for us to appreciate, and not to try and solve.

Although I never met Bruce, I not only admire his work but feel a certain kinship with him. He was a gay man who wrote books and loved beautiful things. I am a gay man who writes books and loves beautiful things.

I'm aware of his presence, as I sleep in the bed in which he slept, as I bathe in the tub in which he bathed. Beatrice, in order to help returning writers feel at home, insists that no objects be removed or changed. I am in precisely the room occupied by Bruce.

His own apartment, in London, was rigorously minimal. An ancient, feathered Inca cloak hung on one wall; otherwise it was all white and gray and low to the floor. If the tower room at Santa Maddalena resembles a seraglio, Bruce's own rooms were more like those of a Shinto shrine.

I suspect he appreciated, or was at least bemused by, the eclectic clutter of Santa Maddalena, where a Calder painting hangs near a ceramic bust picked up at a flea market in Arezzo. Where a chest of drawers exquisitely inlaid with mother-of-pearl sports a lamp bought at a garage sale.

Bruce came here to write when he was healthy, and he came here to write as he began, slowly, to die.

He was a great beauty. Grisha writes of him as "Golden Boy . . . In his eyes the Aegean . . ." He arrived once at Santa Maddalena fresh from a surfing trip in Greece, and (Grisha again) "his shorts—which came to just below the crotch—revealed his hiker's legs in all their splendor. No one would have thought this belated youth capable of writing anything more than his own name. And yet he was virtually glowing with promise."

He was also, by all accounts, charming, magnetic, and narcissistic, but he was one of those rare narcissists whose self-regard creates a nimbus that envelopes the people in its immediate proximity, that elevates you simply because you are the object of the narcissist's attention. He was enormously curious, he was in love with the world,

and it was possible, it seems, in Bruce's company to feel more interesting than you actually were.

He was a connoisseur of objects and of people. As to the latter, one needed to be interesting, and "being interesting" helped if one was a famous writer or a contessa. It helped if the object he collected was a treasure beyond reckoning. When he was cogent, he paid far more than he could afford for rugs, art, and antiquities, each of them an offering with which one could plausibly appease an angry sultan. When his mind began to fade, he bought a collection of dresses that had been worn by the Duchess of Windsor.

When he was cogent and in situ at Santa Maddalena, he was particularly fixated on a triangular shard of glazed terra-cotta that Beatrice smuggled out of Pompeii (yes, by now the truth can be told). He offered to trade her for it some object of commensurate worth, but she refused. The shard still stands on a shelf in the topmost room. I'm looking at it now, the thing that Bruce so coveted. It has outlasted him, as most of our possessions outlive us. Maybe that's part of why we who love objects love them as we do. They will continue to exist after we no longer do.

Bruce's promise began to fade, in this room. Witnessed by the Indian girls and the bookshelves crammed with books and the tile-framed mirror before which the porcelain couple embrace.

In order to picture the tower, you should know where it stands. One walks to it from the main house through a grove of olive trees intertwined with roses. The house and the tower overlook the Arno Valley, and after you've climbed the two staircases to the upstairs bedroom, if you look out the window, you see, on the far side of a valley, the ruins of a Moorish palace—a folly, built by a long-dead nobleman, abandoned, crumbling but still cutting its crenellated, turreted shape out of the sky on the opposite ridge. More immediately, you see that the garden below is alive with at least six different kinds of bees (my favorite is a languid monster just smaller than my thumb), with purple dragonflies and a species of white butterfly that hover ecstatically, by the dozens, around the lavender bushes. Occasionally a hare bounds by. A hare resembles a rabbit in very much the way an Olympic athlete resembles an accountant.

If you wake at dawn and go to the window, you understand that a great, green smell wafts up from the valley at sunup. It is not different—not exactly different—from the smell that pervades Santa Maddalena always, but it is, for reasons I don't understand, deeper and more intense when the sun rises. I can identify honeysuckle and linden, but it's much more complex than that. It's the smell of the green, wakening world.

It is the ripest, most maternal landscape imaginable. It may strike you as

edible—not just in its particulars of fruit and game but in its entirety. You may find yourself wondering why, millennia ago, anyone would have chosen to migrate to the snows of the north or the aridity of the south. I have never seen a landscape so crazy with life.

Bruce, the Golden Boy, the lover of beauty, was crazy with life, here, in this room. And here, in this room, his lights began to fade.

Bruce told almost no one except Grisha that he had AIDS, and even with Grisha, he couldn't call the disease by its name. He died in a hospital in Nice. As Grisha writes, "I saw [an] impatience in Bruce's eyes just a few weeks before his death. Sapphire-blue visionary's eyes glittering frantically in a boyish Anglo-Saxon head that had already become a skull."

We all know, very well, whether we are golden or composed of a less precious material, what waits for us, after we've had our chance to see the white butterflies browsing the lavender and the hares leaping past on legs the size of a child's forearm. After we've hurried through the gate at Santa Maddalena, with our surfboard still tied to the top of our car, in shorts that show our well-muscled legs to their best advantage.

Bruce's ashes are buried at the base of an olive tree on a mountaintop in Greece. Grisha's ashes are buried beside a small stone pyramid in a little grove visible from the tower window. In time—in a very long time, we assume—Beatrice's ashes will be interred beside Grisha's, and a rose bush will be planted on top of them.

Screens have been installed in the windows of the tower room since my first visit, but the first time I was here, most nights when I lay in bed reading, an elegant little pitch-black bat would flutter in through the bedroom window, fly in modest circles around the room, and then perform the act most desired of bats that fly into rooms—go back out again. I don't actually believe in ghosts, only in presences, but it was impossible not to imagine that it was an embodiment of Bruce's spirit, come back to make sure that the walls still bore pink-and-white stripes, that the square table remained in the exact center of the room, and that the Indian couple still embraced on the bureau top.

They do.

A TRIP ATOP AN OTTOMAN: A CONVERSATION

Gary Shteyngart

Beatrice: This is a small description of the bathroom, which is going to be our subject for the day.

There is a freestanding, old-fashioned bathtub, which is leaning on some lion paws. Over the bathtub is hanging a mirror at such an angle so that a person lying in the tub can observe his body reflected in it. The mirror is firmly kept in the lion's claws. There is also next to it a screen, an Art Nouveau screen—I think we found it in the monthly fair of Arezzo—which has three panels, with very carefully painted landscapes on silk. Landscapes and flowers of Tuscany. I always imagine it was the loving work of some spinster. Behind the screen there is a WC and the bidet and also some shelves containing books that are sort of poor parents of the ones in displays in every room of my house.

Gary: There was some [Boris] Pasternak.

B: There was Pasternak as well? He deserves a better place. There were also some kind of mild pornographic French books of my uncle, which I found when I inherited some stray furniture.

I don't know why, but this is a room which somehow takes the imagination of the different people who are using it. Very quickly one realizes that the room has its own rules that you are to follow for your well-being. For instance, the space—it's a sort of mansard—where a person of medium size can stand only on the left side of it, where all the commodities which I've just described are. On the other side, the right, the ceiling is so steep that the only way to survive there is to lie down. To do this there is ready a kind of ottoman which is very dear to me because it belonged, among other totally priceless objects, to my Tante Berjouhi, who was my favorite great-aunt; she was married to Ohannes Pasha—an Armenian but a Turkish subject. That was at the time of the Ottoman Empire, anybody could be coming from a different origin, country, religion, but just the same could reach very high positions.

G: Until 1915.

B: So Ohannes Pasha, my uncle, became the mutasarrif of Mount Lebanon, which was at that time a very important post, a lot of power attached to it, a kind of viceroy. And he happened to be the last representative of the sultan. From there, when the political situation changed, he moved to Rome, and he never went back to Turkey.

G: This was after 1914, or—

B: From 1915 to 1920. The change, yes. God knows why, that little ottoman followed them everywhere they went. I have to describe it: on one side, planted in it there is a kind of roll, a very hard cushion which is, like the rest of it, covered in a sort of brown cut velvet, tobacco brown. On that, my aunt explained to me, you would possibly rest your head without disarranging your coiffure before a state ball or dinner or whatever.

G: That's perfect, because I noticed after a few too many drinks, it's perfect to lie down on it. You know, when I lived in the tower, I imbibed much less than I usually do. The industrious Tuscan countryside really spurred me to labor. But on occasion when, say, an Irishman would show up, I would hoist a few drinks here and there. I remember drinking some strange, green liqueur with John Banville and then coming back fairly sloshed, brushing my cheeks in the bathroom—I had missed my teeth entirely—and then falling gracefully onto the ottoman. Because I am about five foot six on a good day, the contours of the ottoman felt so right for a fainting spell. I stuck my little legs beneath me and dreamed in colors as vivid as the bathroom. The curvy patterns on the walls around me had become the tentacles of a giant squid that I had fished out of the water, and as the night progressed the squid became my father. My analyst had a lot of fun with that, believe me. And then I woke up, crawled over to the bathtub, and soaked for a good few hours. Yes, I remember that ottoman quite fondly.

B: Well, this was very much the habit of the people there. You know, my aunts, they were never, as you would expect of them, like a well-bred English lady would be: sitting

erect on a hard-back chair, you know, with a back completely straight, and that would be good manners. But in that world, everything was much more languid, you could lie down, you could converse, receive the intimate people, possibly plan the dinner with the cook—everything would happen in a lying-down position. Which is what I tend to do myself. It is a good help that position, for thinking, for grief.

G: I think it's great.

B: But anyway, that ottoman was with my aunt in the big house that they had on the Bosphorus, the *yali*, you know those beautiful wooden houses that were overhanging the water. Now very few of them remain. They have been burned all along the Bosphorus and replaced by horrid buildings.

G: Near Istanbul.

B: You know the Bosphorus is a vital part of Istanbul. But you have to go away from the center of the town. The people eventually had a house in town and a *yali* on the sea, I mean, on the Bosphorus. You would go with a coach, with horses, or by water with a caïque. It was already a little trip. Now you go in half an hour or you go with the little ships that crisscross the water, go from one side to the other. And, of course, there is that romantic thing that you said, again the left and the right: one side is Europe and the other side is Asia, so in ten minutes you change your imagination, your world.

Anyway, this ottoman followed, as we said, from the Boshporus to the palace in Beirut, and finally arrived in a very cramped little apartment in Rome, where I spent many hours in her presence. A typical apartment like the White Russian had. Oversized, grand furniture covered in worn silk . . . flanked with no embarrassment by some very ugly utilitarian piece of furniture.

G: That was the only thing that remained from the Armenian side of your family? The only piece of furniture?

B: The things were not only the ottoman, but what there was in the apartment,.

G: But in Donnini, is there anything other—

B: Oh, there are, I'll tell you. Little things here and there. But this was like a token of her. When I was a small girl after my mother died, some years later, in fact, I was put in a convent school in Rome. My father was in Africa. And so they were my only relations—she and her sister—who had an apartment underneath, and they were always living in Rome.

It's interesting. The one with the ottoman was the most intelligent. She was very well-read. She was very sophisticated. Her husband had received his education in the best school there is in Paris.

In fact, among the strange things that she had was the entire first edition of the Diderot *Encyclopédie*. You know the one that is in the Index. You know the kind of book a priest says you can't have, because it's against the religion. Just to possess such a book would be a capital sin. Zola, for instance, was in the Index.

But this is an amusing story: *Encyclopédie* was extremely valuable, and my aunt had no money. She was a great friend of the Armenian clergy in Rome, and the cardinal who used to pay her visits said, "But Madame, you can't have that, it's impossible." And she said, "What do I do with it?" And they said, "Give it to us and we'll do what is necessary." They took all the volumes. And so Grisha said, "Really they stole them, and probably sold them. She could have sold it herself and had some money."

Well, anyway, I was trying to give you the impression of a very small apartment with too big furniture, which didn't fit, except that little ottoman, which was in her bedroom. And I stayed in another room, which was absolutely full with very old-fashioned, elegant trunks covered in leather with silver trimmings and monograms. And she kept things there. Now and then some modest old lady would arrive, and she'd send me away. Out of those trunks she would extract mysterious objects. Maybe, you know, like they did it in the old days, possibly also in Russia—I think it is an immigrant thing—they'd never do a package with paper, they'd make a bundle in a piece of cloth. I'm sure she was selling things, like a silver teapot or something, just to survive.

G: Yes, when my family left Russia, we packed many trunks with Soviet trinkets, like compasses with hammers and sickles, which we sold to Russia-obsessed Italian communists at the flea market in Rome. I know exactly what you mean. Now your family, they didn't have any sort of position in Rome?

B: Yes, they did. She went to see the queen once a year. On that occasion she would put something around her neck. I remember she had a necklace of sapphire that she was keeping for the worst days. When she died, they weren't there. Also various ambassadors' wives would come and see her. Now and then she would dress up.

G: In Italy.

B. In Italy. They were well-known people. But this didn't change her situation.

G: She was still destitute?

B: Maybe not destitute, but she had to be extremely careful. She had tremendous dignity and never lost her sense of humor. You would go there, there was always a nice meal. You know, I imagine that you know about the White Russian.

G: Yeah, that's why I'm very interested in it.

B: It's very much like that. You know, there's nothing, and then suddenly there is a Fabergé object with some diamond around it, with a portrait of the czar. I've seen that many times. Still, there is nothing left. Anyway, that little ottoman arrived to Donnini at some point, and now it has a funny destiny because it is there in that bathroom used by writers of any origin or any kind of sexual inclination.

G: Well, I'm very sorry I never enjoyed a tryst atop the ottoman. Or at least I can't remember if I did. Do you think this was made . . . do you think some of the furniture that they had in the Ottoman Empire, was it imported from the West or was it handicraft, was it made—

B: It was probably handicraft, from there, I would think.

G: In Turkey.

B: Well, as I am telling you, there are certain things which are valuable, but I don't want to speak about that because it will come in another piece. You know I have very nice silver things in the room upstairs. You remember?

G: Yes.

B: In my living room. [Orhan] Pamuk sort of fainted when he saw this . . . very grand kind of silver, you know. Typical of that period—1840 or 1850, something like that.

G: I can empathize with Pamuk. There's something wonderfully hallucinatory about being at Santa Maddalena. I think it's because you never know what object will suddenly slip into your line of vision. On one of my first days—and again, I had had a few too many drinks under my belt—I was wandering around the first floor of the main house and suddenly thought I was looking into some inverted time-traveling mirror, because there was a portrait of a bearded Turkish officer who looked so much like me, and he was either flogging someone or getting flogged himself. I can't remember which now, although my analyst would say that it's very important. Anyway, I remember I made some kind of strange mooing sound and backed away. But I'm interrupting here. Let's return to the ottoman.

B: So what else shall we say?

No, I say that this little ottoman reminds me not only of their lives but a little bit of mine, because when I was sent to Rome by my vague family, I could always count on sleeping somewhere. I think there were three small rooms in that apartment, everything crowded. And at that time I was around eighteen or in my early twenties. I was very much in fashion. I would go out a lot to dancing parties. And whatever time I would come back, she would say "Beatrice," it was three o'clock or four o'clock, "come and tell

me what you did!" It was like a confession, but she was never overpowering. She gave me a sense of family, you know. And then she would give very wise advice and—

G: So this was not in your exact apartment? This was below where your aunt lived?

B: No. It was not mine! It was her apartment. I was there as a guest. No, no. Nothing was mine. It was hers. Because when her husband was young, I think he had been a diplomat in Rome, and they had many Italian friends. So when they had to go in exile, they went to Rome.

G: That's why they chose Rome.

B: They chose Rome. They loved Italy. And then she had enormous patience with me, she would listen to my confession. I found out that I could speak to her about anything. All my first audacious flirts and all that, and she was never scandalized.

G: You were in your twenties?

B: I was eighteen, nineteen, twenty. You know. And she was . . . she didn't use any embellishment when she was talking. She spoke in a very sober way. She never had any complaint about anything. And she had a tremendous, dry sense of humor. And, all of that in fact, it was a way to hide the great tenderness that she had. I think she's probably the only person who really gave me that kind of sense of tenderness, a sense of family. I could say anything, and she wouldn't judge it. Well, in fact, when I met Grisha and we were living together, I had no hesitation to tell her that, she was never scandalized. And then she was very amused to meet Grisha. Grisha says—I don't know if he said it because it sounded well—that a moment that they were alone, she said "Take good care of her. She's a wild little horse, but I'm sure you will be able to manage."(Laughs.) In fact, if you remember *Memoirs of an Anti-Semite*, he describes a Russian lady—I mean she was not Russian, he made her into a Russian—that he goes to see. He brings a package of marron glacé, and the concierge says, "The countess is dead," and all that. That's her. The model for that, the last story of the book, "Pravda."

But now the little ottoman is covered with a piece of old Liberty cretonne linen, with an aquatic subject with birds and plants, which have been the inspiration for the decoration of the whole room and even the bathtub.

G: So the ottoman inspired the rest of it? Because there's a theme here, obviously.

B: The Ottoman is something which is, also Bruce said, it's something floating in the air everywhere, it's not any precise time. But there is a consciousness of the Ottoman times always in my life. Also because I lost my mother when I was six. So my only link with her was through those old ladies . . . and their part of the family that were always ready to tell me stories. So now I think it's for you to ask me about . . .

G: First of all, who was the shortest writer ever to use that bathroom?

B: The what?

G: The shortest?

B: The shortest is you.

G: Is me? (Laughter.) Oh, that's very exciting. I knew I had a special connection to the bathroom because of the relatively low ceilings. I like to be in a room where I can command the furniture, dictate to the walls. A little Napoleonic on my part, but there it is. So, ah, let's see . . . who was the tallest?

B: Michael Cunningham. Very tall. Michael Cunningham, this is not to be put there, is going to speak about the bedroom, which goes with the bathroom. Because he wants to speak about Bruce.

G: Ah ha. Well, obviously Bruce had it.

B: Bruce had it as well, yes.

G: And what's the . . . I mean he writes about it here, right?

B: He wrote in that room.

G: In that room.

B: In the bathroom. He didn't write about the bathroom. Nobody except you and Paul Durcan. But all the writers who came were always asking questions: "Why there is this little bed?" and I didn't always say that. But I think it's interesting.

G: Well, actually it's a great place to get things done. I love also the light that comes into this room. Because I felt so tall and powerful in the bathroom, I would use it as a kind of pacing studio. When I write dialogue-heavy scenes, I pace and talk to myself and then write down my discoveries. Also I would float in the bathtub for many hours and that ridiculously solid Italian sunlight would flood my furry face and torso and ideas would slowly begin to germinate, as if I were some kind of fruit-bearing tree in the springtime.

B: Yes, this you ought to speak about. Because of the strange shape of the room, the window cannot be at the normal height. So they are very low, and it sort of adds to the aquarium feeling.

G: It is an aquarium feeling. Yes, that's a very good way to describe it. In the late afternoon during my second, predinner bath, it was so . . . there was such a flood of light, even when—

B: Sunset is very beautiful there.

G: I've never been there for the sunset. Next time, I must try to be there for the sunset. In the bath. With a nice glass of Muscadet. And some oysters. Oh, my . . .

B: Hmm.

G: Yeah. Where did you get the bathtub?

B: Oh, again, you know, in some kind of junk something . . .

G: Some fair . . .

B: But then it was painted by the same man who did the decoration of the room, which is, in fact, a very elaborate thing because he did it like you would do the old stucco. So it means—and it amused me to know that—the old wall was scraped and made smooth. And on top of it, he applied beeswax.

G: Beeswax?

B: Beeswax! And on the beeswax he painted.

G: Ah!

B: So it's a very elaborate thing.

G: Is that customary in Tuscany to do that?

B: No. It was customary in expensive rooms and all that. But this crazy man decided to do it that way. I wanted to do some rough, naïve drawing, but he decided to do that. You should touch it, it's completely smooth. It's perfect. It's like touching glass.

G: Ah. I've never touched it. This was the crazy Barbacci?

B: Barbacci. *Exacte*.

G: Tell me more about him. How did you meet Barbacci?

B: Barbacci was an old décorateur; he was very able to repair eighteenth-century fresco. He lived in the neighborhood. And he liked women very much, even if he was possibly in his eighties. And he had a fantastic hand, so he could do anything, so, in fact, I spent a lot of time with him. First of all, he was amusing and full of stories. But also I had to be careful not to let him make things too pretty. You know, I wanted them to have a sense of naïveté, like a child would have done it. So it took more than it looks. So what else is there? There is also a chamber pot, you remember? A very pretty Art Nouveau chamber pot. Its position is to be always under the sink, because it leaks.

G: Ah! Now it's coming together. I eyed that chamber pot with great interest, especially in my darker, lazier moments. Where did the chamber pot come from?

B: The chamber pot, again something that somebody brought. It's an old . . . it must be 150 years old. Instead of urination now (laughter), it's useful for something that also can't hold his liquid, like the basin. The basin is very good.

G: The basin is beautiful.

B: This basin is English, of a very good maker, and it was a present from Grisha; he brought it from a trip. But the whole house is an amusement.

G: What about this bat over the mirror?

B: This is a dragon.

G: A dragon.

B: It was bought with the mirror. Now and then he's freshened up. Recently we have been repainting the green of his wings, so a more cruel green. And he has a purple tongue sticking out. Because, possibly, when the people take a shower, his colors fade a little bit, so we touch him up.

G: I had a terrible incident in the bathroom, when a giant bat attacked me. I thought I'm not used to animals.

B: Maybe it was a grandson of the dragon?

G: Yes, that sounds plausible. I was, I don't know, I thought at first it was a bird and then it was an eagle. It was small in the beginning—

B: But did he attack you?

G: Well, he was menacing toward me.

B: He wanted to make friends.

G: I'm very friendly, but I have my limits. So I ran down to, what's his name, the Englishman, the big, redheaded guy. He was very brave and quite sober. He dealt with the enormous bat with his own hands. I was hiding in the bedroom until the Englishman, Tim, I believe, sounded the all clear. I couldn't thank him enough.

B: And I hope you didn't kill the bat.

G: No. He liberated it. Like France.

B: They are very useful, you know. They eat mosquitoes and spiders and things like that.

G: Well, the Englishman—

B: They are considered the angel of the mouse, you know. It's a mouse, but they have wings.

G: Oh, yes.

B: They are like a tiny, little mouse.

G: Well, that was very interesting.

B: They would attack your beard, because this is what they like. They like hair, they could make a nest in it.

G: Maybe so, maybe so.

This page: *Alice, one of the famous pugs beloved by the writers, often shared the studio at top of the tower with whoever was staying there. For instance, she would spend the day with Zadie Smith, and it became a kind of ritual whenever Zadie was in residence. Since that time, Zadie has become a great advocate of pugs.*

A BESTIARY

Robin Robertson

I first heard about Santa Maddalena from my old friend, editor, and enabler Bill Swainson, who has devoted so much of his life to helping writers do the one thing that distinguishes them from the rest, which is to write.

Over lunch, he told me the history of the place, how and why the foundation developed, what its aims were, what the setup was—about Beatrice, Nayla, the dogs—but all I could hear was the word "tower." Tower, tower, *tower*.

I was in the early stages of a third collection, and most of the poems in the first two books had been written on retreat—from various miseries and in various countries—so this seemed like a completely reasonable, rather attractive idea. I accepted an invitation to stay at Santa Maddalena—or, more precisely, the tower at Santa Maddalena—in the first available slot in 2003. For many reasons, March seemed sensible: it would offer fewer hedonistic distractions (the temperature barely strays into double figures, and the pool remains firmly covered), it would be less popular with the terrifying celebrity writers and actors that I understood to be regular houseguests, and it would allow me to enjoy two springs that year: the first in Donnini, the second in London. I was in the death throes of a relationship and I needed as much rebirth as I could lay my hands on.

I had seen some photographs, of course, but my first sight of the fourteenth-century outlook tower through the olive trees was thrilling. It still is. This was to be my home for six weeks.

Entering through a stone archway and a narrow double door, with the stone-and-brick staircase in front of you, you can step down into the charming cottage kitchen on the right or follow the corridor to the sitting room at the far end, looking south over the small, raised garden with a pergola and circular stone table. Everything becomes slightly more eccentric the higher you climb. From the first-floor landing, I have admired the other studio's giant twin beds, the vaguely Procrustean bath, and the devotional study, but my home is on the two floors above. The stone stairs end where the original ruined

tower ended, before Grisha and Beatrice rebuilt the structure, adding an extra level reached by an external staircase designed by the architect Marco Zanuso.

The famous bathroom is set in under the sloping roof beams and is probably the warmest room in the tower. That is not why it's famous, though. And neither is it because of the large mirror held up on the wall by a green dragon. It's famous because of the bath. A deep, claw-foot, roll-top affair, with a deliciously abrasive interior and painted floral sides, it dominates the room. In an early *Vanity Fair* feature on Santa Maddalena, Edmund White was photographed in it, dominating the bath, and from then on, it has been one of the ritual objects of this most secular place. The painting on the bath is a distant echo of the trompe l'oeil murals, which are themselves memorial versions of the elegant chinoiserie covering of the tiny Turkish ottoman sitting snug under the slope of the beams. The tightly worked pattern of the fabric is of reeds and water lilies, herons and hummingbirds. Some local amateur—I imagine—was brought in to replicate the bed motifs on the walls, and he was fairly successful—though the hummingbirds look like heavy, red-nosed hornets. By the time the bath came to be painted, though, the job went to a clearly less gifted artist. The sloping sides of a bath are, admittedly, a challenging canvas, but the one heron that's replicated there seems to have grown a second beak in the process, and the hummingbirds are more fish than fowl. Or, to be cruelly precise, each hummingbird looks like one of those paintings in a medieval bestiary of a bemused man dressed up as a flying fish.

The bedroom is a delight. It's like stepping into a very large, candy-striped hatbox. I've never slept anywhere so pink. The insistent boudoir art—four painted androgynous creatures with stuck-on sequins, braid, and feathers, two lovelorn Indian girls similarly adorned, and four scenes of steamy, bucolic seduction—is all cleverly offset by a very solitary (pink) camel and, over the bed, a severe, admonitory three-dimensional *Last Supper*, rendered in some kind of bone. I sleep magnificently well there and have unusually intelligent, sophisticated, and euphoric dreams, which is due partly to the bedroom's clever artistic balance of the racy and the religious and partly, I like to think, to the ingestion of so many minute particles of the genius of previous incumbents. Including, of course, the genius loci: Bruce Chatwin.

The very first time I climbed the stairs from the bedroom to the study at the top of the tower, the insides of the two windows were clotted black with flies. They were in the air, climbing on every surface, whirling noisily on the floor. It came to me that not only had Bruce Chatwin stayed there, he must also have *died* there. I checked the enormous sacristy cabinet from Lombardy, where the priest's vestments were once kept (which

I thought would be Bruce's first choice), then under the four-poster bed retrieved from a nunnery (which would be a close second), then inside each of the small, white cupboards, but there was no sign of the elusive, enigmatic travel writer. I later discovered that the wretched flies hatch routinely in the roof space as soon as the tower is opened up and heated in preparation for the first writer of the year—and they've been there to welcome me ever since, each of the five times I've come. Poets build careers on making art out of adversity, so I wrote my first Santa Maddalena poem the next day:

La Stanza delle Mosche

The room sizzles in the morning sun;
a tinnitus of flies at the bright windows,
butting and dunting the glass. One dings
off the light, to the floor, vibrating blackly,
pittering against the wall before taxi
and takeoff—another low moaning flight,
another fruitless stab at the world outside.
They drop on my desk, my hands,
and spin their long deaths on their backs
on the white tiles, first one way
then the other, tiny humming tops that
stop and start: a sputter of bad wiring,
whining to be stubbed out.

Once it's been fumigated, and the dead are swept away, the study is, once again, my favorite place to write. Another square room, directly above the perfectly square, pink boudoir, it has a manly, utilitarian feel to it. There are many beautiful objects—a piece of Pompeii terra-cotta, a signed Miró print the same age as me, a camel bridle from Afghanistan, and a row of Barry Flanagan ceramics—but the *most* beautiful thing is the view. You look out south and west over the wooded valleys and ravines that drop to the tributary of the Arno far below, and there is a Moorish castle on the skyline and other palazzi and signal towers in the far distance. Inside, the room's focus is not the nun's bed or the priest's locker but the huge desk that sits in the southwest corner between the two windows. At eight feet long, I cannot stretch to touch both its edges, but it is

perfect for the necessary sprawl of books and papers. It has two pullout writing boards on either side, so when it's dark all over Tuscany and I slide them out, it's like sitting at a flight deck.

With the windows open to the midday sun, on my second or third day working in the tower, I looked up to find a lizard on the sill. He had climbed forty feet to visit me. Or perhaps just to see if there were any more flies around. We don't have lizards in Scotland, so I was unusually interested in these creatures and enjoyed sitting outside in the sun and letting them flicker over my legs, and I remember looking up at the south wall of the tower and thinking it green with tendrils of early vine or ivy then seeing that it was really dozens of basking lizards.

Lizard

Volatile hybrid of dinosaur and toy, this
living remnant throbs on the hot stone:
a prehistoric offcut, six inches
of chlorophyll-green dusted with pollen;
a trick of nature—lithe, ectopic, cuneiform—
a stocking filler, out of place everywhere
but in the sun. Frisking the wall,
its snatched run is a dotted line
of fits and starts, spasmodic, end-stopped.
It pulses once; slips into a rock with a gulp.

Santa Maddalena seems, like that lizard, both ancient and *immediate*. Walking for hours without meeting anyone—seeing the first green in the trees, the hawthorn misting the valleys, the first bees, and brimstone butterflies—I take this sense of slowly releasing energy back to the tower. There is a cohesive and inclusive harmony everywhere, in the art *and* the utile: the glassware, cutlery, fabrics, furniture. Everything has its own story; everything is in conversation with the pieces around it and the natural world outside. Each day at Santa Maddalena feels to me like a gift: a palpable, physical gift. I think this is why I felt I could carry the spring with me up the stairs to my desk—how I could offer it to my younger daughter as a present on her tenth birthday.

Primavera

The Brimstone is back
in the woken hills of Vallombrosa,
passing the word
from speedwell to violet
wood anemone to celandine.
I could walk to you now
with Spring just ahead of me,
north over flat ground
at two miles an hour,
the sap moving with me,
under the rising
grass of the field
like a dragged magnet,
the lights of the flowers
coming on in waves
as I walked with the budburst
and the flushing of trees.
If I started now,
I could bring you the Spring
for your birthday.

THE GEOMETRY OF AN OLIVE GROVE

Terry Tempest Williams

The shape and arrangement of each olive grove has its own geometry, but the shape of the olive grove at Santa Maddalena bears the shape of stories. Each of the fellows who have written here, drops words from the tower's fourth-story windows, which end up dangling from these eccentric branches like olives. The distance walked between the tower and Beatrice Monti della Corte's home for meals cannot be measured in meters or feet but in what happened along the way.

For example, there was the time Marco Cantoni, a friend of the Baronessa, made a surprise visit one evening and filled the dining room with a hundred white votive candles and cooked a spaghetti dinner with his family's secret tomato sauce that somehow we got drunk on. The next night, he came to get me from the tower. I was irritated as I was midsentence on a long-awaited paragraph that had just found its way on the page, but he was not to be deterred. He followed me down the narrow, winding staircase until we were outside the tower, then walking side by side through the olive grove with various trees blessedly between us. Where there was a break in the assemblage of trees, Marco leaned over to kiss me, and a wasp miraculously appeared and stung him on the upper lip!

"You are a witch!" he screamed as his hand applied pressure on the cleavage point below his nose.

"Just a naturalist," I said, "the wasps protect me."

How many steps does it take to cross the olive grove? Just enough to get you to the stone patio quickly when in need.

Or the time walking back to the tower from another electric dinner party where Beatrice holds court and counsel at once, where Max or Colm or Isabella or any other literary or elegant figure you can conjure up is seated around the table sharing their stories, and it ends with the serving of pears, and we eat the soft, sweet fruit of Tuscany. Afterward, Kamila and Emma and I walked back to the tower on a summer

night when it was impossible to tell where fireflies ended and stars began, and we made vows to trust our voices as women and speak when it is all too easy to become mute while under the male gaze.

Or the night when Diran fell asleep on the couch in the living room still holding his cigarette that was resting on the cushion, now in flames. He picked up the burning cushion and ran outside through the gauntlet of olive trees yelling, "Fire! Fire!" but nobody heard him, so he left the cushion outside to smolder when he thought the wet grass beneath the trees had put the fire out. Minutes later, the tower filled with smoke, and I awoke coughing, seeing only smoke, the terror of smoke. I ran down the stairs into Diran's room yelling, "Fire! Fire!" and we both ran out to see the flames rising outside the door inside the olive grove.

By now the Croatian caretakers were beating the cushion as I ran through the olive grove in search of a hose or fire extinguisher. I knew I had seen one in Beatrice's house hanging on the wall. I ran into her house, grabbed the red object off the wall only to realize it was not an extinguisher at all but an art piece. I grabbed a pitcher, lame as it was, and filled it with water and ran back through the olive trees, my nightgown catching on low-lying branches. I heard it rip. I doused the cushion. The fire was out.

The next morning at breakfast, Beatrice heard about the fire. She was more amused than upset. Later that afternoon, she met me in the olive grove. I was standing on a ladder beneath a canopy of narrow, light-streaked leaves, picking olives with the Croatians so they could meet their deadline. I climbed down the ladder and threw a handful of olives onto the white sheet below. Her message was simple and direct: "Don't take life so seriously, Terry." She paused. "Your work, yes, thanks God—but life, no."

The shape of this olive grove keeps expanding with the harvesting of our stories. And it was in the private hours of their enduring beauty that I watched rooks come and go like shadows when I couldn't write. There was comfort in the robins and redstarts I

watched as I forgot myself as a writer and remembered myself as a human being. It was then that my lost words were returned to me, alongside the joy.

At night, after I finished writing, I would lean out the window of the tower and watch bats circle the olive trees in moonlight. I remember thinking there was no place on the planet I would rather be—so magical was this platinum-tipped grove of trees—where even in darkness, the climbing pink roses wrapped around the gnarled trunks were still visible.

But the true measure of Santa Maddalena's silver-leafed olive trees, both ethereal and enduring at once, is in the measure of the earth itself. Each season of each year of each decade creeping into the next century, the roots of the olive trees reach deeper and wider into the Tuscan red dirt. Not far from the olive grove, Gregor von Rezzori is buried. I like to imagine that the roots of these generous trees are now intertwined with the great writer's bones. A stone pyramid marks his grave. Creativity is the geometric equation that Beatrice has given to each of us, through her invitation to write in her community tied to the Italian countryside of Donnini. Literature interfaces with ecology. Roots. Bones. Pages. Leaves. The spines of all the books that have been written here equal the number of stories held in thought as each author walked through the olive grove dreaming.

KEY TO A LEGEND

Sean Borodale

One day in May, following the "Goldman Walk" through the forests around Santa Maddalena, I climbed up into the dry heat at the edge of the olive groves. My bones felt like splinters of scoured rock. The Apennines shimmered in the distance. I could hear the energy of a thin, immersive noise. Eighteen beehives were aligned in the crook between two tracks, the face of each hive painted with an image. This array of unexplained images fixed my attention as I drew each of them, in the order in which they appeared on the hives, into my notebook.

 A symbology—those essential nodes marking a map with its meanings—evolved as I continued on my walk back to the house. The hives that the bees would take nectar to stood, it felt, not in the clearings alongside the forest road as they do but in my own thought-pattern clearings. These parallel, inner beehives, book-like, hid the provenance of their contents: places of treatment, distillation, architecture, grammar, punctuation, arrangement. Words in these emergent inner hives, it felt, were constructed of encrypted pure energy inside sentences, along paragraphs, within pages and spines of beeswax. Writings evolve out of wild circumstance and are stored and transported within books. Bees' nests evolve in natural hollows, like grottoes or trees, but for such entities to become portable, it is easier to build for them a box.

 The writer at Santa Maddalena might report: I scanned the shelves within the darkness of the library. It was before dinner. I was sustained by a memory of a sunset scattering between oak leaves before the mountains that encircle the tower. I had glimpsed this—as it exposed me—through a small oval window in the tower wall. The movement of light had fallen across my face as I bathed in the abrasive bath in that room of painted leaves and birds. Its warmth made me feel like a body of honey thickening in the cell of a comb; a honeycomb of writers at different times. All times felt simultaneous; a time-image of life immeasurably vaster in time than in dimensions of space. From the outside of the tower, I imagined this ellipsis of the bathroom window visible as

a portrait: a framed miniature containing only the luminous image of my head and body suspended in darkness. I imagined other writer-bathers at other stages of a time continuity, suspended in their own cells inside the tower: ellipses of isolation. At sundown before the sharing of the evening meal, we are all present; we can all be found, one way or another . . . not us, precisely, but the gatherings we have worked at, as books; we, the writers who have written, made the journey down the cobbled white roads—to situate, be, write, converse, sleep, eat, drink, bathe, walk, swim, write, listen, rewrite, escape, love, return, argue, embrace . . . publish.

Or, I dreamt of bright white stones in the forests that night, and when I woke in the darkness, an owl was calling outside the tower. I could hear owls further and further off in the depth of distance answering or relaying the sound. Call of the first owl carried further by others. A collective networking act of publication: a sonic symbol of the owl broadcast through a moment of darkness.

The diagrams on the beehives evolved into symbols. I could imagine them across a map: small organs constructed of stars in the night sky, or hieroglyphs describing the essence of an owl cry going from tree to tree, or the sound site of a wolf, or the falling place of a leaf, or passing of a vehicle, or a crisis. Like this beacon tower passing its fire through an aperture of the fourteenth century, the beacons of voices, each specific, topical, present. Orion. The Great Bear. The Pleiades. Eternal symbols traveling through the commonplace mystery of the air. But also symbols for resistance fighters hiding in the woods; for fables of the invisible; for the ultimate, extreme, deep thinker in isolation, like Antonio Gramsci in his prison cell far away, writing, too. Like Oscar Wilde, writing in the dim light of Reading Gaol. Or Bruce Chatwin, at this table, in this totality of all towers.

The beehive images transmuted into symbols, the symbols constructing the legend of a map. A map not entirely in the space of shared geography and slightly unhinged, unsettled across the dream space of a mythography or metatopography. Resembling in the forests, mountains, and river valleys around Santa Maddalena, sites of the mind and acts of imagination extended like fractals into dimensions of topography; contours not of altitude but of authorial intensity. This reality of Santa Maddalena, such as it is, can only exist, pictorially, on a map of symbols of the process of authorial voice, sites of reckoning with the spirit of writing; such is the spirit of storytelling, one way or another, for the simple reason that anyone passing through these forests or taking a tour of the house and garden would miss altogether the total map of its procession, its hauntings, its moments of presence without searching for those hidden acts of writing.

The symbols of Santa Maddalena's metabeehives concretized into a set of meanings—as if they had briefly known the mysteries of the universe—and seemed suddenly to present a less futile reality. I worked, blindly I must add, to write out their facets. I tried to cut them like a jewel cutter—but felt new at my job.

In cutting the first facets of these symbols, I made this observation, which anyone can make: it is the fact of fiction that all of the works written here, surely, contain small elements of observed energy, pieces of the place. Santa Maddalena lurks, it must be wondered, under many of the sentences and lines of the works of authors who have resided here; small slips of shadow under leaves scattered across the ground in the autumn and shadows that survive into the snowfall age of winter.

These symbols have evolved now to describe a cosmology of eighteen moons. A processive community, a zodiac; they declare that this countryside contains a fortress, a graveyard, a court, the world's smallest autonomous citadel, a joker, a death warrant, a birth certificate, a gift of love—various nodes in what has been described elsewhere as "the world republic of letters." Mysterious and mischievous, these symbols describe the elements of a rogue state, each symbol cut like a gem whose light casts a set of revolutionaries in miniature across the table; a camera obscura cast from the light of a candle passing through a cut glass goblet of red wine, which is the staple of conviviality each evening and called in the parlance of the house "ammunition."

Poised always in defiance, and in terrible pursuit of contradictory desire for acceptance, the elements in this legend make leanings toward places, moments, events in the landscape its raw materials. Though they point to stages and confounding problems in the process of writing, the measurements, the energies, and the conductive traits are all specific to Santa Maddalena and are built—in the way that icons are built—out of discarded bird bones, wallowing-hole muds, sounds of insects, owls, the moment of a rose flowering and its corresponding scatter of withered petals, the footsteps of dogs, the wind moving the new leaves, and the corresponding later sound of the wind moving old leaves. The nighttime sound of the tributary river of the Arno that can be heard from the tower. The slowly crumbling yellow, sandy soil at the road's edge. The beam of the moonlight over the sound of a distant train. The "and" and the "and so on."

Sometimes, in the evening, the top room of the tower contains the winding-ticking of a deathwatch beetle; and with the deathwatch, both a sense of having the prison roof slowly hurled from above and of the morbidity of the deathwatch beetle winding

through free time will occur. It is the act of writing, perhaps, that best imagines for us the roof timbers giving themselves back to the forest. Or the stones of the tower throwing themselves back to the hill. But the ticking is resolute, present, as if this single deathwatch beetle, calling out courtship, holds a much longer view of the forest's imagination. So too the symbols on this legend of Santa Maddalena have evolved from ruins; and I sketch them here, in the order in which they appeared on the beehives on that first walk.

The first symbol is either an hourglass or the fata morgana of a pyramid atop a pyramid, one of the central emblems of Santa Maddalena. Its tip channels down the fusion of the stars and that of our own sun, as well as the gray rays of the moon. It is like Yeats's double cone but more extended to the possibility of afterlife. It wicks up warmth and hidden nourishment but also toxins, minerals, the raw chemistry and inner fire of the earth; and, of course, it is the symbol of the buried and the inverted symbol of the hierarchical pyramid, which is that of the upturned or revolutionary moment.

The second symbol is either the peak line of mountains or an irregular heartbeat or it is the winding of the rivers and the roads in the mountains. It is the winter journey of foxes, and the wolf, too.

The third symbol is of a fir tree, which could be construed as a cypress, but it might also be the double aligned arrow of self and voice, or body and voice. It is the reached-out-to, which draws away by a propulsion into the distance, or a commitment into the uncertain.

The fourth symbol is the beehive itself, but is also the symbol of the casa, the house of writers, and of the honeycomb, which is the library, and of conversation—voices evaporated of breath, stored in the darkness of rooms.

The fifth symbol is a pool of equilibrium, or it means the triangulation used by mapmakers to take readings from the dimensions of space; but its center, the triangle, is the pool into which Narcissus, or the equivalent condition of perception, stares.

▽

The sixth symbol is that of the figure seated on the log, headless, or of the thinker seated on his/her head. The head is the seat, in other words, of the figure in repose.

⼽

The seventh symbol is that of the cloister, or monastery, which is a way of walking the horizon—inwardly, circularly, turning a right angle four times to correct the tangent line around a continuity of emptiness.

▢

The eighth symbol is the single arrow of the hunter, which is to say the search, or research, and is the symbol of darkness, the hunch, that the writer places sheer trust in.

↑

The ninth symbol is that of the black star, which is the negative of the bright star. The guide through the darkness requires its dark beam, since the voice has no means of register in light. It is the symbol of pure sound in darkness and contains all the specimens of sound, cry, talk, which are the owl, fox, wolf, night insect. It is also the symbol of the footstep planting itself on the surface of the forest floor or the white road. It represents the inverse of policed thought: the unpoliced act of written speech.

★

The tenth symbol is an abstraction of balance, loosely akin to the yin and the yang, but specific to the writer. It is the open eye and the closed eye; the open way or channel and the closed way or channel. It is the symbol of a choice, not between right and

wrong but between journey and journey, which may be the same journey via a change of perspective or shift in state or condition.

● ○

The eleventh symbol is of the concentric circle minus its central axis. It is the spreading out of the word around the central figure who, in this instance, is not important; it is the symbol of the world's reach, the sense of the world touching almost the skin of the witness; though, of course, in the dark space at its center, the pupil in the eye, the hole in the ear, the witness is implicated. It is the symbol of the difficulty of absence, from which the writer turns (in)to words.

◎

The twelfth symbol is the hourglass of distance or space, rather than that of time or the experience of space.

▶◀

The thirteenth symbol is that of the fracture or breakage of underlying strata and is that of the earthquake, or the unsettling.

🮲

The fourteenth symbol is that of the erosion of the ridge, or body of ground around the path taken, to a point of near total exhaustion. It is the symbol of the wild boar's wallow, the place where the body of a creature, through gradual succession and repletion, wears out a scalloped concavity at a specific location, doing with agitation and pleasure what weather and the cycle of the years do to cliffs and mountains.

)C

The fifteenth symbol is that of the stepping stone and two feet precariously balanced; it is the symbol of the impassable bridge, due to the presence of stubborn

obstacles or of two wishing to pass who oppose each other, blocking the way; but it might also be seen as the symbol of the three roads meeting or of two structures balanced on a precarious foundation.

出

The sixteenth symbol of the arrow linked to the circle is that of the exit of a creature from a hole but might inversely be taken as the symbol of the opening at the exit of a mouth precipitated by the tongue. The reality is that in this landscape, it is the moon casting a beam into forested spaces and showing its exertion on the mind, the strange corner of the brain perceiving or receiving such instances of attention—for the moon here in the depths of forests and mountains governs the sense of a self with a weight close to that of intimate attention, though it is commonplace, and shared equally. It is a moonbeam cast into the cross section of an eye, rather than the corner of a room, though sometimes the two can be conflated.

o→

The seventeenth symbol is that of forestry, of felled, cleaned poles of timber ready for haulage to sites of treatment and construction. It is the symbol of planting as an aspect of the landscape of this region. It is the symbol of a grid and of a prison, which is echoed in the spines of books as they are found standing along bookshelves at Santa Maddalena. It is the symbol of real experience of time but behind the bars of hours.

||˙||

The eighteenth symbol is of the glitter of stars passing over, a sky of space in which each star is a node passing invisible currents of strength to other nodes, casting the shapes of constellations for unknown futures. These are the stars of pause, of quiet, of intimacy, of drawing together, or of staying alone under the big, wild, eerie vacuum of space itself.

※

Mountains can be seen from many places at Santa Maddalena. Small glimpses of parts of the spine of Italy. The windows of Santa Maddalena are a clock without time or pattern except that of the writer looking up from writing. Each of these moments of contact with the mountains and plants and elements of the weather of this precise location has gained a resonant force in the writings of books.

The room's shadows will turn about through small portals, those clock holes: the sprocket holes of the house and tower. The winding mechanism of the spaces is time; the chimes are the conversations at mealtimes. The words that you will write—we write—are the silent, immeasurable teeth of cogs that invent themselves at each moment of turn. It is time for lunch.

Standing at the branch of three roads, I choose. The road I follow leads left toward the house of Riccardo and Nayla. The rough heath of the forest is heather rich. Christmas box scatters the ground, sharp leaved with bright red berries. Behind the verticals of trees I can see Donnini. The horizontals are narrow. I feel them across distances, but often I come upon them where they fall away. It is time to turn back. The loops of interval draw me like a magnet in the heart of an ocean. Between Scylla and Charybdis, a glint in a storm's eye. What does a wisteria feel, growing and being pruned—edited.

Far south

far north

far west

far east

looking up at the air, as the writer walks toward the house: The rind of mountains is around us. A circle of crags and jagged lines, which stand up as rocks do. Big storms bang and echo within the cauldron. We are boiling too, all of us, being thrown upward in bursts of energy and dropped in the convections of our voices. What do we do all day in solitude? All the while, a parasol mushroom was opening in the garden, like a mask in a Noh theater.

As the lilac bleeds scent, the dripping evening scent is the coal tar scent of lilac in flower. The writer writes under the first star; the evening light on the lilac leaves is like the waxed surface of bronze. I am terra-cotta tonight—fired, shelved on the bed in the center of the room. Rediagnosed: I am air inside the chemistry of clay. Below me is the pyramid. I am balanced. I begin to connect corners, points, a trigonometry of

haunting; to a graveyard by the tower; to a graveyard in the garden. I, too, sepulchral. The Apennines are my distant memory of a far, thin crust of white before the snows have melted.

 We come here with our mosaics in pieces. Everything hallucinates into writing. Thin brooms of shadow on the road dispel malign spirits. The trance is of serenity, of slow time breaking the racing, anxious structures of time elsewhere. Time here is ground into cobbles as you walk. Anxiety falls, dripping into the air around rose petals where, as scent, it falls with the cooling evenings, drifts as vapor over the tributary into the Arno, and, eventually, flows through Florence, with other vagrant, mixed-up shades, unresolved spirits of stress. Dante caught some of their energetic strands and wove them via acts of memory around spindles of his inferno. The ruins under you are in synchronicity: both the falling scars of the cliff and the trickling sands from the banks of the roads; the ruins of insect bodies scattering the garden; the ruins of your texts.

 Oak leaves are a measurement of time, from the first delicate leaves to the stiffer leaves that blacken over the summer weeks. Starlings appear with shards of dark in their frock coats, glinting like pieces of black glass from a cut glass compass. Distant dog barks splinter in the night. They too are sound as a form of black glass. Suddenly affronting. A shower of sound upward, suddenly splintering against the ear, but this affliction is also a gift. Everything here is a gift, a prompt, a question, a space, a realization, that there is a way of inching forward. The time path of paper is metaphysical; the stones of the roads, a hidden image . . . but you see, I do not describe a landscape as a big picture, to myself or to anyone.

 Who is its witness? I know that these symbols serve a purpose. Or no purpose. I do not know. But here is a legend, or the key to a legend, for this broad, intimate landscape that has played host, been stage to numerous acts of authorship, which has trickled out into combining shapes of words, in novels, letters, books, poems, play scripts, film scripts. The silent architecture, the silent geometry, the silent topography in which writers concentrate: the tower, the White Room, the lawn, the gazebo, the bench by the pyramid, the mythical spaces that have become—like a small city, with a market, a graveyard, a church, a library, a newsroom, a public bath, a chapel, a winery—the world's smallest city.

ABOUT SANTA MADDELENA

The Santa Maddalena Foundation for Writers and Botanists was established in 2000 to honor the novelist and memoirist Gregor von Rezzori, who died in 1998 at the age of eighty-three, and to offer a retreat that provides freedom and tranquility to work alongside other writers of exceptional merit and promise.

Santa Maddalena lies outside the village of Donnini, twenty-five kilometers (sixteen miles) southeast of Florence. It is spread across thirty hectares of grounds, on which stand two buildings—a stone house built over the course of the fifteenth and sixteenth centuries and a fourteenth-century signal tower—as well as a converted barn/studio, a swimming pool, and a pool house.

The house was initially a farmhouse, in which domestic animals were kept on the ground floor. The tower, which predates the house, was originally intended to warn neighbors of imminent invasions: a fire was built at the top of the tower—a warning beacon—hence the name "signal tower."

When the Rezzoris—Beatrice Monti della Corte and her husband, Gregor von Rezzori—discovered Santa Maddalena in 1967, it was a ruin. They set about restoring the house and the tower. Once the restoration was complete, the Rezzoris became known for their hospitality. The late writer Bruce Chatwin was a particularly frequent guest and spoke often of Beatrice's "flair for putting fantasies into action."

As Chatwin wrote of Santa Maddalena's early days, he recalled

I have tried to write in such places as an African mud hut (with a wet towel tied on my head), an Athonite monastery, a writers' colony, a moorland cottage, even a tent. But whenever the dust storms come, the rainy season sets in, or a pneumatic drill destroys all hope of concentration, I curse myself and ask, 'What am I doing here? Why am I not at the Tower?' . . . the Tower is a place where I have always worked, clearheadedly and well, in winter and summer, by day or night—and the places you work well in are the places you love the most.

Shortly before Gregor's death, he and Beatrice began to discuss her dream of preserving Santa Maddalena as a place for writers in need of quiet concentration. As a result, Santa Maddalena has been set up as a retreat to honor Gregor, who remains among the century's most significant writers.

Santa Maddalena invites writers of fiction, nonfiction, poetry, drama, or screenplay to live and work there, either during the months of March to June or from September to October. Although the lengths of the writers' stays may vary according to their schedules, a typical residency lasts for six weeks.

Along with Santa Maddalena's fundamental purpose—to provide gifted writers with uninterrupted time in which to work—it promotes relationships among writers from many different countries and cultures. An essential aspect of Santa Maddalena's mission is to help break down whatever barriers that may exist among writers who live and work in far-flung, diverse places; writers who might not meet under other circumstances.

Although Santa Maddalena invites writers who produce a wide range of work, it places particular emphasis on those who focus on botany and other aspects of the natural world.

As Beatrice puts it: "I would wish for Santa Maddalena to preserve its beauty and its capacity to pass on its own gifts to creative people, especially writers and botanists. Writers and students of the natural world can learn from one another and deepen their understanding and enjoyment of the place for themselves and those who will follow after them. Santa Maddalena is not a place of grandeur or pomposity; its magic is in its easygoing simplicity. Yet it offers a sense of space, and writers can benefit from the use of that space, inside and outside. Solitude and space are the most luxurious gifts Grisha and I have received from Santa Maddalena. We have a responsibility to preserve such rare gifts, so that they may sustain other writers from around the world for years to come."

ABOUT THE AUTHORS

Beatrice Monti della Corte grew up in Capri, where, since adolescence, she befriended writers and artists, such as Alberto Moravia, Elsa Morante, and Graham Greene. She opened Galleria dell'Ariete in Milan in 1955, which was the first Italian gallery to show artists such as Francis Bacon, Antoni Tàpies, Lucio Fontana, Robert Rauschenberg, Sam Francis, Enrico Castelani, and Piero Manzoni. She married writer Gregor von Rezzori in 1967, and that same year, they began restoring the derelict and long-abandoned farmhouse and outbuildings that became Santa Maddalena. In 2000, two years after Gregor's death, Beatrice converted the house and outbuildings into the Santa Maddalena Foundation, an international residency for writers. The Santa Maddalena Foundation not only offers uninterrupted time in which to work, it fosters dialogue among writers from diverse backgrounds. It welcomes writers from different countries and cultures and does not distinguish between writers with international renown and writers at the early stages of their careers—in other words, writers who might not meet under other circumstances. To date, Santa Maddalena has hosted more than 170 writers.

François Halard travels around the world and emotionally captures the places that inspire him. For many years he has photographed the studios and residences of the greatest artists and architects of the twentieth century including Luis Barragán, Eileen Grey, Robert Rauschenberg, Cy Twombly, Louise Bourgeois, Giorgio Morandi, Luigi Ghirri, John Richardson, Saul Leiter, Andrés Serrano, and Curzio Malaparte. His books of photographs include: *Francois Halard 2: A Visual Diary*, *Papa*, *This is the House That Jack Built*, *Visite Privée*, *Casa Ghirri*, *Saul Leiter*, *Barceló: Terra Ignis*, *Les Lieux de la reine*, *La maison de verre*, *Marie Antoinette and the Last Garden at Versailles*, and *Villa Malaparte*, among many others. Recent exhibitions include *Le temps des ruines* at Galerie Chenel in Paris, *Je refléterai ce que tu es* at Collection Lambert in Avignon, *À la recherche du temps perdu* curated by Oscar Humphries in London, *Polaroïds Italiens* at Sotheby's in London, *Saul Leiter* at the Post Gallery in Tokyo, and *Architecture* at Galerie Demisch Danant in New York City. He was guest curator for the 2018 edition of Design Miami/Basel. Born in 1961 in France, he divides his time between New York, Paris and Arles.

Michael Cunningham is the author of the novels *A Home at the End of the World*, *Flesh and Blood*, *The Hours*, *Specimen Days*, *By Nightfall*, and *The Snow Queen*, as well as a short story collection, *A Wild Swan and Other Tales*. *The Hours* won the 1999 Pulitzer Prize for Fiction and the 1999 PEN/Faulkner Award for Fiction. Cunningham's fiction and nonfiction have appeared in the *New Yorker*, the *New York Times*, the *Atlantic Monthly*, the *Paris Review*, among other publications.

CONTRIBUTORS

Tash Aw is the author of four novels, including, most recently, *We, the Survivors*, as well as a memoir of his contemporary Chinese-Malaysian family, *The Face: Strangers on a Pier*. His writing has won the Whitbread Book Award, the Commonwealth Writers' Prize, and the O. Henry Award. He is a regular contributor to the *New York Times*, the *Guardian*, and the *London Review of Books*, and his work has also appeared in the *New Yorker* and *Granta 100* (an anthology of distinguished writers published in honor of *Granta*'s one hundredth issue), among other publications.

John Banville's books include his early novels *Nightspawn*, *Birchwood*, and *The Newton Letter: An Interlude*, all of which are fictional portraits of the lives of eminent scientists and scientific ideas. His other books include a collection of short stories, *Long Lankin*; and the novels *The Book of Evidence*, which won the Guinness Peat Aviation Book Award and was shortlisted for the 1989 Booker Prize; *Ghosts*; *Athena*; *The Untouchable*; *Eclipse*; *Shroud*; *Prague Pictures: Portraits of a City*; *The Sea*, which won the 2005 Man Booker Prize; and *The Infinities*. He received the Franz Kafka Prize in 2011.

Elif Batuman has been a staff writer at the *New Yorker* since 2010. Her first novel, *The Idiot*, was a finalist for the 2018 Pulitzer Prize for Fiction. She is also the author of *The Possessed: Adventures with Russian Books and the People Who Read Them*. She is the recipient of the Whiting Award, the Rona Jaffe Foundation Writers' Award, and the Terry Southern Prize for Humor. Her work has appeared in *Harper's Magazine*, the *New York Times*, the *Guardian*, and the *London Review of Books*, among other publications.

Stefan Merrill Block's first book, *The Story of Forgetting*, won Best First Fiction at the Rome International Festival of Literature, the Ovid Prize from the Romanian Writers' Union, the Merck Serono Literature Prize, and the Writers' League of Texas Book Award for Fiction. His subsequent novels are *The Storm at the Door* and *Oliver Loving*. Block's stories and essays have been featured in Radiolab and have appeared in the *New York Times*, the *New Yorker*, the *Guardian*, *Granta*, and the *Los Angeles Times*, among other publications.

Sean Borodale is a poet and visual artist. His poetry collections include *Bee Journal* and *Human Work*. His book *Notes for an Atlas* is an extended narrative poem written while walking through London. In 2014, Borodale was named as one of the Next Generation Poets—twenty British and Irish poets "expected to dominate the poetry landscape of the coming decade"—by the Poetry Book Society, which makes this selection of poets every ten years.

Emmanuel Carrère is a novelist, journalist, screenwriter, and film producer. He is the author of *The Mustache*; *Class Trip*; *The Adversary*, a New York Times Notable Book; *My Life as a Russian Novel*; and *Lives Other Than My Own*, which won the Globe de Cristal for Best Novel in 2010; *Limonov*; and *The Kingdom*. For *Limonov*, Carrère received the Prix Renaudot and the Prix des Prix in 2011 and the Europese Literatuurprijs in 2013. Among his subjects are author Philip K. Dick, mass murderer Jean-Claude Romand, and Christ's apostles.

Maylis de Kerangal is the author of *Naissance d'un pont*, which won the Prix Franz Hessel and Prix Médicis in 2010 and the Premio Gregor von Rezzori in 2014. Her novel *Réparer les vivants* won the Grand prix RTL-Lire and the Prix du roman des étudiants France Culture-Télérama (Student Choice Novel of the Year from France Culture and Télérama). Its English translation, *Mending the Heart* (published in the U.S. as *The Heart*), won the 2017 Wellcome Book Prize and was one of the *Wall Street Journal*'s Ten Best Fiction Works of 2016. *The Cook*, the English translation of *Un chemin de tables*, was a *New York Times* Book Review Editors' Choice in 2019.

Deborah Eisenberg is the author of several story collections, including *Transactions in a Foreign Currency*, *Under the 82nd Airborne*, *All Around Atlantis*, *Twilight of the Superheroes*, and, most recently, *Your Duck is My Duck*. *The Collected Stories of Deborah Eisenberg* was published in 2010. She is the recipient of the MacArthur Fellowship, the Whiting Award, and the Guggenheim Fellowship. Her stories have appeared in the *New Yorker*, the *Paris Review*, and other publications and have been included in *The O. Henry Prize Stories* and *The New Granta Book of the American Short Story*.

Ralph Fiennes is an actor and director. He met Beatrice and Grisha von Rezzori when he was filming *The English Patient* in 1995.

Adam Foulds was named one of *Granta*'s Best of Young British Novelists in 2013 and the Poetry Book Society's Next Generation Poets in 2014. His literary awards include the *Sunday Times* Young Writer of the Year, the Costa Poetry Award, the Somerset Maugham Award, the South Bank Show Award for Literature, the Encore Award, and the European Union Prize for Literature. His novel *The Quickening Maze* was shortlisted for the Man Booker Prize in 2009.

Francisco Goldman has published four novels and two books of nonfiction. *The Long Night of White Chickens* won the Sue Kaufman Prize for First Fiction. His other books include *The Ordinary Seaman*; *The Divine Husband*; *The Art of Political Murder*, which won the Index on Censorship TR Fyvel Book Award and the WOLA-Duke Human Rights Book Award; and *The Interior Circuit: A Mexico City Chronicle*. His most recent novel, *Say Her Name*, won the 2011 Prix Femina Étranger.

Andrew Sean Greer is the author of six works of fiction, including *The Path of Minor Planets*, *The Confessions of Max Tivoli*, *The Story of a Marriage*, *The Impossible Lives of Greta Wells*, and *Less*, which won the 2018 Pulitzer Prize for Fiction. Greer has been a New York Public Library Cullman Center Fellow and a winner of the California Book Award and the New York Public Library Young Lions Award. He is the recipient of a National Endowment for the Arts grant and a Guggenheim Fellowship. His work has appeared in *The O. Henry Prize Stories*.

Henry C. Krempels has worked as an actor, writer, and director. He is founder and artistic director of Theatre Anima, whose focus is on the faltering line between fact and fiction. Working in the realms of experimental theater and new writing, his work has been commissioned by BBC Radio 4, the *Observer*, *VICE*, *Newsweek*, and the *Guardian*. Recent credits include: *The Sleeper* (tour), *Blue Departed* (VAULT Festival), *This is Somewhere Else* (BBC Radio 4), *Ru(i)ns* (Bodega 50), *Anna B Savage's Live Show* (Omeara, Soup Kitchen), and, most recently, the short film *Baby Grand*.

Dany Laferrière is a novelist and journalist. His novels include *How to Make Love to a Negro Without Getting Tired*, *Eroshima*, *An Aroma of Coffee*, *Dining with the Dictator*, *Why Must a Black Writer Write About Sex?*, and *The Return*. He is the recipient of the

Prix Médicis, the Grand Prix du livre de Montréal, the Prix des libraires du Québec, and the International Literature Award - Haus der Kulturen der Welt. He was elected to the Académie Française in 2013.

Hisham Matar's debut novel, *In the Country of Men*, was shortlisted for the 2006 Man Booker Prize and won several international prizes, including the Royal Society of Literature Ondaatje Prize and the Commonwealth Writers' Prize for Best First Book. His second novel, *Anatomy of a Disappearance*, was published in 2011. His memoir *The Return* received the 2017 Pulitzer Prize for Biography, the PEN/Jean Stein Book Award, the Prix du Livre Étranger France Inter/Le Journal du Dimanche, the Rathbones Folio Prize, and the Slightly Foxed Best First Biography Prize. It was one of the *New York Times*'s top ten books of the year.

Andrew Miller is the author of eight novels, including *Ingenious Pain*, *Casanova*, *Oxygen*, *The Optimists*, *One Morning Like a Bird*, and *Pure*. *Oxygen* was shortlisted for the Booker Prize in 2001. He has been awarded the James Tait Black Memorial Prize, the Premio Grinzane Cavour, the International IMPAC Dublin Literary Award, and the Costa Book of the Year. His most recent novel, *Now We Shall Be Entirely Free*, was published in 2018.

Michael Ondaatje is the author of seven novels, a memoir, a nonfiction book on film, and several books of poetry. His novel *The English Patient* won the 1992 Booker Prize, the Canada Australia Prize, and the Governor General's Literary Award. A subsequent novel *Anil's Ghost* won the 2001 Irish Times International Fiction Prize, the Giller Prize, and the Prix Médicis Étranger. He is a Companion of the Order of Canada and a recipient of the Sri Lanka Rathna, the highest honor given by the government of Sri Lanka for foreigners.

Robin Robertson has published seven books of poetry. He has received the Petrarca-Preis, the E. M. Forster Award from the American Academy of Arts and Letters, and all three Forward Prizes: Best Single Poem, Best First Collection, and Best Collection. His collection of selected poems *Sailing the Forest* was published in 2014. *The Long Take* was published in 2018 and won the Walter Scott Prize for Historical Fiction, the Goldsmiths Prize, and the Roehampton Poetry Prize. It was the first poem to be shortlisted for the Man Booker Prize. His latest book is *Grimoire: New Scottish Folk Tales*.

Kamila Shamsie is the author of seven novels. Following the publication of her second novel, *Salt and Saffron*, she was named one of Orange's 21 Writers of the 21st Century. Her four most recent works were written, in part, at Santa Maddalena. They are *Offence: The Muslim Case*, *Burnt Shadows*, *A God in Every Stone*, and her most recent novel, *Home Fire*, which won the Women's Prize for Fiction and was longlisted for the 2017 Man Booker Prize. She is a Fellow of the Royal Society of Literature and was one of *Granta*'s Best of Young British Novelists in 2013.

Gary Shteyngart is the author of the novels *The Russian Debutante's Handbook*, which won the Stephen Crane Award for First Fiction and the National Jewish Book Award for Fiction; *Absurdistan*, which was chosen as one of the ten best books of the year by the *New York Times Book Review* and *Time* magazine; *Super Sad True Love Story*, which won the Bollinger Everyman Wodehouse Prize; and *Lake Success*. His work has appeared in the *New Yorker*, *Esquire*, *GQ*, the *New York Times Magazine*, among other publications.

Zadie Smith is the author of the novels *White Teeth*, *The Autograph Man*, *On Beauty*, *NW*, and *Swing Time*; three collections of essays, *Changing My Mind*, *Feel Free*, and *Intimations*; and a collection of stories, *Grand Union*. Smith was elected as a Fellow of the Royal Society of Literature in 2002. She was named one of *Granta*'s Best of Young British Novelists in 2003 and again in 2013. *White Teeth* won the James Tait Black Prize, the Whitbread First Novel Award, and the *Guardian* First Book Award. *On Beauty* was shortlisted for the 2005 Man Booker Prize and won the Orange Prize for Fiction.

Adam Thirlwell is a novelist and essayist. He is the author of the novels *Politics*, *The Escape*, and *Lurid & Cute* and a novella, *Kapow!*. His essays appear regularly in the *New York Review of Books*. He was twice named one of *Granta*'s Best of Young British Novelists and is a recipient of the Somerset Maugham Award and the E. M. Forster Award from the American Academy of Arts and Letters.

Colm Tóibín is the author of nine novels, including *The Blackwater Lightship*; *The Master*, which won the International IMPAC Dublin Literary Award and the *Los Angeles Times* Book Prize for Fiction; *Brooklyn*, which won the Costa Novel Award; *The Testament of Mary*; and *Nora Webster*. He is also the author of two story collections: *Mothers and Sons* and *The Empty Family*. Among his works of nonfiction are *Love in*

a Dark Time: Gay Lives from Wilde to Almadóvar and *Mad, Bad, Dangerous to Know: The Fathers of Wilde, Yeats, and Joyce*. He has been three times shortlisted for the Man Booker Prize.

Juan Gabriel Vásquez's novel *The Sound of Things Falling* won the Premio Gregor von Rezzori in 2013 and the International IMPAC Dublin Literary Award in 2014. Among his other works are novels *The Informers*, *The Secret History of Costaguana*, and *Reputations* and a collection of stories, *Lovers on All Saints' Day*. He has received the Premio Qwerty, the Premio Nacional de Periodismo Simón Bolívar, and the Premio Casa de América Latina de Lisboa.

Edmund White is the author of more than two dozen works of fiction, memoir, and criticism, including the novel *A Boy's Own Story* and *Genet: A Biography*, which won the 1993 National Book Critics Circle Award and the Lambda Literary Award. He was made Chevalier (and later Officier) de L'Ordre des Arts et des Lettres by the French government in 1993. White cofounded the Gay Men's Health Crisis, the world's first provider of HIV/AIDS prevention, care, and advocacy. He received the 2018 PEN/Saul Bellow Award for Achievement in American Fiction and the 2019 National Book Foundation Lifetime Achievement Award.

Terry Tempest Williams is an author, ethicist, and environmental activist. Among her sixteen books of creative nonfiction are *Refuge: An Unnatural History of Family and Place*, *When Women Were Birds: Fifty-four Variations on Voice*, *The Hour of Land: A Personal Topography of America's National Parks*, and, most recently, *Erosion: Essays of Undoing*. Her honors and awards include the Robert Marshall Award from the Wilderness Society, the Distinguished Achievement Award from the Western Literature Association, the Wallace Stegner Award from the Center of the American West, and the David R. Brower Conservation Award.

ACKNOWLEDGMENTS

In my long and colorful life, five essential elements have always been present: extraordinary landscapes, art, books, loving friends, and dogs. Complete lists of any of those elements, from landscapes to friends, would be far too long. But beauty and affection have been with me, always.

When Grisha and I moved to Tuscany, we had the pleasure of transforming a ruin into a very agreeable home—a place to gather our friends, our books, our dogs, and some of the spectacular views of Tuscany (they say that Dolce Stil Novo was born and flourished here). The temptation to put all of that history on paper was irresistible. And so *A Tower in Tuscany: Or a Home for My Writers and Other Animals* was born.

I've had generous and enthusiastic collaborators throughout this process. My dear friend Michael Cunningham has been a tireless, effective, and affectionate partner in making this dream a reality.

Nicolás Gaviria has been my assistant, colleague, and friend (and also shares my love of dogs and books).

Grisha's hand is always on my shoulder. Many of the writers in residence at Santa Maddalena have worked in Grisha's studio, and they too felt his spirit in their work.

We are fortunate that the photographs were shot by François Halard, not only a great photographer but a real expert on Santa Maddalena, with whom I have shared many adventures and funny stories.

This book would not exist without the devotion and faith of Andrew Wylie, my literary agent; Klaus Kirschbaum, my editor; Dung Ngo, the designer, and Charles Miers, publisher of Rizzoli USA. I am grateful, as well, to Elisabetta Sgarbi, and to La nave di Teseo, for publishing the Italian edition.

A very special thank you to all my friends who have so generously given their thoughts and stories to this project, as well as those who have given a piece of their lives to these pages. It is a precious gift, for which I am deeply grateful.

And, finally, thanks to all my friends of the four-legged variety, whose warmth I can still feel on my lap.

First published in the United States of America in 2021 by

Rizzoli International Publications, Inc.
300 Park Avenue South
New York, NY 10010
www.rizzoliusa.com

Copyright © 2021 Beatrice Monti della Corte
Photographs © 2021 François Halard

Publisher: Charles Miers
Design: Dung Ngo
Editor: Klaus Kirschbaum
Copy Editor: Gloria Nantz
Production Director: Maria Pia Gramaglia
Managing Editor: Lynn Scrabis

Copyright © 1996 Gregor von Rezzori for quotes from *Anecdotage: A Summation*, by Gregor von Rezzori. Published by Farrar, Straus and Giroux, New York.

All rights reserved. No part of this publication may be reproduced, stored in a retrieval system, or transmitted in any form or by any means, electronic, mechanical, photocopying, recording, or otherwise, without prior consent of the publishers.

ISBN-13: 978-0-8478-7010-3
Library of Congress Catalog Control Number: 2020945387

2021 2022 2023 2024 / 10 9 8 7 6 5 4 3 2 1

Printed in Italy

Visit us online:
Facebook.com/RizzoliNewYork
Twitter: @Rizzoli_Books
Instagram.com/RizzoliBooks
Pinterest.com/RizzoliBooks
Youtube.com/user/RizzoliNY
Issuu.com/Rizzoli

Ghanaian Cooking At Its Best

Ghanaian Cooking At Its Best

SUE CAMPBELL, NEE AMOO-LAMPTEY

GHANAIAN COOKING AT ITS BEST

. . .

Copyright © 2014 by Sue Campbell

ISBN 978-0-9862791-0-2

All rights are reserved solely by the author. The author declares that the contents are original and do not infringe on the rights of any other person.

No part of this book may be reproduced in any form except with permission from the author. Unless otherwise indicated.

Food props and most of food pictures by Sue Campbell.

70 RECIPES AND UP TO 200 IMAGES IN COLOR.

Dedications

To my parents for giving me the best education and a happy well balanced upbringing.

To our innovative ancestors'. This cook book is to celebrate and share some of the legacy of food creation and preparation left by our innovative ancestors. I believe sharing food amongst ourselves and with others despite our differences connects us all and brings harmony and peace to make the world a better place for all mankind.

Acknowledgement

I thank God the creator for giving me the will power to achieve my dream of this Cookbook.

I thank all my brothers and sisters from the bottom of my heart for supporting me in different ways to achieve my dreams and aspirations.
I thank my family and friends for being my food tasters and critics.

A BIG thank you to anyone and all the Professionals involved in guiding me in creation of my cookbook. I appreciate all of you from the bottom of my heart. This Cookbook could not have materialized without you!
Thank you all again!

Table of Contents

Dedications and Acknowledgements ... *Page 5*
Useful Websites .. *Page 7*
Some of Accra's Infrastructure & Monuments .. *Page 8*
Pictures of My Parents and Our Family Home ... *Page 9*
Introduction – Brief Family History of Writer ... *Pages 10-11*
African Cooking & Cook's Tips ... *Pages 12-13*
Ghana's Vegetation, Plants and Food Grown ... *Pages 14-15*
Ghanaian Food in General .. *Pages 16-25*
Basic Products & Utensils You Should Have in Your Kitchen *Pages 26-27*
Drinks & Smoothie ... *Pages 28-33*
Breakfast Dishes .. *Pages 34-39*
Snacks & Appetizers .. *Pages 40-47*
Side Dishes ... *Pages 48-59*
Ghana Tomato Gravy ... *Page 60-63*
Pepper Relishes ... *Pages 64-69*
Baked Fish or Fried ... *Pages 70-71*
Baked Spicy Citrus Chicken ... *Pages 72-73*
Baked Spicy Pork – Domedo .. *Pages 74-75*
Jollof Rice ... *Pages 76-79*
Staples .. *Pages 80-87*
Stews .. *Pages 88-97*
Soups .. *Pages 98-105*
Aprapransa ... *Pages 106-107*
Desserts ... *Pages 108-119*
Quick Cake Desserts ... *Pages 120-121*
Measuring and oven temperatures in Fahrenheit, Celsius and Gas mark *Page 122*
Index ... *Pages 123-129*

Useful Websites

- www.ghanamuseums.org
- www.touringghana.com
- www.aximbeach.com
- www.hansbotelghana.com
- www.aburigardens.org
- www.African-regent-hotel.com
- www.gbhghana.net
- www.goldentulipaccrahotel.com
- www.elminabayresort.com
- www.whitesandsholidays.com
- www.shopafrica53.com
- www.bridetidings.com
- www.afrodrive.com
- www.threemasks.com
- www.wikipedia.org
- www.google.com
- www.youtube.com
- www.marians-artwork.com
- www.moevenpick-hotels.com/en/africa/ghana/accra/hotel-accra/overview

USEFUL WEBSITES

Independence Arch

SOME OF ACCRA'S INFRASTRUCTURE & MONUMENTS

Kwame Nkrumah Memorial Park

Accra National Theater

Aburi Botanical Gardens

Mum
1948, Cape-Coast, Ghana

Dad & Mum's Wedding Pic
1946 Cape-Coast, Ghana

My Family Home
Built in 1957, Accra, Ghana

PICTURES OF MY PARENTS & OUR FAMILY HOME

Introduction

Brief family history of writer

Akwaaba! (Means welcome in Fante)

This cookbook gives me the opportunity to let you look through a joyous window of my exciting culinary experience as a child to adulthood in Accra, Ghana, West Africa. I enjoy the Ghanaian cuisine to the fullest and could not find a cookbook that captured the Ghanaian culinary experience with the pictures I wanted to see. I decided to write a cook book to share the spicy, delicious and colorful Ghanaian cuisine with the world. In this cookbook I will be using mainly Ga and Fante names of foods interchangeably. I will use Ewe, and Hausa names of foods occasionally.

I was born in the early 1960's in Accra the capital of Ghana, West Africa. Ghana is a tropical country with colorful luscious tropical plants, flowers, colorful fruits, vegetables, palm trees, coconut trees, and spices. The temperature is between 64F-100 F throughout the year. Ghana has two rainy seasons April-July & September-November. Harmattan season is between December-January when it is cool & foggy in the mornings and late evenings. Ghana is 5 degrees north of the equator, with the Atlantic Ocean and Gulf of Guinea to the south along the coast. Ghana is sandwiched between Ivory Coast to the West, Togo to the East and Burkina Faso to the North.

Ghana is known for its Cocoa exports for production of chocolate around the globe. Ghanaians speak at least 30 local languages but English is the Lingua Franca and it is taught at school from infancy. In the capital Accra, Ga, Fante, & Twi are the most spoken languages.

My father the late Isaac Amoo-Lamptey Esq. was a lawyer by profession, a Ga from the capital Accra, and my mother the late Mary Amoo-Lamptey, Nee Moses was a cosmetologist, fashion designer and an entrepreneur, a Fante from Cape Coast. Cape-Coast is along the coast to the south west of Accra and approximately 90 miles by road. My mother was a fantastic cook and a genius in the kitchen because the meals she cooked for the family were always delicious whether she used a lot of ingredients or few ingredients. In Ghana Fante women are known for their exceptional culinary skills. There is a saying in Ghana "If you marry a Fante woman you are a very lucky man because you would be fed delicious meals and never go hungry!"

My mother believed in teaching her female children to cook from the age of about 11 years old. At the weekends I would make banana fritters, omelets and porridge for breakfast. As I got older my mother would sometimes send me to the market for some cooking ingredients. She would let me make a list of what she wanted me to buy, and I would be driven to the market by the chauffeur or I would use a taxi to get to the market.

When I returned home from the market she would give me instructions on what to do, and praise me a lot as I cooked. She would say things like "What a wonderful daughter God has blessed me with!" Her praises made me feel good although I would have preferred reading an adventurous book instead of cooking (I guess her cooking lessons paid off huh? ☺).

Quote from my mother: "Education without domesticity is no education"

Tip from my mother: "Add a little chili and salt gradually, then taste your food, if you put too much chili or salt a good dinner is ruined!"

African Cooking

Ghanaian and African cooking is about touching, estimating, watching and practicing with ingredients under supervision from our mothers and aunties until we get it right and become confident in the kitchen.

There have always been some Ghanaian cookbooks available. Typically my mother and other Ghanaian mothers never refer to a cookbook to cook a Ghanaian meal. Every mother is now a seasoned cook so she uses basic methods her mother taught her, and puts her own spin on her creation. My mother's meals usually turned out delicious and fantastic!

My mother when baking would refer to recipes for baking cakes, pastries etc. otherwise her Ghanaian cooking was freestyle with experience and delicious.

Although the verbal and demonstrative practical method of Ghanaian cooking has worked for centuries for the most part, a cookbook of course makes life easier so one can share their written recipes with family, friends and the world.

Feel free to adjust sugar, chili or salt to your taste. If you need more ground herring or shrimps in your dish feel free to personalize to your taste.

I tried and tasted all of the recipes with family and friends. I had to tweak one or two until I got it right. All of the recipes got the thumps up, so be confident and get cooking.

Cook's Tips

<u>Measuring</u>: I have used a cup of 250 mls mostly because it simplifies cooking for most people. I like the simplified method of measuring using a cup, instead of dealing with different grams, ozs and Ibs, and converting them before starting the preparation of a meal. I have used the odd oz or Ibs for canned items and some fresh produce e.g. fresh ginger, potatoes, spinach and okra.

<u>Meat and fish</u> - I have used Ibs for chicken and meat but I have also mentioned <u>pieces of chicken, fish or meat</u> I like the freedom the cook has, instead of the rigidity with weights.

<u>Measuring level</u> - Not heaped for most of the measurements. e.g. Baking products like flour, sugar or baking powder. Ground spices are not heaped, if they are I will say so.

<u>Flour</u> - All-purpose flour not Self-rising. Self-rising tends to be very salty.

<u>Fat for baking</u> - I used Vegetable Spread but Margarine should work.

<u>Lemon or Lemon juice</u> - Used on all meat, and seafood

<u>Orange juice</u> - Occasional use of orange juice on meats.

Most of the recipes serves up to 6 people.

AFRICAN COOKING & COOK'S TIPS

Ghana's Vegetation, Plants and Foods Grown

• To name a few •

Plants and flowers: Palm trees, coconut trees, bougainvillea, crotons, lilies, orchids, hibiscus and roses. Most plants found in the tropics grow in Ghana.

Fruits: Mangoes, oranges, tangerine, lemon, pineapples, bananas, avocados, guavas, paw paws (papaya), sugar cane, sour sop, and cocoa (seeds used for making chocolates)

Vegetables: Tomatoes, onions, green peas, different species of chilies, variety of beans, carrots, lettuce, garden eggs, aubergines, (eggplant) okra, lettuce, spinach, cauliflower, cabbage and carrots.

Legumes & Nuts: Groundnuts, different variety of beans e.g. lentils, black eyed beans, red kidney beans, agushi.

Carbohydrates: Corn, rice, plantains, yams, cassava (yucca) cocoyam (malanga) sweet potatoes and regular potatoes.

Spices & herbs: Ginger, garlic, cloves, guinea pepper, basil, thyme, lemon grass, peppermint, curry, cinnamon, nutmeg – Most of the spices have beneficial medicinal purposes. e.g. ginger is good for indigestion, and it is an anti-emetic.

Oils: Coconut oil, peanut oil, shea butter, cocoa butter (for white chocolate), sunflower oil and palm oil made from palm nut fruit. Palm kernel oil is from the nut inside the cracked shell of the palm nut fruit.

African Violet Plant

Cocoa Pods on Tree

Garden Eggs, Aubergine Peppers

A Variety of Spices

Lemon Grass Plant

Pineapples

Sour sop

GHANA'S VEGETATION, PLANTS AND FOOD GROWN

Ghanaian Food In General

Ghanaians eat what most people eat and drink on planet earth but processed the Ghanaian way so I will be focusing on what is typically Ghanaian authentic cuisine. Ghanaians are generally enthusiastic about their food. Our foods are colorful, spicy and delicious and we know that. The cuisine in Ghana is colorful, eclectic, exciting, spicy and fun!

Our stews, soups and relishes are tomatoes, onions and chilies based and are spiced usually with aromatic spices like ginger, cloves, and guinea peppers. Curry, nutmeg and herbs e.g. basil & bay leaves are used in stews and soups too. Salted fish e.g. Momoni (salted moist dried fish), Kobi (salted dried tilapia fish), or ground dried shrimps or dried herring are added on if preferred. Whether salted fish or powdered fish is used in a dish depends on what kind of stew or soup is being cooked and the cook's preference. If you are cooking soups you do not add oil, if you are cooking stews oil goes in the pot first. Some pepper relishes are cooked with oil, some are prepared without oil.

We have fast food restaurants and regular restaurants selling Ghanaian and foreign foods. It is nomal to find Ghanaian food cooked at home sold in street kiosks, chop bars and restaurants all over the country.

Cold drinks are ginger drinks, fruit juices made from pineapples, oranges and mangoes, soda/fizzy drinks, malt drinks, locally brewed drinks from corn and caramel called Nme daa and good old very cold water usually called ice water. Ghana locally produces beers e.g. Star beer Club beer, Gulder and Guinness. Other alcoholic beverages available are some of the usual ones you will find all over the world like different types of wine, cocktails and spirits. Locally brewed alcoholic beverages are Palm wine, Pito and Akpeteshie. Ghanaians look forward to cold drinks because the weather is usually hot and sweltering.

Boforot- Donuts

Local Beers

Black Eye Beans, Fried Plantain, Gari & A Splash of Palm Oil

DRINKS

<u>Hot Drinks:</u> Teas - Home brewed ginger & cloves, lemon grass, peppermint, black or green tea. Coffee, hot chocolate and holicks.

<u>Cold Drinks:</u> Ginger drinks, fruit juices, Nme daa (locally brewed drink from sprouting corn and caramel) milk or chocolate drinks, fizzy drinks, malt drinks, beers, guinness, and home brewed alcoholic beverages like Palm wine (from palm trees) and Pito from fermented sorghum (a type of grain).

BREAKFAST

Eggs, cheese, sausages and porridges made from grains like wheat, millet, oats, rice and corn. Different types of bread and fried accompaniments. Lunch and dinner dishes are eaten for breakfast as well.

BREADS AND SNACKS

Different breads e.g. Sweet sugar bread, tea bread (sugarless), whole wheat bread are eaten with porridges for breakfast. Boforot, (doughnuts/donuts with yeast) or regular doughnuts/donuts, and pancakes are eaten for breakfast too. Some snacks are fried or baked and are unique to Ghanaians e.g. Akara (fried spicy black eyed beans donuts) Achomo (chin chin), Poloo (coconut crunchies) Chips (savory flour snack) are eaten as snacks.

PROTEIN

Beans, pork, beef, bush meat like deer, goat meat, lamb or mutton. Some people eat offal in Ghana like in other countries too. Cow, goat & pigs head, tongue, feet, tripe and intestines. Cow's feet or pigs feet are added to steak and fish in soups e.g. light soup or palm nut soup or stews e.g. stew for waakye. Wele (pronounced waylay) smoked skin of cow is used in stews and soups too. The offal gives the content of the dish variety. Most offal generally is used to make light soup.
Seafood such as fish, lobsters, crabs, shrimps, prawns, mussels, oysters, octopus and other shell meat such as snails are consumed as well.

CARBOHYDRATES

Rice, corn, cassava (yucca), cocoyams (malanga), sweet potatoes, yams, green plantains, & ripe plantains.

COOKING OILS

Peanut oil, coconut oil, palm nut oil, shea butter, and cocoa butter.

Ghana Crabs

Palm Oil

Snails

GHANAIAN FOOD IN GENERAL

MAIN COURSE MEALS

GRAVIES, STEWS AND SOUPS
At least tomatoes, onions, chilies as the base, (garlic is optional). Our main course meals are flavored with momoni (salted moist dried fish), Kobi (salted dried tilapia fish) dried shrimps, dried herring, and spiced with ginger, cloves, guinea pepper, curry, nutmeg and herbs like basil & bay leaves.

PEPPER RELISHES - KNOWN AS SHETOR.
Shetor means pepper in the Ga language. It is freshly ground in a Ka or blender. At least tomatoes, onions, chilies & salt, (garlic is optional) and it is spiced with ginger.

The pepper relishes are eaten as a sauce with any of the prepared carbohydrates like boiled rice, banku, kenkey, gari instant hot soakings and eaten with baked or fried meat or fish, canned fish or meat e.g. sardines, or corned beef.

Assorted Pepper Relishes

Relish Grinding in Ka

GREEN SHETOR
Made from kpakpo shetor which is green in color, or green bonnet peppers, tomatoes, onions & salt.

RED SHETOR
Made from fresh red lady fingers chilies or red bonnet peppers, tomatoes, onions & salt.

BLACK SHETOR
Fried pepper relish: Oil, dried chilies, tomatoes, onions, garlic, ginger, dried shrimp or herring or both.

GHANAIAN FOOD IN GENERAL

CARBOHYDRATES - POPULAR STAPLES

<u>Banku</u> - <u>Ma</u> - Fermented corn dough is cooked and kneaded into a smooth sticky ball and eaten with fried or baked fish with relishes, stews, or soups.

<u>Kenkey</u> - Banku partially cooked and mixed with raw corn dough then made into round balls or oval shapes and covered with dried corn husks, plantain leaves or fig leaves and cooked for few hours. It is eaten with pepper relishes with meat, fish, stews or soups. It can be mixed with sugar & milk also.

<u>Fufu</u> - Steamed and pounded cassava (yucca), cocoyam (malanga), yam, or green plantain is pounded in a mortar and pestle until sticky and eaten with soup of your choice e.g. light soup, palm nut soup, and peanut soup. It is not eaten with fried stews usually. Fufu powder is available at African or Caribbean stores.

<u>Gari</u> - (Cassava grains) Gari hot instant soakings - Gari is poured into hot water, the water strained immediately and left for a minute or two. It can be made into a mold and eaten with grilled, fried meat or fish with a spicy relish or stew or soup of choice.

<u>Omo towo</u> - (Rice balls) Rice cooked with more water so it is soft and made into balls eaten with any of the soups e.g. light, peanut or palm nut soup, stew of your choice or steamed, grilled, fried fish or meat or canned fish or meat e.g. sardines, or corned beef with a pepper relish.

GHANAIAN FOOD IN GENERAL

Steamed Carbohydrates - Cassava (yucca), cocoyam (malanga), sweet potato, yam, green and ripe plantain. They can be eaten with any soup or stew, steamed, grilled, fried fish, or meat, canned fish or meat e.g. sardine, or corned beef with a pepper relish.

Fried Carbohydrates - Cassava (yucca), cocoyams (malanga), sweet potatoes, yams, and ripe plantains are fried and eaten with fried fish or meat, or canned fish with a pepper relish. Ripe plantain is usually fried as a side dish, or can be eaten as a main mail or eaten as a snack.

Kelewele - Spicy fried plantain is eaten as a snack with peanuts in the evenings or as a side dish or on its own.

Green plantain - Not fried in big chunks but usually thinly sliced in coin shapes or shredded for plantain chips as a snack.

Banku, Omo Towo, Gari

Boiled Carbohydrates

Fresh Carbohydrates

GHANAIAN FOOD IN GENERAL

CARBOHYDRATES AND THEIR PROCESSES

Rice, corn, cassava (yucca), cocoyams (malanga), sweet potatoes, yams, green plantains, & ripe plantains. These carbohydrates above processed in various ways accompany our stews, soups and spicy relishes. The carbohydrates are steamed & pounded, dried in the sun, fermented & kneaded, soaked, grated & cooked, dried and ground, dried and roasted into grains, steamed as is or fried.

Some of these carbohydrates are used for breakfast dishes too.

Rice and its processes:

Rice - Steamed

Omo towu - Rice balls cooked with more water and made into balls

Rice water - Rice porridge with sugar & milk for breakfast

Corn and its processes:

Dried Corn grains: Corn on the cob (raw) dried in the sun until very dry. The corn is removed from the cob and sold as grains at the market.

Eko Egben (Ga), (Grits): Ground dry corn cooked for breakfast eaten with milk & sugar.

Tom Brown: Dried corn grains roasted in a pot on a fire or in the oven then taken to the mill to be ground into powder.

Tom Brown uses:

1) Breakfast - porridge eaten with sugar & milk.

2) Aprapransa - Tom brown mixed into regular palm nut soup. Optional black eyed beans added.

3) Used instead of flour for thickening Tatale, Kaklo or Ablongo.

GHANAIAN FOOD IN GENERAL

MA: Fermented corn dough.

Ma - Dried corn grains washed and soaked in water for three days, washed again, strained and taken to the mill to be ground. Water is added to the ground corn powder and mixed into a paste. It is covered and left for another three days to ferment. After this process it is called Ma.

Ma uses:

Koko: Corn porridge for breakfast

Banku - Ma mixed with water and salt and cooked and kneaded into a smooth sticky ball and eaten with fried or baked fish or meat with a pepper relish, or stews, or soups.

Softer Banku - See Agblima: Ma mixed with 50 % Agblima for for a softer consistency.

Kenkey – Banku partially cooked is mixed with corn dough and then made into round balls or oval shapes and covered with dried corn husks, plantain leaves or fig leaves and cooked for few hours. It is eaten with a pepper relish with meat, fish, stews or soups.

Whole Ga Kenkey

Ice Kenkey (sweet) - Kenkey mixed with water, sugar and milk. It is kept in bottles or plastic bottles in the fridge and eaten later with peanuts.

Ga Kenkey with Fried Fish, Ghana Gravy & Plantains.

GHANAIAN FOOD IN GENERAL

Cassava (yucca) and its processes:

Gari - Cassava grains. Grated cassava strained of starch for three days and roasted over open fire. It turns into grains known as Gari.

Gari hot instant soakings - Gari is poured into hot water, the water strained immediately it is left for a minute or two. It can be made into a mold and eaten with grilled, fried meat or fish with a spicy relish stew or soup.

Gari cooked kneaded in hot water (eba) - Gari is poured into hot water but it is kneaded on the fire for few minutes into a sticky ball.

Gari soakings (sweet) - Gari is soaked in cold or temperate water with sugar and milk. Fresh coconut milk may be used instead or water. Peanuts are usually eaten with it.

Agblima - (fermented raw cassava) Cassava is soaked in water for three days to ferment and taken to the mill to be ground to a moist mash. Water is added to make into a paste and left for three days to ferment. When cooked like banku it is called Akple. Aglima and Akple names originate from the Ewe tribe.

Akple - Cooked Agblima. Can be starchy when cooked so for a not too starchy consistency 50% Ma may be added before cooking then one gets a not too starchy outcome.

Kokonte - (fondly called Lapiiwa) Cassava (yucca) is cut up and dried in the sun, then taken to the mill to be ground. When ground it is a light brown powder and it is cooked like banku but the consistency is like fufu. It is usually eaten with any of our soups. e.g. light soup, peanut soup or palm nut soup.

AUTHENTIC GHANAIAN BREAKFAST, LUNCH AND DINNER
Some examples.

BREAKFAST: Sandwiches with hot chocolate, teas and coffee, porridges like regular Ma Koko, Hausa Koko with Akara or doughnut/donut (boforot) Meat pies with cold or hot beverages, lunch menus are consumed too e.g. Kenkey and fish, rice and fish or meat stews, waakye and fish and meat stews, fried plantains and beans stew served with spicy pepper relishes with red palm oil (and optional gari) fondly known as (red red). Fufu and any of our soups e.g light soup, palmnut soup, and peanut soup.

LUNCH: The breakfast menu minus the porridges and their accompaniments are eaten for lunch. Meat pies with cold beverages, banku and okra stew or soup is added. Kenkey, banku and fried fish and prawns with a pepper relish (shetor), rice and meat stews, waakye and fish and meat stews, fried plantains and beans stew served with spicy pepper relish, red palm oil (and optional gari) and fondly known as (red red). Kelewele (spicy fried plantain) as a side dish. Fufu and any of our soups. Kebabs - Chicken and Beef are spiced with Suya (Suya is a blend of chilies, peanuts and salt). (Shrimps powder is optional.) The Suya blend originates from the Hausa's in Northern Ghana.

DINNER: Kenkey, banku and fried fish and prawns with a pepper relish (shetor) rice and meat stews, waakye and fish and meat stews, beef or chicken kebab spiced with Suya spice. Roasted spicy pork known as domedo and kelewele (spicy fried plantain) and peanuts are abundantly sold at street corners and night markets. Any carbohydrate with any stew, or soup. Fufu with any soup of your choice, sandwiches with hot chocolate, tea and coffee.

Above are only some examples of what is usually eaten. Eat whatever tickles your fancy!

Kelewele Ingredients

Palm Nut Soup with Banku

GHANAIAN FOOD IN GENERAL

Basic ingredients and utensils you should have in your pantry.

Some people buy prepackaged cubes made from dried shrimps and stock and put in stews or soups I do not I use freshly ground dried shrimps or herring, and freeze any excess for later use.

Dry Ingredients

Flour - All-purpose <u>not self-rising</u>. Self-rising flour is usually too salty. Rice, rice flour, baking powder, salt, black eye beans, sugar (brown & white) ground spices i.e. onions, garlic, paprika, chili, ginger, gloves, curry, star anise, nutmeg, cinnamon and herbs like basil thyme, mixed herbs & bay leaves. If you prefer fresh basil or bay leaves that is fine.

Canned/Bottled/Frozen

Canned fruits e.g. pineapples, mangoes, few cans of crushed tomatoes of 28 ozs, (3 cups), few cans of tomato puree (29oz), peanut butter, raisins, corned beef, sardine, mackerel or salmon, milk, mixed vegetables, green peas, baked beans and vinegar.

Ingredients in your fridge

Lemon, or lemon juice, fresh regular tomatoes and cherry tomatoes, carrots, cucumber, lettuce, butter lettuce, vegetable spread, eggs, salad cream, or ranch. Ginger at least 1.5 lbs. for ginger drink.

Vegetables and fruit rack

Bananas, pineapples, mangoes, oranges, red delicious apples or apples of choice. White onions, red onions, garlic, yam, coco-yam (malanga) or potatoes, cassava (yucca), green & ripe plantains.

Useful utensils

Different sizes of pots, frying pan, blender, Ka (Ghanaian grinding mortar & pestle) Eta (Ghanaian Banku wooden spoon) or regular wooden spoon. Ladles, can opener, good set of kitchen knives including Mezzaluna, grater, juicer, rolling pin, food processor, whisk, chopping board, sieve, muslin cloth or ¼ of meter of cotton fabric or a new knee high/ pop socks for straining your ginger drink.

AFRICAN STORE INGREDIENTS AND READY MADE PRODUCTS

- Gari

- Corn flour – For making Ma for Koko, Banku or Kenkey.

- Banku mix

- Agblima (fermented cassava)

- Fufu powder mix

- Kokonte powder

- Waakye leaves – if not available buy browning sauce

- Black Shetor in jars (usually has shrimps)

- Canned Palm nut cream 800g/28oz

- Kobi (salted dry Tilapia)

- Momoni (salted dry moist fish)

Ready-made snacks
Ghana doughnuts/donuts, achomo known as chips or chin chin (savory flour crunchies)
Plantain chips.

- Dry whole shrimps or ground dried shrimps may be ground and used to flavor stews and soups or used for Black Shetor

- Dried ground herring – Used in conjunction with shrimps for Black Shetor, either or is fine.

- Use above instead of dried shrimps if you are allergic to shrimps

- Black eyed beans fresh or canned

Clockwise From Top Right - Donuts, Achomo, Mixed Nuts, Chips

BASIC PRODUCTS & UTENSILS YOU SHOULD HAVE

Drinks & Smoothie

DRINKS & SMOOTHIE:

STRAINING: If you do not have a juicer use ¼ of a meter of muslin cloth or cotton fabric thrown over a sieve or use a new knee high/pop socks to strain drink.

PINEAPPLE & GINGER DRINK

Ingredients
- 1 whole fresh pineapple or canned juice of 500mls
- 2 inches ginger (peeled)

Process
- Wash and peel pineapple, slice flesh off pineapple, add ginger, place in juicer. If using blender pour mixture of pineapple & ginger through a sieve to strain or you may choose not to strain and drink it thick with all that fiber goodness.

Garnish
- Sliced pineapple or wedge with cherry stuck into pineapple with a cocktail stick on side of glass.

Pineapple & Ginger Drink

DRINKS & SMOOTHIE

GINGER DRINK WITH CLOVES AND LEMON

May be drank hot or cold

Must have
- A blender or grater
- Straining: ¼ of meter muslin cloth or cotton fabric thrown over a sieve or use a new knee high/pop socks to strain drink.
- A pot that holds 3 liters of water

Drink will be boiled for 5 mins (Pasteurization)

FYI
What to do with ginger chaff residue after sieving mixture?
Squeeze chaff into tiny balls and put in a sandwich bag loosely, freeze for ginger tea later.

Why tiny balls? It's easier to remove after it is frozen otherwise it would be a block of ginger chaff.

Making ginger tea: Pour hot water over a ball or two. Leave to steep for 5 mins. Pour through a small sieve into another cup. Add sugar, honey or agave.

Ingredients
- 1 Ib of fresh ginger - washed and peeled or just washed well with skin on.
- 3 liters of water in total
- 2 cups of sugar (Brown or white)
- ¼ -½ teaspoon of ground cloves or 4 whole cloves
- 2 Tablespoons of lemon juice with pulp or without. *(I love the pulp floating in my drink)*

Process
- Put 1 cup of your sugar in the pot and add 1 liter of water to start the dissolving process
- Hook your sieve with straining cloth in it over pot, or stretch pop socks/ knee high onto suitable bowl. Cut up ginger for blending or grate.

Ginger Drinks

DRINKS & SMOOTHIE

Blend half of ginger with 1 liter of water, or grate and add water and whole cloves if using
- Pour through sieve into pot or pour into stretched pop sock/knee high into another pot
- Pick up straining cloth or knee high and squeeze gingery mixture through it

Repeat above process with rest of ginger
- Make sure your water is 3 liters in total
- Add ground cloves if using

Could take up to 15 minutes to come to a boil. Keep an eye so it does not overflow.
Stir; adjust sugar to your taste. Put on fire & boil for 5 minutes. Take off heat.
Add the 2 tablespoons of lemon juice
- You can drink hot, or cold. When cool pour into jugs and store in refrigerator for later. Settling of ginger and cloves residue is normal and full of goodness.
- Stir your cold drink before serving or drinking.
- Serve with a slice of green lime or lemon wedged onto the side of the glass.

FRUITS, GRAIN OR PLANT DRINKS IN GHANA.

- All available fruits e.g oranges, tangerines, pawpaws (papaya), mangoes, guavas, sour sop, coconuts e.t.c
- Nme daa is a Ghanaian drink made from sprouting corn and caramelized sugar. It is made for occasions like outdoorings. The sprouting corn grains are boiled and strained and then caramelized sugar is added.

Plants
- Peppermint or Lemon grass leaves are used for cold or hot teas.
- Cloves and lemon juice can be made into hot drink.
- Process - Boil mint or lemon grass
- Strain through a sieve
- Add sugar

Drink hot or cold.

Sour Sop Drink

DRINKS & SMOOTHIE

SPICY PINEAPPLE & MANGO SMOOTHIE WITH GINGER AND PAPRIKA

Ingredients
- 2 cups mango chopped (fresh or frozen)
- 2 cups pineapple (fresh or frozen)
- 2 cups cold yogurt
- 1 inch ginger (peeled)
- Pinch of paprika or chili powder (adjust to your taste)
- ½ cup brown sugar or honey (optional) sometimes the pineapple or mango is not sweet)
- Adjust to your taste.

Process
- Put all ingredients in blender or smoothie maker, puree to your preferred consistency.
- Garnish with sliced pineapple and cherry or a wedge of pineapple.

Spicy Pineapple & Mango Smoothie

DRINKS & SMOOTHIE

6

DRINKS & SMOOTHIE

Breakfast Dishes

Banana Fritters with Pineapple

BREAKFAST DISHES

BREAKFAST DISHES

Porridges are eaten sweetened with sugar and tinned milk. Peanuts, raisins or currants may be added. They are accompanied by sweet breads, brown bread, tea bread, boforot, meat pie or Akara also known as kose. Akara is black eyed beans soaked skinned and pureed and spiced with onions, chili, ginger and salt and fried. Omelets may be eaten with kenkey and pepper relishes too.

MA Koko (Ga) Akasa (Fante) - Corn Porridge

Ingredients
- 1 cup Ma
- 2 cups of water
- Sugar (to your taste) add before cooking or add after it's cooked.
- ½ teaspoon of nutmeg (optional)
- Salt to your taste.

Ma Koko

Process
- Mix together Ma and water.
- Place on medium heat keep stirring until it thickens.
- Cook for up to 10 mins or until cooked.
- Pour into bowls and add tinned milk, dried nuts and fruits of your choice

Other koko
- Hausa koko - (Spicy Koko) Ground millet with ginger, chilies & salt. Cooked like regular koko.
- Hausa koko is a recipe from the Hausa's in Northern Ghana but it is eaten all over Ghana.

Hausa Koko with Peanuts & Raisins

RICE WATER (Rice Porridge)

Ingredients
- 1 cup raw rice
- 4 cups water
- Sugar to your taste
- Salt to taste
- Cinnamon or nutmeg (optional)

Rice Water with Cinnamon & Evaporated Milk

Process
- Wash rice add the water
- Cook on medium heat for 30-40 minutes
- Leave lid half open otherwise froth from rice will overflow.

You may add cinnamon or nutmeg or both to your taste. It just means your rice water will be light brown. I love it with cinnamon & nutmeg.

Rice Water

BANANA FRITTERS

We all have Bananas that overripe in the fruit bowl sometimes. Banana fritters is adding overripe Bananas to your pancake mixture and frying it. You can use normal Bananas and mash it up with a fork and add to your pancake mixture too.

Ingredients
- 4 overripe Bananas = At least 2 cups
- 2 cups of over ripe mashed bananas
- 1 Egg
- 1½ cups of all-purpose flour
- ½ cup of sugar or to your taste
- ½ teaspoonful of nutmeg
- ½ teaspoon of cinnamon
- 1 teaspoonful of lemon juice or orange juice
- Pinch of salt to your taste
- Oil for shallow frying

Fritters with Pineapple & Cream with Slivers of Lemon Rind

BREAKFAST DISHES

Process
- Wash and peel over ripe Bananas
- Mash over ripe Bananas in a bowl
- Add egg, sugar, nutmeg and lemon juice or orange juice
- Add flour
- Heat oil on medium heat
- Test fry a small portion to check consistency adjust to your taste
- Scoop 1 tablespoon of mixture in hot oil in pan, flatten, repeat process until you fill pan with fritters. When cooked on one side and brown, turn on other side to cook.
- Place on kitchen towel to drain oil

Eat for breakfast or dessert. Enjoy with chopped pineapples with whipped cream or ice cream.

MPOTOWPOTOW

Potow means "mash it" in Fante so the name means "mash it, mash it". Usually eaten at the weekends for breakfast or brunch. Great for hangovers, brunch, lunch or dinner. It is a hot pot made by semi mashing your carbohydrate of choice and leaving it lumpy. Yam, cocoyam (Malanga) or potatoes may be used. Ground shrimp or herring, or any meat or fish of your choice, tomatoes, onions, chilies, vegetables, spices, oil, butter or palm oil are added. Over the years I have used sausages, prawns, smoked pork neck, black eyed beans and spinach in mine. *Personalize yours.*

Ingredients
- 8 Medium Malanga, Small tuber of yam or 10 medium potatoes
- 1lb of smoked Turkey ham (chopped)
- Use meat or fish of your choice. Smoked mackerel, sausages, prawns, smoked pork neck, or shredded rotisserie chicken
- 2 medium tomatoes (chopped)
- 1 medium onion (chopped)
- 2 bay leaves
- Chili powder and salt to your taste
- 1 cup of mushrooms (chopped)
- 1 cup of canned veg or frozen veg
- ½ cup of cooked black eyed beans or canned beans of your choice
- ½ - 1 cup of palm oil/vegetable oil/ or butter

Mpotowpowtow with Cut-up Tomatoes

BREAKFAST DISHES

Mpotowpowtow

Process
- Washed and peel carb of choice, chop into chunks
- If using uncooked meat, cook until almost tender then add your chopped washed carbohydrate
 If using cooked meat, add your chopped carb and frozen veg to meat
- Add water to the level of the chopped carbohydrate
- Add bay leaves, chilies, chopped onions, tomatoes, salt and pepper to your taste
- When soft and you have too much water strain and keep for later for thinning dish if needed
- Add beans, canned veg, mushrooms and oil
- Start mashing contents gently enough to leave some lumps of carb
- You may need to add juice from carb or hot water to get a thinner consistency if needed.

BREAKFAST DISHES

OMELET WITH RED ONIONS, MIXED BELL PEPPERS, AND MUSHROOMS.

Ingredients
- 4 Eggs
- 1 Red onion (small)
- ¼ of mixed bell peppers i.e. green, red, & yellow
- 1 Medium tomato and a handful mushrooms
- Ground garlic, chili and salt to your taste
- Handful of spinach or herbs of choice
- 1 Tablespoon of vegetable oil for frying

Process
- <u>Slice</u> onions and mixed peppers
- Crack 4 eggs in bowl
- Add <u>sliced</u> red onions, mixed peppers, tomato & mushrooms
- Season with garlic, chili & salt to your taste
- Add handful of spinach and herbs of choice
- Heat oil on medium heat add beaten eggs with peppers etc
- When starting to cook you can divide into 2 or 4 pieces
- Flip on other side until cooked.

Eat with kenkey or bread with a hot beverage or ginger drink

Omelet In Progress

Omelet With Kenkey Red Shetor & Black Shetor

Something different I love to eat sometimes:

Omelets with Red delicious apples (chopped or sliced) with onions, green, red & yellow peppers & mushrooms.

Don't cover omelet when cooking. It loses the crunch of the red delicious apples. You can use any apples of your choice of course.

BREAKFAST DISHES

Snacks & Appetizers

Meat Pies

SNACKS & APPETIZERS

MADE WITH FLOUR, MEAT, AND COCONUTS
Served at Ghanaian weddings, engagements or any celebratory functions or just eaten as snack.

REMEMBER: All measurements are level not heaped.

GHANA DONUTS

(Makes 30 small balls)

Deep fried in at least a pan or fryer of 7 inches diameter

Ingredients
- 2 cups All-purpose flour
- 1 teaspoonful baking powder
- ½ cup of sugar
- ½ cup of vegetable spread
- Salt to your taste
- 1 egg - Beaten
- ½ teaspoonful of nutmeg
- ½ teaspoonful of cinnamon
- 1 cup of water or milk not both
- Oil for deep frying

Clockwise Donuts, Chips & Achomo (Chin Chin)

Process
- Mix all dry ingredients
- Add vegetable spread
- Add beaten egg, add water or milk _not_ both
- Mix together
- After mixing you should get a thick consistency
- Heat oil, dip 2 teaspoons into water - one for scooping up mixture and one for scooping mixture out of spoon into hot oil
- Turn often to get even brown color
- Place on kitchen paper to drain oil

GHANA CHIPS

The Ghana chips, Achomo or poloo all taste crunchier when fried than baked.

After the pastry is cut into strips and rolled before cutting, they come up chunkier and nicer than if cut from the strips. Cutting them diagonally looks prettier than cutting them straight.

GHANA CHIPS - Crunchy savory snack with onions & a little paprika or chili powder. You will need a pair of scissors or a pastry cutting machine.

Ingredients
- 5 cups All-purpose flour
- 2 cup vegetable spread
- ½ teaspoon of baking powder
- 1 medium onion (finely chopped) or 2 teaspoons powdered onion
- Salt to taste
- ½ teaspoon of paprika
- ½ cup of cold water to mix
- Oil for deep frying

Ghana Chips In Progress

Process
- Mix flour, vegetable spread, paprika, onion and salt to taste, add the ½ cup cold water
- Roll into 2 big balls
- Sprinkle flour on chopping board
- Roll one ball flat with rolling pin into width of ¼ inch thick
- Cut up in long strips of ½ an inch wide on cutting board or table
- Roll each strip into a cane- chips look better if rolled before cutting.
- Cut up with scissors diagonally not too thin
- You will get many chunky chips
- Throw some flour amongst the chips so they do not stick together

Fry until golden brown or bake at 350 F in middle of oven for 30-45 minutes
When cool store in a tight container with a lid or plastic bag for later consumption.

You can add peanuts, cashews or raisins to chips. Enjoy with drink of your choice.

SNACKS & APPETIZERS

ACHOMO

Also known as "Chin Chin" It's a sweet chunky crunchy snack.

Ingredients

- 2 cups of flour
- ½ teaspoon of baking powder
- ½ teaspoonful of nutmeg
- ½ teaspoonful of cinnamon (optional)
- ¼ cup of vegetable spread
- ¼ cup of sugar
- ¼ cup cold water or cold milk not both or it will be runny
- 1 egg (Beaten)
- Oil for deep frying

Process

- Mix flour and all your dry ingredients.
- Add your vegetable spread and eggs
- Add water or milk
- Knead, roll flat with rolling pin into width of ¼ of an inch thick
- Cut up in long strips of ½ an inch wide on cutting board or table
- Roll each strip into a cane then cut up diagonally not too thin
- Fry until golden brown or Bake in middle of over at 350 F for 30- 45 mins

POLOO (Coconut Crunchies)

Ingredients

- 3 cups of shredded coconut flakes- unsweetened or sweetened
- 2 cups All-purpose flour
- ½ a cup of vegetable spread
- ¼ cup sugar
- ½ teaspoon baking powder
- ½ teaspoon nutmeg
- ¼ cup milk or water
- Salt to your taste
- Oil for deep frying

Process

- Mix all ingredients
- Add vegetable spread
- Add milk or water
- Make into a ball
- Throw some flour onto kitchen counter or chopping board
- Roll flat ¼ thick cut up into small shapes of your choice
- Heat oil
- Fry until golden brown or bake in oiled tray in middle of oven.
- Bake at 350F for 45 mins -1 hr

SNACKS & APPETIZERS

MEAT BALLS (Baked)

Small as an appetizer or make big balls for "Egg in the middle meat balls" Both size balls could be a snack or a Ghana Basic tomato gravy could be poured over it and eaten with a staple.

Ingredients
- 1Ib Mince Turkey or Beef
- 1 teaspoon lemon juice
- 1 teaspoon chili powder
- 1 Large chopped onion
- 2 teaspoons of Garlic powder
- 1 teaspoon of Black pepper
- 3 teaspoons thyme or mixed herbs
- 1 teaspoon of salt or to your taste
- 1 Egg for binding meat & spices mixture
- 2 Tablespoon of flour to bind meat mixture
- 2 cups of bread crumbs or flour for coating before baking

Meat Balls

For eggs in middle
- 8 hard boiled eggs peeled and tossed in flour

Process
- Add lemon juice to meat and all above ingredients
- Test ingredients by frying a little piece of meat to check the seasoning
- Adjust salt & pepper and any other ingredient to your taste
- If making small meat ball roll into balls, toss in bread crumbs or flour.
- Bake at 350F for up to an hour.

For eggs in the middle
- Toss peeled eggs in flour, wrap meat around eggs and roll the big balls in flour or bread crumbs
- Bake for at 350F for 1 hour

SNACKS & APPETIZERS

MEAT PIE

Filling - Mincemeat, corned beef, or canned fish e.g. Tuna or Salmon. Ghana basic gravy or corn flour and some water may be used to thicken filling. Make your filling before making your pastry. *See filling on P46.*

Cutters
If you do not have cutters improvise with a regular drinking mug, a round or square saucer as a cutter. Round saucer of 7 ½ ins, and a dessert or fruit bowl of 4 ½ ins works very well as cutters.

Recipe for crust & filling for 10 pies. Cutter diameter 4 ½ ins.

Ingredients
- 2 cups of All-purpose flour
- 1 cup of vegetable spread
- Salt to your taste if needed
- 2 Tablespoonful of cold water or milk
- 1 Egg beaten, or Milk for brushing on pies before baking.

Recipe for crust for 30 pies. Cutter diameter 4 ½ ins.

Ingredients
- 6 cups of all-purpose flour
- 3 cups of vegetable spread
- Salt to your taste if needed
- ¾ cup of cold water or milk
- 1 Egg beaten or Milk for brushing on pies before baking.

Tuna Pie Filling

SNACKS & APPETIZERS

Meat Pie For Baking

Process for crust
- Mix flour, with vegetable spread until you get a crumbly mix
- Add cold water or milk
- Roll pastry into big balls
- Sprinkle some flour on chopping board and roll pastry to 1/8 of an inch thick
- Use a round cutter or a square cutter. Decide what shape you want your meat pies

Round Cutters:

Half moon shape: Fill the half of the pie facing you with a table spoon or two of filling, moisten the edges with milk, or beaten egg, fold the other half towards you and seal pie by pressing edges down with tips of finger or use a fork to press down and go around pie making straight marks with the fork. The shape will be half-moon. Poke holes in pie with a fork. Brush pie with beaten egg or milk before baking.

For oval shape: Fill middle of pie, moisten the edges with milk, or beaten egg and fold from the outside of pie to the center of pie. Pinch pie shut along the top of pie from one end to the other. The shape will be oval. Instead of pinching at the top of your pie, you can make pleats at the top of the pie by pulling the pastry and pleating at the top. Poke holes with a fork on top of pie.
- Brush pie with beaten egg or milk before baking.
- Bake at 350 F for 45 minutes or slightly brown and cooked.

SNACKS & APPETIZERS

Filling for 1 cup of canned fish or meat (10 pies)

- 1 cup of canned fish (drain water before flaking) or canned meat
- ½ cup of canned mixed veg or cooked mixed veg
- ¼ teaspoon of ground onions, chili, black pepper, thyme and curry.
- 1 Egg beaten, or Milk for brushing along edges of pie or top of pies before sealing prior to baking.
- ¾ Tablespoon of meat or fish filling for 4 ½ ins cutter.

Combine canned fish or meat with spices and vegetables above, heat for 5 minutes, put aside cool for filling pies later.

Ingredients for 1Ib mince beef filling for pie

1-2 ladles of <u>Ghana basic tomato gravy</u> may be added to mincemeat & extra spices of choice e.g. chili powder, garlic, thyme and curry powder if needed. If not using the Ghana tomato gravy, you may use corn flour/starch with a little water to thicken.

Ingredients

- 1 Ib of Mince beef
- 1 teaspoon lemon juice
- 1 cup canned or cooked mixed vegetables
- 1 large onion (finely chopped)
- 1 teaspoon Chili powder (adjust to your taste)
- 1 teaspoon of Salt (to your taste)
- 1 teaspoon of Black pepper
- 2 teaspoonful Garlic powder
- 1 teaspoon black pepper
- 3 teaspoonful's of Thyme or mixed herbs
- 1 tablespoon of corn flour/starch mixed with a ¼ cup of water.

Process for filling

Add chopped onions and spices to Minced meat simmer until meat is cooked.
Add mixed vegetables and corn flour and water mixture - Use your judgment in regards to consistency of filling. Taste and adjust salt & pepper and seasoning to your taste.

Let it cool for filling pies later.

SNACKS & APPETIZERS

Side Dishes

SIDE DISHES

GHANA SALAD

It has same ingredients as regular tossed salad but canned salmon, baked beans, mixed veg and salad cream are added. Instead of canned fish you may replace with shredded roast chicken, (rotisserie), smoked chicken, or cooked shrimps. It is a rich and creamy salad made in Ghana.

Enjoy with Ghana tea bread, buns bread or whole wheat bread rolls or bread of your choice.
Makes a full bowl of 8 x 8 inch (20cm x 20cm)

Ingredients

- 1 Butter lettuce or green leafy lettuce
 Separated for garnishing around bowl
- 1 medium lettuce - shredded
- 1 small cucumber - Deseeded and sliced
- 1 small red onion- sliced
- 2 medium carrots - chopped or shredded
- 2 medium tomatoes - deseeded and sliced
- ½ a cup of cherry tomatoes (whole)
- 1 cup baked beans
- 1 cup canned Green beans
- 1 cup canned mixed vegetables
- 1 cup cooked chopped potatoes (optional)
- Black pepper, chili powder, & salt to your taste
- 4 boiled eggs (peeled and cut into wedges). *Cutting eggs into slices are boring....*
- 2 cups drained & deboned pink salmon, tuna, cooked prawns, or cooked chicken
- 1 lemon - squeeze over meat or fish of choice and season with salt & pepper to your taste
- Salad cream is usually used if not available use Ranch or Mayonnaise.
 Mayonnaise should be mixed with tinned evaporated milk and whisked in the absence of Salad cream.

SIDE DISHES

Process
- Slice up all ingredients *e.g. Lettuce, vegetables, carrots, cucumber, onions, tomatoes*
- Eggs - cut in wedges
- Onions- Slice and leave in vinegar with salt for 5 mins (If too acidic add some sugar to vinegar) *After removal of onions from vinegar, drain on kitchen paper*
- Drain water from all canned vegetables

Salad Bowl Preparation
- Wipe bowl with vinegar
- Garnish edge of bowl with separated Butter lettuce.
- Leave some regular tomatoes or cherry tomatoes, red onions, cucumber and eggs for garnishing.
- Layer base of bowl with shredded lettuce and distribute half of all ingredients, one at a time in the bowl to make a layer. Spice first layer with salt & pepper to your taste and finish first layer with your salad cream of choice.
- Repeat layering process of <u>all</u> your ingredients. Spice with salt and pepper to your taste.
- Garnish with ingredients put aside earlier. Top layer should look pretty with the tomatoes, eggs, red onions, cucumber. Drizzle salad cream of choice and sprinkle some chili powder on the egg wedges.

Seems like a lengthy process above but once you get started it gets easy and falls into place.

Ghana Salad- No Cream

OTHER SIMPLE SALADS
- Tossed salad with chopped pineapples and/or firm ripe mangoes or both
- Cole slaw with pineapples, mango or chopped apples.
- Season with black pepper, chili powder and salt or dressing of choice.

SIDE DISHES

OTO

Cooked Mashed Yam or Semi ripe plantain, with spicy red palm oil with eggs

Traditionally the Yam Oto is usually made in the morning for the celebrant on occasions like birthdays, engagements, and weddings. The Plantain Oto is usually eaten with peanuts. *Potatoes works very well too.*

Ingredients

- ½ a tuber of yam (Puna is the best) or 6 semi ripe plantains or 5 Ibs or 10 medium potatoes. *Makes 6 cups of mashed yam/semi ripe plantains or potatoes*
- ½ cup of Palm oil
- 1 small onion (sliced or chopped)
- ¼ teaspoon of chili powder (or to your taste)
- ¼ teaspoon of salt (or to your taste). Add salt to mashed carb directly otherwise it sits bottom of palm oil.
- 1 teaspoon of curry powder (optional)
- 4 boiled and peeled eggs

Process

- Peel and boil yam, plantains or potatoes and strain water
- Mash in Ka, or use pestle for Ka, or fork and mash in a bowl
- Heat palm oil in pan, fry onions, add rest of ingredients <u>except</u> salt pour palm oil over mashed carbohydrate and mixed together.
- Add salt directly to carbohydrate

Serving Oto

Traditionally it is served in a Ka and garnished with whole eggs.

To Mold Oto

You may use an ice cream scoop to make small balls or make a big mold.

Big Mold: Oil a bowl with palm oil, and fill with Oto mixture and press down on Oto to fit into bowl. Use a knife and run it along sides of bowl. Place a flat plate upside down of top of mold. Turn Oto onto a flat plate and reshape mold. *Garnish with boiled eggs.*

Oto with eggs

SIDE DISHES

PLANTAIN

GREEN PLANTAIN USES

Green plantain chips - Fried with just salt or spiced up. The green plantains can be shredded or shaved or cut into thin coin shapes and then fried or baked to a crisp.

RIPE PLANTAIN

Ripe Plantain: Fried, roasted or grilled can be eaten on its own, served as a side, or eaten with peanuts. Can be grilled at barbecues as a side. Can be eaten baked or fried and eaten with any of the Ghanaian stews or soups. e.g. chicken stew, palava sauce, light soup, peanut soup or palm nut soup.

Red Red: Is fried ripe plantain eaten with black eyed beans stew cooked with Palm oil or cooked black eyed beans drizzled with palm oil with a fried pepper relish eaten with or without gari.

Kelewele - Spicy fried ripe plantain spiced with at least ginger, chilies, onions and salt (cloves and guinea peppers are optional) cloves and guinea peppers have similar flavors so use either or. Kelewele is sold with peanuts at street corners or in kiosks all over Ghana in the evenings.

OVER RIPE PLANTAIN DISHES

Sometime Plantains overripe get soft and black. This is perfect for Tatale, Kaklo and Ablongo. The over ripe plantain are mashed or blended and spiced then fried as fritters, balls or baked in a tin.

PLANTAIN - FRIED

Ingredients
- Ripe firm plantain
- Salt to taste or Salt & pepper
- Oil for shallow or deep frying

Process
- Plantain - Wash and cut a line down the skin and peel.
- Cut whole plantain into slices of circular coin shapes or slice whole plantain into two vertically and cut into diagonal slices
- Season with salt or salt and pepper
- Heat oil in frying pan or fryer
- Fry until brown
- Eat as a side with any dish. *E.g. Rice & stew, or as a side with other meals*

KELEWELE

Spicy fried ripe plantain spiced with at least ginger, chilies, onions and salt (cloves or guinea peppers are optional) cloves and guinea peppers have a similar aroma and flavor so use either or.

A must: At least ginger, onions, chili & salt. (cloves or guinea peppers are optional)
You can use fresh or ground ingredients. I use ground ingredients for convenience.

Ingredients

- 2 Ripe medium plantains (Feels a little soft and getting black)
- ½ teaspoonful of ground dry ginger, onion, chili, and salt
- ½ teaspoon of cloves or guinea pepper (optional)
- Oil for shallow frying in frying pan
- Deep frying can work but if plaintain is too soft it soaks too much oil

Process

- Wash and peel. Cut a line down the skin and peel.
- Cut whole plantain into slices of circular coin shapes or slice whole plantain into two vertically.
- Cut the two halves diagonally about ½ an inch apart
- Spice with ginger, chilies, onion and salt
- Heat oil in frying pan; add spiced chopped plantain, once cooked and brown turn on the other side to brown. Once cooked and brown evenly remove and put on kitchen paper towel to cool.

Enjoy as a side or with peanuts.

Kelewele Ingredients

Kelewele Frying

Ready To Serve Kelewele With Peanuts

SIDE DISHES

A LITTLE OVERIPE PLANTAIN
But you don't feel like making Tatale? After spicing plantain be it with salt & pepper or for kelewele toss in flour and fry. It comes up crispy and very nice.

OVER-RIPE PLANTAIN DISHES for Tatale, Kaklo, Ablongo

TATALE - Over ripe spicy plantain fritters.

Sometime Plantains get forgotten when they are put away to ripe so they overripe get soft and black. That is perfect for Tatale. The over ripe plantain is mashed or blended and spiced with at least ginger, onions, chili & salt. (cloves or guinea peppers are optional)

Flour, Ma or tom brown are used to thicken mixture so it can be fried.

Shallow fry in a frying pan. Do a fry test to check if Tatale is firm enough when fried. If not add more thickener of choice above. Fry 1 Tablespoonful of mixture in frying pan and flatten. Repeat process. Eaten usually with bambara beans (Aboboi) as a meal. Sugar is usually added to the bambara beans before consumption. It is fondly called "Tatale ke Aboboi" Ke means "and" in Ga language.

TATALE

5 over ripe soft & black plantains = 3 + cups at least

Ingredients

- 3 cups of very soft plantain. (Blend with fresh onions and ginger if using)
- 1 ½ cups of flour (or thickener of choice mentioned earlier)
- 1 inch of ginger or 1 teaspoon of ground ginger
- 1 teaspoonful of cloves or guinea pepper
- 1 small onion finely chopped or blended or 1 teaspoon of ground onion
- ½ teaspoon of chili powder
- ¼ spoon of salt or to your taste
- Oil for shallow frying

Mixture with Red Onions & Spices

Tatale, Ablongo & Kaklo

SIDE DISHES

Process

- Mix all ingredients above, test fry a little piece if not firm enough add more flour or thicker of choice.
- 1 Tablespoonful of mixture in frying pan and flatten. Repeat process.
- When cooked and evenly brown on both sides, remove onto kitchen paper and drain oil.

KAKLO - Is the Tatale spicy mixture but made into balls and deep fried. Balls may need a little more thickener. Do a fry test first.

ABLONGO - Is the Tatale spicy mixture but baked in a tin. Bake at 350 F for 45min

Ablongo to be Baked

ABOBOI (Cooked Bambara Beans)

Eaten with fried plantain, tatale, kaklo, or Ablongo above.

Ingredients

- 2 cups Bambara beans (wash and soak overnight)
- 4-5 cups of water for cooking
- ½ teaspoon of chili powder
- ½ teaspoon of salt or to your taste
- 1 tablespoon of tomato paste
- 1 small onion (chopped)
- 2 tablespoons of sugar (add when beans are cooked)

Process

- Wash and soak beans overnight
- Rinse beans, add chopped onions and salt
- Add 4 cups of water to start, you may need 1 more cup of water later
- Simmer on medium heat for up to 2 hours or until soft
- Add chili powder and tomato paste when almost soft
- When soft mash about a quarter of beans to thicken
- Add 2 tablespoons of sugar before consuming.

Eaten usually with tatale and kaklo of course you can eat with fried plantains or Ablongo.

Bambara Beans

Tatale & Aboboi

SIDE DISHES

GARI FOTOR – MOIST GARI MIXED WITH TOMATO STEW

Gari is moistened with cold water, flaked and fluffed and a tomato gravy or stew is added.

Plain Gari Fotor - Gari mixed with Basic Ghana Tomato gravy.

A plain Gari fotor is usually a side dish for Waakye. The Gari fotor is sprinkled over waakye with the meat or fish stew. Boiled eggs on the side may be added.

Garnish with green vegetables, green peppers or leafy vegetables.

Gari Fotor

OTHER STEWS FOR GARI FOTOR – SEE STEW SECTION

- Eggs stew - Tomato based stew cooked with beaten eggs
- Corned beef stew with or without eggs
- Tuna or prawn stew
- Black Shetor - May be used to mix the moistened Gari and canned Sardines or Tuna flakes is added. Ideal for a quick meal.

GARI FOTOR

Ingredients

- 2 cups of Gari
- 2 tablespoons water sprinkled on Gari and flaked
- ½ cup of cooked mixed vegetables- green beans, peas and carrots
- 1 teaspoonful of curry powder (optional) for a spicier Fotor
- Add 2 ladles of Basic Ghana tomato gravy or any of the tomato based stews above.

Check seasoning and adjust to your taste

SIDE DISHES

MOI MOI
Skinned Black eye beans pureed with spices and then steamed. Mixed vegetables meat or boiled eggs may be added before steamed.

AKARA
Fried skinned black eyed beans donuts eaten in the mornings with Hausa koko or as an accompaniment to other porridges in Ghana.

Some of the spicy mixture for moi moi could be fried before tomato paste, mixed vegetables or meat or fish is added and that becomes Akara.

MOI MOI

Preparation
Traditionally steamed in Plantain or Banana leaves but any steaming moulds work.
- Blender
- 10-15 medium foil tins with lids for steaming beans mixture or make foil pockets.
- Make sure the edges are folded twice so mixture doesn't ooze out while steaming.
- Big pot to hold foil tins or foil pockets for steaming on a stove

Ingredients
- 4 cups of Black eyed beans must be soaked at least 5 hours or overnight and skin peeled off
- 3 cups of water for blending beans and onion
- 1 can corned beef or see optional additional protein options below.
- 1 large fresh onion (chopped)
- 1 teaspoon of ginger powder
- ½ a teaspoon of chili powder (adjust to your taste)
- 1 tablespoon of tomato paste
- 1 teaspoons of salt (adjust to your taste)
- 1 cup mixed vegetables (canned or roar)
- ½ a red bell pepper - chopped
- 1 cup vegetable oil, palm oil, or butter (palm oil will give it a reddish color)

You can choose to make a plain moi moi or have meat in it.
Protein to use is up to you. You can combine the protein.

SIDE DISHES

Moi moi

Below Are Suggestions:
- Canned corned beef, 1 cup ground shrimps or herring, 1 cup canned fish, or any shredded smoked fish, baked or steamed chicken, cooked shrimps, hard boiled eggs (peeled and cut in half or used whole) to put in center of Moi moi before steaming.

SIDE DISHES

Process
- Test beans to see if skin peels easily. Rub beans together to get skin off
- Place some of the skinned beans with some of chopped onions in blender and some of the 3 cups of water.
- Repeat process until you have pureed beans with onions
- Add rest of all other ingredients including meat of choice <u>except boiled eggs</u>. If using boiled eggs, add them after you have put the pureed mixture in the foil tin. It is so you don't get your boiled eggs mashed up in the mixture before they make it to the individual foil tins. Taste and adjust salt & pepper
- Get foil tins or foil pockets ready. Fill them ¾s full of the pureed spicy bean mixture.
- Add your boiled eggs if using them. Seal them tight, put them in the pot as you seal them.
- Fill the pot with the foil tins or pockets halfway. Add water almost to the level of the foil.
- Cover pot with a lid and put on medium heat.
- Steam for 45min – 1 hour
- You may need to top up pot with hot water later.
- Once cooked it is firm and soft to the touch

Moi moi may be eaten on its own or as a side.

Something different I love to eat sometimes:

Hummus with black & green olives, sliced red onions & tomatoes, handful of cherry tomatoes thrown into hummus and sprinkled with paprika. Eaten with tossed salad with vinaigrette and whole wheat pitta bread hot from the toaster. *Yummy!*

SIDE DISHES

Ghana Tomato Gravy

Fried Fish with Ghana Tomato Gravy

BASIC GHANA TOMATO GRAVY

The Basic Ghana Tomato Gravy is the base for our stews.

At least tomatoes, onions, chilies as the base and it is flavored with momoni (salted moist dried fish), Kobi (salted dried tilapia) dried shrimps, dried herring. Aromatic spices like ginger, cloves, guinea pepper, curry, nutmeg and herbs like basil & bay leaves are used as well.

The goal is to not use too many tomatoes. You want a good balance of tomatoes and onions. You do not want a too much Tomatoey sauce.

What to spice the Basic Ghana Tomato gravy with depends on what one is cooking. If cooking Jollof rice, corned beef stew, chicken stew or meat stews you generally do not add kobi, (salted dried tilapia) or momoni (salted moist fish) or ground shrimps or herrings. Some people add shrimps or herring to their meat stews or Jollof stews. So there are no hard rules sometimes.

If cooking all other Ghanaian stews then you may add momoni (salted dried moist fish), or kobi (salted dried Tilapia) or ground shrimps or herring for that pungent aromatic smell and flavor. Some of the onions may be sliced instead of all pureed.

BASIC GHANA TOMATO GRAVY RELISH

This relish is a reduced version of the gravy.

It is simmered with the lid off for a thicker fried sauce and a little more pepper and more spices are added to the gravy. The sauce is spooned over some fried fish or meat or as a side sauce with any of the prepared carbohydrates e.g. steamed rice, banku, kenkey, gari instant hot soakings (eba) and eaten with baked, or fried meat or fish, or canned fish or meat e.g. sardine, or corned beef. The Basic Ghana Tomato gravy relish may be spooned over kebabs too.

BASIC GHANA TOMATO GRAVY (Smooth)

Makes 1 liter of smooth tomato gravy

Ingredients

- 1 can 28oz or 3 cups crushed tomatoes or blended fresh tomatoes
- 1 tablespoonful of sugar (if using canned tomatoes)
- 2 large Onions (chopped)
- 2 bay leaves
- 2 cloves of garlic (optional)
- 1 Tablespoon of curry
- ½ -1 teaspoon of salt
- ½ - 1 teaspoon of chili powder or fresh pepper of choice
- 2 tablespoons of tomato paste
- 1 cup vegetable oil

Process

- Blend tomatoes with chopped onions
- Heat oil and pour in blended mixture of tomatoes & onion
- Add rest of ingredients in pot
- Cook on medium heat with half of lid on for 20 mins
- Reduce heat to a simmer for 5 mins.

Basic Ghana Tomato Gravy Relish

- Keep simmering for another 15 mins with half of lid on.
- You may add 1 teaspoon of ground nutmeg, curry powder and ginger for a spicier outcome
- Continue until you get a thick consistency
- Adjust salt & pepper to your taste

Chopped Onions & Tomatoes for Gravy

Ghana Tomato Gravy Bubbling In Pot

Ghana Tomato Gravy - In Progress

GHANA TOMATO GRAVY

Pepper Relishes

Omelet and Kenkey with Red & Black Shetor

PEPPER RELISHES

They are our condiments for our staples. A Popular staple is kenkey, fried or grilled fish with a relish of choice. Pepper relishes are known as Shetor in Ghana. Shetor means pepper in the Ga language. The pepper relish is freshly ground in a Ka or blender using at least tomatoes, onions, chilies & salt. Garlic & ginger are optional in addition to the basic ingredients above.

RED SHETOR

Made from red lady fingers chilies or red bonnet peppers, tomatoes, onions and salt.

GREEN SHETOR

Made from the kpakpo shetor (small round green chilies) or green bonnet peppers, red or green, tomatoes, onions & salt. Green tomatoes are a little bitter so you may have to add some sugar.

ABOM

When the above Shetor relishes are made in a Ka and an optional steamed momoni or kobi is added with steamed (malanga) coco yam leaves. Optional hot oil of choice may be added to the pepper relish. The Abom is eaten with grilled or steamed Kobi or fish or meat of choice including canned fish. The abom is eaten with carbohydrate of choice e.g. Steamed green or ripe plantains, yam, banku, kenkey or gari hot instant. (Eba)

Various Relishes

BLACK SHETOR

Fried pepper relish. Oil, tomatoes, onions, garlic (optional) ginger, dried chilies, shrimps or herring or both. This Black shetor is cooled and stored in clean dry jars in the fridge or taken to boarding schools. In Ghana Boarding schools are the norm. Children from 12-18 years old go to Boarding schools around the country. The Black Shetor is a must for boarding school chop boxes. Gari soakings and canned fish and black shetor is a favorite at Boarding schools. The Black Shetor relish goes well with fresh bread or toast, staple of your choice, e.g. fried plantain with any grilled meat, fried fish or canned fish or meat of your choice.

RED SHETOR

Ingredients
- 2 Tomatoes (ripe and chopped) or 1 cup of canned chopped or crushed tomatoes
- 2/3 Deseeded Red bonnet pepper or any red chilies of your choice or
- ½ -1 teaspoon of ground chili
- ½ medium onion
- 1 inch of fresh ginger or ½ teaspoon ground ginger
- Salt to your taste

Process
- Grind all ingredients in Ka or blender
- Grind until semi smooth or smooth
- Garnish with any of these choice: Chopped red or white onions, tomatoes, or avocado pear.

GREEN SHETOR

For a completely green effect use Green tomatoes but green tomatoes are a little bitter so you may have to add a little sugar.

Ingredients
- 10 Kpakpo shetor or green chilies of choice
- ½ medium onion
- 2 Ripe medium Tomatoes (chopped) or for a completely green effect use Green tomatoes
- 1 teaspoon of sugar (optional if using green tomatoes)
- 1 inch of fresh ginger or ½ teaspoon ground ginger
- Salt to your taste

Process
- Grind all ingredients in Ka or blender
- Grind until semi smooth or smooth
- Garnish with chopped red or white onions, tomatoes, or avocado pear.

Kpakpo Shetor In Progress in Ka

PEPPER RELISHES

Domedo with Ghana Tomato Gravy & Black Shetor with Kenkey

BLACK SHETOR

Fills at least a 30 oz. jar. Clean bottle suggestions. Bottle in sterilized dry jar by previously boiling jar in hot water or put washed bottles in oven at 350F for 30 minutes and cool. Empty washed out jars work too. Make sure you wash your hands and dry them out with a kitchen paper towel not used kitchen napkin otherwise your Black Shetor will go bad soon. Bottle and store in refrigerator for months.

Ingredients

- 1 cup ground chili powder (½ cup ground and ½ cup of crushed chilies may be used)
- 1 cup ground shrimp or herring
- Handful of dried whole shrimps, or bits of herring, thin slices of fried meat or beef jerky (optional)
- 2 medium onions (chopped)
- 14 ozs or 1 ½ cups Tomato paste
- 1 cup of water
- 2 Inches of fresh ginger or 2 Teaspoons of ground ginger
- 1 teaspoonful salt or to your taste
- 2 cups oil

PEPPER RELISHES

Process

Do not put pureed onions in the oil yet because it would splatter. I like to reduce the mixture down first.

- Blend onions & fresh ginger with the 1 cup of water until smooth
- Pour onion blend and add tomato puree in a pot, add salt
- Simmer on low heat with lid open as best as you can
- Reduce mixture until it is thick & sticking to bottom of pot
- Add oil. Once your mixture starts floating in the oil
- Add dry ingredients of ground shrimps or herring
- Add handful of dried whole shrimps, herring or cubed or slices of fried meat or beef jerky in sauce *(optional)*
- Add ground chilies spoonful at a time in case it's too hot for you.
- Do not cover pot completely- you want mixture to dry out
- Mixture starts turning brownish stir every few minutes
- Adjust heat & salt to your taste.
- Simmer for at least 30 mins or until you get a dark brownish black color
- Make sure it doesn't burn. Once done. Remove from heat, cool for few hours.
- Bottle and store in refrigerator for months.

Black Shetor Ingredients

PEPPER RELISHES

Kenkey (Fante) with Baked Chicken plantians& Black Shetor Relish

PEPPER RELISHES

Baked Fish or Fried

Baked Tilapia with Eba & Relishes

BAKED FISH OR FRIED

BAKED TILAPIA

Ingredients
Spices are for one fish so add more spice accordingly if using more fish.
- 1 Large Tilapia
- ½ a Lemon for squeezing juice into fish's gut and over fish
- 1 small onion (sliced for gut of fish if baking)
- ½ teaspoon of salt, ginger, nutmeg, chili powder, onion, garlic, curry powder
- Oil for baking or shallow frying
- Flour for coating fish if frying

Process
- Clean fish, remove gills
- Dry fish with kitchen paper
- If baking or frying make three slashes on each each side of fish

Baking
- Oil baking tray
- Add fish and squeeze lemon over fish & gut
- Mix salt and all the spices together
- Rub mixed spices in gut of fish, in slashes and on fish
- Fill gut with onions if baking.
- Bake at 350 F uncovered for 15-30 mins until cooked

Fried Fish & Kenkey

SHALLOW FRYING
- Heat oil on medium heat
- Fry fish uncoated or coat fish with flour
- Fry until crispy, remove and place on kitchen paper to drain excess oil

Something different I love to eat sometimes:
Baked fish in Peanut paste/butter sauce. After spicing fish, Mix ½ cup of Peanut paste/butter with 1 cup of water. Pour over fish or chicken and bake above. *Delicious!*

Baked Spicy Citrus Chicken

BAKED SPICY CITRUS CHICKEN

Ingredients
- 5 lbs chicken or 5 chicken quarters
- 1 medium orange or ½ cup of Orange juice (for squeezing over chicken)
- 1 teaspoon of Salt, chili, ginger, nutmeg, onion and garlic.
- 2 Teaspoons of cloves
- 1 medium red onion (sliced)
- Bell peppers (mixed) ¼ of green, yellow and red (sliced)

You can bake straightaway or marinade overnight in refrigerator and bake later in oven at 350F for up to 1 hr

Process
- Skin chicken. Don't wash with water yet.
- Pour copious amount of salt on chicken, rub on chicken to get rid of the mucous.
- Now wash with water, drain all water
- Poke tiny holes in flesh of chicken with a knife
- Squeeze orange juice over chicken
- Mix salt and spices together and rub on chicken
- Cover with foil or same size baking tray
- Bake at 350 F for an hour
- Add sliced onions and mixed bell peppers last 10 minutes of baking time.

Spicy Citrus Chicken to be Baked

For variety of baked chicken in a sauce:
- Bake chicken in Basic Ghana tomato gravy ingredients
- Add cooked Ghana Basic tomato gravy to chicken last 10 mins of baking time.
- Add barbecue sauce last 10 mins of baking time.
- Add sliced onions and mixed bell peppers to all 3 options last 10 mins of cooking time if preferred.

Eat with Jollof rice, kenkey or plain white rice.

Something different I love to eat sometimes:
Baked chicken in Peanut paste/butter sauce. After spicing chicken, Mix ½ cup of Peanut paste/butter with 1 cup of water. Pour over fish or chicken and bake above. *Delicious!*

Baked Spicy Pork

BAKED SPICY PORK

74

BAKED SPICY PORK (DOMEDO)

Domedo is sold at night markets in Accra. Osu night market in Accra does some fabulous Domedo, kenkey and kelewele.

Ingredients
- 2 Ibs of pork or 6 medium pork chops
- 1 small Lemon (squeeze juice over meat)
- 1 teaspoon chili
- 1 teaspoon salt
- ½ teaspoon of crushed pepper flakes
- 1 teaspoon of cloves, ginger, garlic
- 1 cup of water for baking meat.

Spiced Roast Pork Shoulder

Process
- Mix all spices together
- Squeeze the lemon juice on Pork chops
- Spice meat
- Turn meat once in lemon juice and spices
- Add the cup of water
- Bake at 350F covered with foil or baking pan same size for an hour

Eat with kenkey or Banku with Ghana tomato gravy and/or relish of choose.

Roast Pork Shoulder

Jollof Rice

JOLLOF RICE

Jollof rice is rice cooked in The Basic Ghana Smooth Tomato Gravy. Tomato paste is added as well to give it an even more bright pinkish color. Jollof rice is always a favorite dish because of its appetizing color. Use other vegetable oil not palm oil for Jollof rice.

Meat for Jollof

The meat for the Jollof rice may be baked on the side or it may be spiced and steamed in advance and the stock and meat is incorporated into the dish.
- 1 Can corned beef *(optional)* by itself in dish or in combination to baked meat
- 8-12 pieces of spiced steamed chicken or meat- leave a cup of stock to add to gravy later
- Roast meat or pork, rotisserie chicken, or individually baked chicken.
- Meat balls or Egg in the middle – See Appetizers and Snacks section

Ingredients

0.75 liters already made Ghana Basic Tomato Gravy or use recipe below from scratch
- 1 Can (14 ozs) tomatoes or 2 cups or 0.5 liters of crushed tomatoes or blended fresh tomatoes
- 1 tablespoon of sugar–if using canned tomatoes
- 2 medium onions (chopped)
- 3 cloves or garlic (optional)
- 2 tablespoons of Tomato paste
- 2 Bay leaves or handful of Basil (Emi in fante)
- ½ a teaspoon of salt
- ½ -1 teaspoon of chili powder or fresh pepper of choice
- 1 cup vegetable oil

For Jollof you need to add the extra ingredients below to your 0.75 liters already made Basic Ghana Tomato gravy, or add to your gravy from scratch.

Jollof with Plantains

Extra Ingredients for Jollof

- 2 Star Anise *(optional)*
- 1 tablespoon of curry *(optional)*
- 1 teaspoon of nutmeg
- 4 cups of long rice- To be added later to gravy
- 1 cup of stock from meat or chicken steamed earlier
- 2 cups of water (if you don't have stock use 3 cups of water)
- 2 cups of mixed veg of carrots, green peas and green bean. Frozen or canned.

Adjust Salt and pepper to your taste.

Process

- Blend tomatoes with onions and *(optional garlic)*
- Heat oil and pour in blended mixture of tomatoes and onions
- Add extra Jollof ingredients except rice
- Simmer for 15 mins with half of lid open
- Add 3 cups of boiling water total or water and stock
- Add 4 cups of long rice
- Place on low heat for 30 minutes.
- After 30 minutes stir, add corned beef or spiced steamed meat and mixed vegetables.
- Cover pot and check in 30 minutes if cooked
- Taste and adjust seasoning
- Should be cooked in 1- 1 ½ hours.

Jollof In Progress

Jollof In Progress

Jollof In Progress with Mixed Vegetables

JOLLOF RICE

Baking Jollof rice at 350 F for 1-1 ½ hours

- You can bake after you simmer the gravy for 15 mins. Pour gravy into baking dish add 4 cups or rice, 3 cups of water or water and stock. Bake in preheated oven at 350F for 30 minutes. After 30 minutes remove from oven, add your corned beef or steamed meat and mixed vegetables. Cover dish and bake for another 30 mins or until rice is soft. Adjust salt & pepper.

Serve with meat of choice, Ghana salad or tossed salad or steamed broccoli, cauliflower & carrots with fried plantains.

Jollof Served

JOLLOF RICE

Staples

Rice with Egg in the Middle Stew

STAPLES

BANKU BALLS

You will need Eta (traditional wooden spoon) or a strong regular wooden spoon to turn and knead mixture.

Ingredients

Equal part or Ma to water. Have hot water available for adding to mixture later

- 2 cups of Ma (fermented corn dough)
- 2 cups of water
- 1 teaspoon of salt or to your taste

Process

- Mix Ma with 1 cup of water in pot put on medium heat
- As it thickens knead against side of pot making sure there are no lumps in mixture
- Add 1 more cup of hot water around mixture
- Make large holes with wood spoon in mixture
- Cover mixture and let it simmer for 10 mins
- Flip mixture on other side cover and leave to simmer for another 10 mins
- Knead against side of pot cover for 10 mins.
- It should have formed into a thick pap consistency
- If too thick for you add a little hot water and keep covering pot and kneading
- Repeat step above until the rawness is gone and it tastes cooked.
- Wet a bowl with water and scoop some of it into the bowl. Turn edges of banku towards center and flip over, or wet a plate and roll the ball into balls or into a cylinder shape.

Eat with soup or stew of choice, or baked or fried fish with a relish.

Banku Close-up

GA KENKEY

(Komi means kenkey in the Ga language) Available abundantly throughout Ghana and African stores around the world. It is initially cooked like Banku but raw corn dough is added to it and then made into balls and cooked in corn husk leaves. If you don't have leaves use aluminum foil to wrap mixture then cook for 1hr – 1 ½ hours or cook in a pressure cooker for less time.

Ingredients

- 4 cups Ma (Corn dough) - Use 2 cups for Banku
- 2 cups Ma- for mixing with Banku later before it's made into a ball
- 3 corn husks - washed and separated
- Salt to your taste
- 1 cup water for mixing Banku and Ma later.
- Corn husks or Aluminum foil
- Use recipe for Banku.

Process

- When Banku is cooked remove from heat, place in a bowl and add the 2 cups Ma.
- Add 1 cup water, mix well together, taste and add more salt to your taste. The consistency should be very soft but not runny. Some of the water will evaporate when cooked.
- Open up moist corn husk leaves lay the corn leaves overlapping each other in your hand
- Scoop up about 1 cup and lay in leaves very close to the rounded edge of leaves. Keep overlapping leaves. When at end, twist the end of the corn husks around and put them in the middle of the kenkey ball. Reseal kenkey. It should feel tight but a bit soft.

Should make about 5- 6 balls in total

Arrange in pot cover with water up to Kenkey level and bring to boil and simmer for 1hr –1 ½ hours or until cooked. Pressure cooker will be less time.

STAPLES

FANTE KENKEY *(Dokunu means kenkey in the Fante language)*

Fante kenkey uses the same ingredients as Ga kenkey. Fante kenkey is wrapped in banana leaves or wrapped in fig leaves and cooked same way as Ga kenkey. If Fante kenkey is wrapped in fig leaves, it is called Akron kron Dokunu. It goes very well with "fante fante" stew.

STEAMED CARBOHYDRATES

Any of our carbohydrates are steamed with salt and eaten with grilled fried fish or meat with a relish or any stew or soup of choice.

FUFU

Traditionally steamed and pounded Cassava (yucca), Cocoyam (malanga), Yam, or Green plantain in a mortar and pestle until sticky and mouled into a ball.

Pre packed dry fufu mixes: Cooked like Banku but has Fufu consistency. It is available in African and Caribbean shops around the world. Follow instructions on box or generally 1 cup of fufu mix to ¾ of water to start off with. Heat and knead at side of pan, add a little water as necessary cover and leave to simmer, knead again, keep simmering and kneading until cooked and you get a good firm sticky consistency.

Wet a bowl with water all around scoop some fufu in it and mold using your wooden. Flip over.

Fufu is eaten with soups e.g. light soup, palm nut soup, and peanut soup.

It is not eaten with stews in Ghana.

Fufu in Ka

STAPLES

KOKONTE

(Fondly called Lapiiwa) Cassava (yucca) is cut up and dried in the sun until dry then taken to the mill to be ground. When ground it is a light brown powder and it is cooked like Banku but the consistency is like Fufu. It is eaten with soups e.g. light soup, peanut soup or palm nut soup.

Ingredients
- 1 cup of Kokonte powder
- ¾ cup of water to start
- ½ cup of hot water as necessary later
- Salt to your taste

Process
- Mix Kokonte powder and water together
- Place pot on medium heat
- Stir as it thickens and knead
- Add ½ cup of hot water if necessary
- Heat and knead at side of pan, add a little water as necessary cover and leave to simmer, knead again, keep simmering and kneading until cooked and you get a good firm sticky consistency Wet a bowl with water all around scoop cooked Kokonte into it and mold and flip over.

Serve with soup of choice.

RICE- PLAIN STEAMED RICE

Ratio of rice to water is always 1: 1-1½ depending on rice. You can fry some chopped onions in oil before adding the rice and water.

You may cook white rice with lemon slices and thyme or bay leaves and cloves.

STAPLES

Ingredients
- 1 cup rice
- 1- 1½ cups water – start with 1 cup
- 1 small chopped onion *(optional)*
- 1 tablespoon of vegetable oil *(optional)*
- 1-2 Bay leaves *(optional)*
- Salt to your taste

Process
- Wash rice add water and salt
- Place on medium heat
- Simmer for 15-20 mins or until soft & fluffy.

Coloring your rice yellow
- Curry or yellow food coloring
- Additional bay leaves or thyme and cloves may be added.

Suggestions for garnishing your steamed rice.
- Fried sliced onions
- Fried sliced onions with mixed vegetables
- Fried sliced onions with mixed bell peppers
- Fried sliced onions and cherry tomatoes
- Shredded carrots and spinach

Rice Molds Garnished with Vegetables

STAPLES

OMO TOWO - RICE BALLS

Needs more water than steamed rice. You will knead it with a wooden spoon once cooked.

Ingredients
- 1 cup of rice
- 2 cups of water
- Salt to your taste

Process
- Wash rice add water and salt
- Place on medium heat
- Once cooked & soft knead with a wooden spoon against pot.
- Scoop into balls, or toss in a deep wet bowl to create a ball.
- Popularly eaten with palm nut soup and called <u>Towo safi</u>. Name originates from the Hausa's in Northern Ghana. *You can eat with any soup or stew of choice.*

Omo Towo

WAAKYE

Rice & black eyed beans cooked with millet leaves. Leaves are known as waakye leaves.
If you cannot obtain millet leaves you can use browning sauce.

Ingredients
- 2 cups soaked black eyed beans or 2 cups canned black eyed beans
- 1-2 millet leaves
- 2 cups of rice
- 2 cups waters
- Salt to your taste
- 1 teaspoon of browning sauce *(optional if no waakye leaves available)*

Waakye Gari Foto & Egg

STAPLES

Process
- Add rice to almost soft black eyed beans cooked with millet leaves.
- If using canned black eyed beans add the millet leaves to the rice and water
- If no millet leaves is available use browning sauce.
- If millet leaves or browning sauce is not available you can cook your rice and beans without millet leaves or browning sauce. It just means your rice will not be too brown.
- Add water
- Salt to your taste.
- Put on medium heat when it boils lower heat and simmer for 20-30 mins or until soft.
- Eat with meat or chicken stew with optional black shetor, plain gari fotor and boiled eggs.

GARI HOT INSTANT

Gari soaked in hot water for few minutes

Ingredients
- 1 cup of Gari
- 3 cups of hot water
- Salt to taste
- Table knife for holding off Gari in bowl
- Padded coaster for holding bowl

Process
- Pour the hot water in a bowl
- Add salt to your taste
- Stir water and add Gari
- Immediately use padded coaster to hold bowl & pour off hot water while holding knife against Gari. Let it stand for a minute or two. You can scoop into small balls, make a big ball or eat from bowl.

Eat with grilled or fried fish with a relish of choice or any soup or stew.

Stews

STEWS

The Basic Ghana Tomato gravy (smooth) is the base of all the stews in the cookbook. *You may use any of the oils of your choice i.e. vegetable oil or palm nut oil (red oil)*

If you are making chicken stew or meat stew you have to jazz up the gravy with nutmeg, curry powder, optional star anise, and more salt or pepper to your taste.

If cooking all other Ghanaian stews you usually use an assortment of meat. e.g. Okra, Kontonmire (cocoyam leaves) or Spinach with Agushi, or Agushi only stews. You also add momoni (salted moist dried fish), Kobi (salted dried Tilapia) or shrimps or herring for that pungent aromatic smell and flavor of African cooking.

BASIC GHANA TOMATO GRAVY (SMOOTH)

This makes 1 liter of smooth tomato gravy

Ingredients

- 1 Can 28 oz or 3 cups of crushed tomatoes or blended fresh tomatoes
- 1 table spoonful of sugar if using canned tomatoes
- 2 large onions *(chopped)*
- 2 cloves of garlic *(optional)*
- 2 Bay leaves
- ½ a teaspoon of salt
- 1 tablespoon of curry *(optional)*
- ½ - 1 teaspoon of chili powder or fresh pepper of choice
- 1 cup vegetable oil

Process

- Blend tomatoes with chopped onions
- Heat oil and pour in blended mixture of tomatoes and onion
- Put rest of ingredients in pot
- Simmer on medium heat for 20 mins with half of lid on
- Reduce to low heat for 5 mins to bring the oil to the surface if you prefer.

You can incorporate plain fried fish, or flour coated fried fish or cooked meats into your Basic Ghana Tomato Gravy (smooth) or turn it into a brown stew.

MEAT OR FISH STEWS

- 1 whole chopped Rotisserie chicken or equivalent of spice steamed chicken or beef.
- 6 Medium pieces of plain or flour coated fried fish
- Meat balls or Egg in the middle meat balls. Use meat balls recipe from Appetizers & Snacks.

Incorporate 1 liter Basic Ghana Tomato gravy with meat or fish above.

- Extra spices
- 1 teaspoon or nutmeg
- 2 star Anise
- 1 tablespoon of curry
- 1 medium onion and 2 medium carrots (sliced)
- Simmer for 15 minutes

Eat with staple of your choice. eg. Kenkey, Rice, Gari, any steamed Carbs

Chicken Stew

BROWN STEW

If starting from scratch Brown 2 tablespoons of flour in oil before adding the blended mix of tomatoes & onions for Basic Ghana Tomato gravy (smooth)
Add the "extra spices" and simmer for 10 minutes.
Add steamed or cooked meat above. Add freshly sliced onions and carrots. You need to add ½ -1 cup of stock or water to thin out the sauce to your taste.
Simmer meat or fish of choice with stew for 10 minutes and serve.

You can brown the flour separately in a little oil and pour into an already prepared Basic Ghana Tomato Gravy. Follow steps above.

Eat with staple of your choice. e.g. Kenkey, Rice, Gari, any steamed Carbohydrate.

Pork Chops Brown Stew with Onions & Bell Peppers

STEWS

CORNED BEEF, CANNED FISH OR KOBI STEW WITH EGGS

Ingredients

- ½ a liter of Basic Ghana Tomato gravy
- Add more pepper to your taste
- 2 Eggs (beaten)
- ½ teaspoon of nutmeg
- 1 teaspoon curry powder
- 1 can corned Beef 12 ozs/ 340 grams *(usually a bit salty)*
- Or 14 ozs of canned Salmon or Mackerel
- Or 2 medium kobi washed and steamed. Debone your fish and flake into big chunks

Process

- Beat eggs, pour into gravy as it cooks turn few times until almost cooked
- Add canned corned beef or deboned canned fish, or kobi chunks
- If using corned beef, break up corned beef gently into stew *or*
- Slice up corned beef into 4 slices and incorporate gently into the gravy & egg stew.
- Spoon over some stew & eggs over corned beef
- Adjust pepper & salt to your taste
- Simmer for 5 mins

Eat with puna yam, rice or any staple of choice with vegetables.

Corned Beef Stew

Corned Beef Stew with Rice & Plantain & Vegetables

Beans Stew with Plantain & Palm Oil aka Red Red

BEANS STEW

Usually eaten with fried plantain. Fondly known as <u>red red</u>.

Ingredients
- 1 cup Basic Ghana Tomato gravy
- 1 cup canned fish of choice – e.g. tuna, salmon, mackerel or smoked fish.
- 2 cups cooked black eyed beans or canned
- 1 cup of palm oil

Process
- Heat oil palm oil
- Pour gravy and beans into oil
- Adjust chili and salt to your taste
- Simmer for 10 mins until ready

May be eaten with rice and plantains or any staple apart from fufu and kokonte.

STEWS

OKRA STEW OR OKRO & GARDEN EGGS OR OKRA & AUBERGINE STEW

Okras only may be cooked in the Basic Ghana Tomato gravy or combined with garden eggs. *In the absence of Garden eggs, Aubergine (eggplant) may be used.*

Our traditional stews are usually made with an assortment of meat e.g. beef, pigs trotters, or cow's foot, canned or smoked fish, snails, and crabs. You can just use one type of meat if you prefer e.g. steamed beef, chicken, or pork chops. You can use exclusively just fish e.g. tilapia, or snapper.

Ingredients

- 30 fresh Okras *(chopped finely)* or 30 ozs frozen cut okra - Okra stew only
- 20 Okras & 10 garden eggs - *(chopped finely)* - Okra stew & garden eggs
- 20 Okras & 2 medium aubergine plant – Aubergine must be peeled
- 1 liter Basic Ghana Tomato gravy cooked with vegetable or Palm oil
- 1 cup extra oil of vegetable or Palm oil
- 1 teaspoon of chili powder or to your taste
- 10 pieces of spiced steamed meat or Chicken (28 ozs or 3 cups) of canned fish
- 1 cup of fish/meat stock or water.

OR

Assortment of meat and fish below:

- 10 pieces of beef
- 4 pig's trotters
- 4 snails *(optional)* steam separately so you can remove shell
- 1 Lemon - Juice for steaming assorted meat & snails
- Spices - lemon juice, ginger, chili, & salt
- 2 cups or 14 ozs canned fish of choice e.g. tuna, salmon, mackerel or smoked
- 1 pack of smoked peppered mackerel or kippers can work too
- 4 Blue crabs or 2 large crabs *(steam lightly so it can be cleaned)*
- 1 medium piece of washed momoni, or medium kobi *(salt must be washed out of kobi)* and OR 3 Tablespoons ground shrimp or herring.

Okro Stew & Banku with Plantains

STEWS

Process
- Wash your meat, steam meat & snails with the lemon juice, ginger, chili, & salt
- Leave 1 cup of stock from steaming meat to be added to stew later.
- Heat Palm oil or Vegetable oil in pot
- Add 1liter of Basic Ghana Tomato gravy (smooth)
- Add washed momoni or kobi if using
- Add the 3 tablespoons of ground shrimps or herring
- Add crabs, Simmer for 5 mins remove crabs and set aside
- Add your cooked meat of choice, smoked fish, and snails if using.
- Add chopped okra or the okra & garden eggs or aubergine
- Add the 1 cup of fish or meat stock or water
- Simmer for 20 mins until okras and aubergines are reduced and cooked
- Add crabs set aside previously.
- Adjust salt & pepper to your taste

Eat with staple of choice

PALAVA SAUCE

Kontonmire (Cocoyam or Malanga leaves) or Spinach with Agushi (dried white melon seeds) The Agushi gives the green leaves a contrast.

Ingredients
- 1 liter Basic Ghana Tomato gravy cooked with vegetable oil or Palm oil
- 1 Cup extra oil of vegetable or Palm oil
- 1 teaspoon of chili powder or to your taste
- 10 pieces of steamed and spiced meat or chicken or 28 ozs (3-4 cups) canned fish.
- 3 Tablespoons ground shrimp or ground herring
- 1 Cup of stock or water
- You may use assorted meat and fish: *See Okra stew*
- 30 ozs of chopped Kontomire leaves or fresh spinach or frozen spinach *(if frozen thaw and squeeze out water*
- 2 cups of ground Agushi

In absence of Agushi you can use:
- 2 beaten Eggs or
- 2 cups of goat cheese

STEWS

Bolied Staples (Carbs)

Close-up of Palava Sauce with Agushi

Gari with Palava Sauce

Process
- Heat Palm oil or Vegetable oil in pot
- Add 1 liter of Basic Ghana Tomato gravy (smooth)
- Add washed momoni or kobi if using
- Add the 3 tablespoons of ground shrimps or herring
- Add steamed meat of choice, steam for 5 mins
- Add Agushi and spinach (Add the cup of water or stock)
- Simmer for 20 mins until reduced and cooked
- Adjust salt & pepper to your taste
- Simmer for 5 mins

Serve with staple of choice

AGUSHI STEW

Ingredients
- 1liter Basic Ghana Tomato gravy cooked with vegetable or Palm oil
- 1 cup extra oil of vegetable or Palm oil
- 1 teaspoon of chili powder or to your taste

You may use assorted meat and fish & crab see Okra stew or
- 10 pieces of steamed and spiced meat or chicken or
- 28 ozs of canned fish or 3 medium Kobi washed and steamed and flaked
- Leave 1 cup of stock from steaming meat or Kobi
- 3 Tablespoons ground shrimp or ground herring
- 4 cups of ground Agushi
- 4 cups total of stock and water

STEWS

Process
- Heat Palm oil or Vegetable oil in pot
- Add 1liter of Basic Ghana Tomato gravy (smooth)
- Add washed momoni or kobi if using
- Add steamed meat or Kobi
- Add the 3 tablespoons of ground shrimps or herring
- Add Agushi
- Add 4 cups of water and stock
- Simmer for 20 mins
- Adjust salt & pepper to your taste

Eat with Banku, Rice, Omo towo or Gari hot instant

FANTE FANTE STEW

Fresh Fish cooked in palm oil Tomato stew. Invented by the Fante's hence its name.

Ingredients
- 6 cleaned Snapper, Tilapia or fish of choice with gills removed. Cut into 2 or 3
- 1 Lemon or 2 tablespoon of lemon juice for fish
- 1 can 28 oz or 3 cups of crushed tomatoes or blended fresh tomatoes
- 2 medium onions *(chopped)*
- 2 cloves of garlic *(optional)*
- 2 inches of fresh ginger or 2 teaspoons of ground ginger
- ½ a teaspoon of salt or to your taste
- 1 teaspoon of chili powder or fresh pepper of choice
- 1cup palm oil

Process
- Spice fish with at least salt & pepper
- Squeeze lemon juice over fish
- Blend all ingredients
- Heat palm oil
- Pour tomatoes blend into pot
- Add spiced fresh fish
- Simmer gently until cooked
- Adjust salt & pepper

Eat with rice or kenkey of choice or Banku

Agushi Stew with Boiled Cassava

STEWS

Soups

Chicken Light Soup with Vegetables

SOUPS

Tomatoes, onions and chilies are the base of our soups. You may cook chopped Cassava (yucca) Green plantain, Cocoyam (malanga) or Yam in any of the soups last 10 mins of cooking instead of eating soup separately with your staple of choice.

<u>**(NKRAKRA (Fante for Light soup)**</u>

CHICKEN LIGHT SOUP

Ingredients

- 5lbs or 10-12 pieces of chicken
- ½ a Lemon squeezed over chicken
- 14 ozs or 2 cups crushed tomatoes
- 2 Tablespoons tomato paste
- 2 large onions
 (½ chopped onion for steaming meat)
- 1 inch peeled ginger *(chopped in 4 pieces)*
- 2 Bay leaves or handful of fresh Basil leaves
- 1 teaspoon chili powder
- 2 teaspoon of salt
- 3 cups of water for steaming chicken
- 1-1.5 liters of hot water depending on how thick or light you want your soup
- Adjust salt & pepper to your taste
- Vegetables *(optional)*
- 10 mushroom, 1 cup chopped carrot,
- 1 cup of chopped aubergine, 8 whole okras or chopped

Process

- Spice chicken with salt & chili, and ½ of 1 onion.
- Add 3 cups of water and all ingredients except tomatoes & 1 ½ onions.
- Steam for 15 mins
- Blend tomatoes and rest of onions
- Pour over chicken
- Add 1- 1.5 liters of hot water
- Simmer for 30 minutes or until cooked
- Adjust pepper & salt to your taste
- Vegetables – Cook in a different pot with some of soup or cook in soup
- If cooking in soup, add vegetables last 10 minutes of cooking. You can remove cooked vegetables from soup when cooked and serve on fufu while dishing out food.
- You can remove chunks of ginger or leave them in soup

Eat with fufu omo towo, & gari or kenkey

APONKYE NKRAKRA (GOAT MEAT LIGHT SOUP)

Ingredients

- 5 Ibs of chopped goat meat or 15 pieces of chopped goat meat
- 14 ozs or 2 cups crushed tomatoes
- 2 Tablespoons tomato paste
- 2 large onions
- 1 liter of water for steaming goat meat
- 1Inch peeled ginger *(chopped in 4 pieces)*
- Chilies & salt to your taste
- Vegetables *(optional)*
- 10 mushroom, 1 cup chopped carrot
- 1 cup of chopped aubergine,
- 8 whole okras or chopped

Process

- Spice goat meat with ginger, salt and chilies
- Add 1 liter of water
- Steam for 45 mins or almost soft
- Blend tomatoes and onions pour over goat meat
- Add 1-1.5 liters of hot water depending on how thick or light you want your soup
- Simmer for 30 minutes or until cooked
- Adjust pepper & salt to your taste
- Vegetables – Cook in a different pot with some of soup or cook in soup
- If cooking vegetables in soup, add last 10 minutes of cooking. You can remove cooked vegetables from soup when cooked and serve on fufu while dishing out food.
- You can remove chunks of ginger or leave them in soup
- Adjust salt & pepper to your taste

Usually eaten with fufu but you can have with any staple of choice

Fufu & Light Soup with Assorted Meat, Crab & Vegetables

LIGHT SOUP WITH ASSORTED MEAT, FISH & CRAB

Ground shrimps or herring is added if assorted meat, fish & crab is used for soups.

Ingredients

- 12 pieces of beef
- 6 pig's trotters
- 6 medium snails *(steamed removed from shell and cleaned)*
- 3 Tablespoons of ground shrimps or herring
- 14 ozs canned fish, e.g. mackerel, or salmon or 2 medium smoked fish
- 4 live Blue crabs or 2 local Ghana crabs *(steam lightly and clean)* or frozen crabs
- 14 ozs or 2 cups crushed tomatoes
- 2 Tablespoons tomato paste
- 2 large onions
- 1 small lemon
- 1 inch peeled ginger *(chopped in 4 pieces)*
- Chilies & salt to your taste
- Vegetables *(optional)*
- 10 mushroom, 1 cup chopped carrot
- 1 cup of chopped aubergine
- 8 whole okras or chopped

SOUPS

SOUPS

Process

- Steam your meat & pig trotters with the spices & lemon juice until almost soft.
- Add blended tomatoes and onions:
- Add 1-1.5 liters of hot water depending on how thick or light you want your soup
- Add ground shrimps or herring
- Simmer for 30 minutes
- Last 10 mins - Add steamed crabs, canned fish or smoked fish
- Vegetables – Cook in a different pot with some of soup or cook in soup
- If cooking vegetables in soup, add last 10 minutes of cooking. You can remove cooked vegetables from soup when cooked and serve on fufu while dishing out food.
- You can remove chunks of ginger or leave them in soup
- Adjust salt & pepper to your taste

Eat with fufu, omo towo, gari or kenkey

NKATE NKWAN (PEANUT PASTE/BUTTER SOUP)

Ingredients

- 5 Ibs or 10-12 pieces of chicken or assorted meat & fish as for light soup
- 2 cups of groundnut paste or peanut butter
- 14 ozs or 2 cups crushed tomatoes
- 1 inch peeled ginger *(chopped in 4 pieces)*
- 2 tablespoon Tomato paste
- 2 large onions
- 2 Bay leaves
- 3 cups water for steaming
- Chilies & salt to your taste
- 3 Tablespoons of ground shrimps or herring *(if cooking assorted meat & fish)*
- Vegetables *(optional)*
- 10 mushroom, 1 cup chopped carrot
- 1 cup of chopped aubergine
- 8 whole okras or chopped

SOUPS

Process

- Spice chicken with salt, chili and ginger
- Add 3 cups water
- Steam chicken for 15 mins
- Blend tomatoes and onions and peanut paste/butter
- Pour over chicken
- Add 1-1.5 liters of hot water depending on how thick or light you want your soup
- Simmer for 30 minutes with half of lid on, stir. Watch pot so it doesn't overflow.
- Adjust pepper & salt to your taste
- Vegetables – Cook in a different pot with some of soup or cook in soup
- If cooking vegetables in soup, add last 10 minutes of cooking. You can remove cooked vegetables from soup when cooked and serve on fufu while dishing out food.
- Remove chunks of ginger.
- Adjust salt & pepper to your taste

Eat with Kokonte or fufu or any staple of choice

Palm Nut Soup with Banku in Ka

SOUPS

ABENKWAN (PALM NUT SOUP)

Ingredients

- 5 Ibs or 10-12 pieces of chicken *(or assorted meat & fish as for light soup follow recipe)*
- 1 can 28 ozs Palm nut cream
- 14 ozs or 2 cups crushed tomatoes
- 1 inch peeled ginger *(chopped in 4 pieces)*
- 2 tablespoon Tomato paste
- 2 large onions
- 3 cups water for steaming
- Chilies & salt to your taste
- 3 Tablespoons of ground shrimps or herring *(if cooking assorted meat & fish)*
- Vegetables *(optional)*
- 10 mushroom, 1 cup chopped carrot
- 1 cup of chopped aubergine
- 8 whole okras or chopped

Process

- Spice chicken with salt, chili and ginger
- Add 3 cups water
- Steam chicken for 15 mins
- Blend tomatoes and onions, pour over chicken or assorted meat & fish
- Add 1 can 28 ozs Palm nut cream to pot
- Add 1-1.5 liters of hot water depending on how thick or light you want your soup
- Simmer for 30 minutes with half of lid on. Watch pot so it doesn't overflow.
- Adjust pepper & salt to your taste
- Vegetables – Cook in a different pot with some of soup or cook in soup
- If cooking vegetables in soup, add last 10 minutes of cooking. You can remove cooked vegetables from soup when cooked and serve on fufu while dishing out food.
- You can remove chunks of ginger or leave them in soup
- Adjust salt & pepper to your taste

Eat with fufu, kokonte or rice. Add fried ripe plantains, or baked ripe plantains.

SOUPS

Aprapransa

APRAPRANSA (FANTE) AKPLIDZI (GA)

Palm nut soup mixed with Black eyed beans and Tom brown.

Ingredients

- 2 cups of Palm nut soup
- 2 cups of Tom brown
- 1 cup of cooked or canned black eyed beans
- 1 Tablespoon of ground shrimps or herring
- 1-2 cups of hot water
- Adjust salt & pepper to your taste

Process

- Heat palmnut soup, beans and ground shrimps or herring
- Add Tom brown; stir it into palm nut soup until mixed well with soup
- Add 1-2 cups hot water if needed for softer consistency
- Heat for up to 10 mins.

Serving suggestions

You may dish out as is or make into a mold

To make into a mold

Wet a bowl or preferred mold with palm nut soup put the Aprepensa in mold, press it into the mold to take shape of bowl or mold. Use a table knife to go round Aprepensa in mold to free it for easy removal. Cover bowl or mold with flat plate, tip over mold onto plate to reveal Aprapransa mold. Tidy mold up so it is even all around.

Garnish with some of soup, crab and meat from main soup.

Palm Nut Soup

Palm Nut Fruit

Aprapransa

APRAPRANSA

Desserts

DESSERTS
108

DESSERTS

KOBE CAKE (SHREDDED COCONUT IN CARAMELIZED SUGAR)

Makes 10

Ingredients

- 2 cups shredded coconut *(unsweetened or sweetened)*
- 1 cup of brown sugar *(at least)*
- ½ cup of water
- 10 whole cherries
- 10 cocktail sticks *(optional)*

Line baking try with wax paper or spray baking tray with oil in readiness for caramelized shredded coconut.

Process

- Add brown sugar and water
- Heat pan until contents are dissolved and caramelized and dark brown.
- Caramelized sugar gets very hot. Please do not put some in your hand to taste. Drop some on the wax paper instead, let it cool before tasting.

Kobe Cake with Cherries

- Sprinkle shredded coconut in caramelized sugar and mix the two well until both are covered
- Using tablespoon scoop up the caramelized coconut and make heaps of a reasonable amount and make a dent in middle for cherries.
- Prick cherries through caramelized coconut until almost touching bottom of tray.

NKATE CAKE (PEANUT BRITTLE)

Whole or crushed peanuts in Caramelized sugar. *(No recipe)*

TROPICAL FRUITS & COCONUT PIE

(Papaya, mango, and pineapple & shredded coconut) you may mix fresh fruits and canned fruits.

You will need 2 x 9 Inches *(deep)* frozen pie cases or use pie crust pastry recipe for meat pie. Roll pasty and line a 9 inch baking pan with the pastry. You can cover pie with a crumble instead of making it a pie. *See recipe for crumble below*

Ingredients
- 2 cups of chopped ripe papaya
- 2 cups of chopped ripe mango
- 2 cups of chopped pineapple
- 1 cup of shredded coconut
- ½ cup of sugar
- ½ teaspoon of nutmeg
- ½ teaspoon of cinnamon

Process
- Thaw 1 pie case beforehand
- Mix nutmeg and cinnamon with sugar
- Fill frozen pie case with the fruits and coconut flakes
- Add the sugar mixed with nutmeg and cinnamon
- Pull & cover fruits with 2nd thawed pie case *(leave a little pastry for decorating pie)* and pinch edges of both cases shut.
- Use the extra pastry left and cut out some designs for your pie or hand make a design like I did in the picture.
- Poke holes in top layer so heat can escape otherwise juices will ooze out
- Bake at 370 for 45 min – 1 hr

Tropical Fruit Pie

For crumble

- 1 cup of flour
- 2 cups of oats
- ½ cup of sugar
- ½ cup of vegetable spread or oil
- ½ teaspoon of nutmeg
- ½ teaspoon of cinnamon
- Mix it all up until crumbly and cover your fruits with crumble.
- Bake at 370 for 1 hr.

Serve with whipped cream or ice cream

Baked Fruit Pie

Tropical Fruit Pie with Shredded Coconut

DESSERTS

CASSAVA PUDDING

Fits into 2 oiled baking tins of 3 ins x 8 ins

Ingredients
- 3 cups of grated Cassava
- ¼ cup of vegetable spread
- ½ cup of sugar
- 1 egg
- ½ teaspoon of baking powder
- ½ cup of raisins
- ½ teaspoon of nutmeg
- ½ teaspoon of cinnamon
- Pinch of salt or to your taste

Process
- Mix above ingredients together
- Pour in 2 oiled baking tins of 3ins x 8 ins
- Bake in preheated oven at 350F for 45 mins – 1hr

Serve with shredded coconuts.

Cassava pudding with raisins

GARI AND COCONUT PUDDING

Fits into 2 oiled baking tins of 3x8 ins and 5 muffin tins

Ingredients
- 2 cups of Gari
- 3 cups of water
- 2 cups of shredded coconut
- ½ cup of vegetable spread
- ½ cup of sugar
- 2 eggs *(beat and put aside)*
- 1 teaspoon of baking powder
- ½ cup of raisins
- ½ teaspoon of nutmeg
- ½ teaspoon of cinnamon
- Pinch of salt or to your taste

Process
- Put gari in a bowl add the water stir and leave for 10 mins for gari to absorb water.
- Except the beaten eggs - Mix all the above ingredients together
- Taste and adjust if necessary then add your eggs
- It will feel thick and moist but not creamy or runny
- Fill your oiled 2 tins and the muffin tins above
- Bake in preheated oven at 350 F for 45 mins - 1hr

Serve with shredded coconut

Gari and coconut pudding

DESSERTS

BANANA AND RICE BREAD

It fits perfectly into 2 oiled baking tins of 3 ins x 8 ins

Ingredients
- 6 large Ripe Bananas = 3 cups of of pureed Banana– *(at least)*
- 3 cups of pureed bananas
- 1 cup of rice flour
- ½ teaspoon of nutmeg
- ¼ cup of vegetable spread
- ¼ cup of sugar
- ½ teaspoon of baking powder
- Pinch of salt or to your taste

Process
- Puree bananas in blender
- Add rest of ingredients
- Pour in 2 oiled baking tins of 3 ins x 8 ins
- Bake in 350F oven for 45 mins - 1hr
- Serve with ice cream, nuts or almond flakes.

Banana & Rice Bread with Ice Cream & Almonds

TIGER NUTS (ATADWE) MILK DRINK

You would need a blender and muslin cloth, or ¼ meter of cotton cloth or a new pair of knee highs/ pop socks for straining the milk out of the blended tiger nuts.

Ingredients
- 4 cups Tiger nuts *(previously washed & soaked overnight)*
- 4 cups of water for blending
- ½ cup of sugar
- ¼ teaspoon of nutmeg

Tiger Nuts & Milk

DESSERTS

Process
- Blend the tiger nuts in blender with water and strain and boil for 5 mins.
- You may add sugar or nutmeg, or drink it natural.
- Drink hot or cold.

TIGER NUTS CUSTARD - *ATADWE MILKYE*

Ingredients
- 4 cups Tiger nuts *(previously washed & soaked overnight)*
- 4 cups of water for blending
- ½ cup of sugar
- ¼ teaspoon of nutmeg
- A pinch of salt
- 2 Heaped Tablespoons of corn flour/starch

Process
- Blend the tiger nuts in blender with water and strain into pot
- Add sugar and nutmeg
- Add corn starch/flour
- Heat on medium heat until it thickens
- Taste and adjust sweetness to your taste
- Pour into small nice molds
- Eat hot or cool molds for refrigeration later
- Eat cold molds with cream and garnish with a mint leaf or two.

Tiger Nuts Custard (Plain)

Tiger Nuts Custard with Cream & Mint Leaf

DESSERTS

DARKUA

Spicy peanut nibble rolled in crushed peanuts.

Ingredients

- 1 cup smooth peanut paste/peanut butter
- ¼ cup of sugar
- ½ teaspoon of nutmeg
- ½ teaspoon of chili or to your taste
- 1 teaspoon of ginger powder
- 1 teaspoon of cloves
- ½ cup crushed peanuts for rolling darkua balls in.

Process

- Mix ingredients together taste and adjust to your taste.
- Freeze for 10 mins to harden so you can roll them in between your hand into tiny balls. Toss them in the crushed nuts and serve or keep in fridge until needed.

Darkua Peanut Butter with Chili, Cloves and Ginger

Darkua Balls Rolled in Crushed Peanuts

TROPICAL FRUIT SALAD

Use Tropical fruits of choice. e.g. Mangoes, pineapples, papaya, tangerines, oranges, and some shredded coconut.

<u>Spicy syrup for fruit salad:</u> Make syrup by heating sugar with water, add ground nutmeg, cinnamon, ginger and peppercorns.

Pour over fruits or enjoy fruits with ice cream or cream.

PINEAPPLE UPSIDE-DOWN GINGER CAKE WITH SHREDDED COCONUT FLAKES

Pineapple preserve or jam is spiced with ginger and spread at base of oiled cake tin before sliced pineapples filled with cherries are added.

FYI: I used a Star shaped baking tin of 7½ x 10 ½ wide.

Use an equivalent suitable baking tin. Bake at 350F for 40 minutes.

Ingredients

- 3 cups All-purpose flour
- 1 cup vegetable spread, extra for oiling baking tin
- 1 cup light brown sugar
- 4 large eggs
- 2/3 cup of molasses
- 2/3 cup evaporated milk
- 2 teaspoons baking powder
- 7 pineapple slices out of 20 ozs. canned pineapple slices
- 7 whole cherries
- 3 teaspoons of heaped ground ginger
- ½ teaspoon nutmeg
- ½ teaspoon cloves
- 1 cup of coconut flakes – for sprinkling over cake when done

Topping for spreading at base of oiled tin.

- 4 tablespoons of pineapple preserve or jam
- 1 heaped teaspoon of ground ginger

Pineapple Jam & Ginger

Cream being mixed

Nutmeg Cloves & Ginger

DESSERTS

Process

Preparing baking tin

- Oil baking tin generously with some of the vegetable spread, add 4 tablespoons of pineapple preserve or jam mixed with 1 heaped teaspoon of ground ginger.
- Spread gently over oiled base of tin covering the whole base of tin.
- Add 7 slices of pineapple slices or until pineapple slices <u>fill the base of tin</u> completely. Fill the holes in the pineapple slices with whole cherries.
- Whisk vegetable spread, light brown sugar in a bowl until soft and drops off easily.
- Break eggs in separate bowl before adding to make sure they are not bad eggs.
- Add eggs and whisk in addition to cream of sugar and vegetable spread.
- Add 3 teaspoons of heaped ground ginger, ½ teaspoon of nutmeg and gloves.
- Add molasses and evaporated milk
- Add baking powder to flour; add to cake mixture gradually
- Whisk or mix together with a spatula. It will feel thick and creamy.
- Pour in oiled baking tin spread with pineapple preserve or jam spiced with ground ginger, with pineapple slices filled with the cherries lining bottom of baking tin.
- Bake in middle of oven at 350F for 40 mins
- When cooked it should come clean when cocktail stick is inserted
- Let it cool for 10 mins, cover cake with a flat plate
- Tip over gently so pineapples and cherries are released at bottom of tin saturated with the pineapple preserve or jam. What a delight!

Sprinkle coconut flakes over pineapple upside down ginger cake. Enjoy with ice cream or whipped cream if you wish.

Mixing the Eggs

Pineapple/Cherry Topping

The Batter

DESSERTS

Pineaapple Upside-Down Ginger Cake

DESSERTS

Quick Cake Desserts

Lemon Cake with Fruits
In Progress

Lemon Cake with Fruits &
Whipped Cream

QUICK CAKE DESSERTS

Buy ready to go cake mixes and bake or buy already made plain cakes at bakeries.

Create quick desserts by adding whipped cream, canned and fresh fruits, nuts, plain chocolate bits and granola.

Method 1:
Cut cake horizontally into two and fill with whipped cream and canned and fresh fruits of your choice.

Method 2:
Cut up cake of choice, fill a big dessert bowl with 2 layers of cut up cake, whipped cream, canned and fresh fruits, plain chocolate bits, almonds or nuts of choice and granola.

Measuring and Oven Temp

500 ml

250 ml

Measuring Cup

DEGREES FAHRENHEIT	DEGREES CELSIUS	GAS MARK	DESCRIPTION
225	110	1/4	Very slow
250	120/130	1/2	Very slow
275	140	1	Slow
300	150	2	Slow
325	160/170	3	Moderate
350	180	4	Moderate
375	190	5	Moderately hot
400	200	6	Moderately hot
425	220	7	Hot
450	230	8	Hot
475	240	9	Very hot

Oven Temperature Chart

Index

A

Abenkwan	104, 105
Ablongo	22, 52, 54, 55
Aboboi	55
Abom	65
Aburi Gardens	8
Accra	9, 10
Achomo	17, 41, 43
African	12
African Violet	15
Agblima	23, 24
Agushi	94
Agushi Stew	95, 97
Akara (Kose)	17, 24, 35, 57
Akasa	35
Akpeteshie	16
Akple	24
Akplidzi (Ga)	106-107
Akronkron Dekuno (Type of Fante - Kenkey)	83
Akwaaba	10
Anti-emetic	14
Aponkye Nkakra (Goat Light Soup)	100
Appetizers & Snacks	40-47
Apple	39, 50
Aprapransa (Fante)	106-107
Atadwe	114
Atadwe Milkye	115
Atlantic	10
Aubergine	14, 93
Avocado Pear	4, 14, 66

B

Baked & Fried Fish	70, 71
Baked Beans	49
Baked Spicy Citrus Chicken	72, 73
Baked Spicy Pork – (Domedo)	67, 74, 75
Bambara Beans	55
Banana & Rice Bread	114
Banana	11, 14, 35-37, 114
Banana Fritters	34, 36
Banana Leaves	83
Banku	20, 21, 23, 24, 81
Banku Mix	25
Basic Ghana Tomato Gravy	60-63, Stews
Basil	14, 16
Beans	14, 18, 92
Beef	18, 44
Beef Jerky	68
Beer	17
Black Eye Beans	14, 37, 57
Black Eye Beans Stew	17, 92
Black Shetor	19, 65, 67-69
Boforot	17
Boiled Staple	95
Bonnet Pepper	19, 66
See Gravies, Relishes, Soups & Stews	
Bread	17
Breakfast	17, 22, 24, 34-39
Brown Stew	91
Buns Bread	17
Burkina Faso	10

Index

C
Cabbage .. 14
Cakes ... 121
Canned Fish .. 49, 91
Cape-Coast .. 9, 11
Carbohydrates 14, 20-22, 82
Carrots .. 14
Cassava 14, 21, 24, 29, 83, 84
Cassava Pudding 112
Cauliflower ... 14
Cheese .. 17
Cherries ... 108, 109
Chicken 13, 69, 90, 99, 100
Chilies – Relishes, Salad, Soups & Stews
Chin Chin 17, 24, 41
Chips 17, 24, 41, 42
Chocolate ... 17
Cinnamon – *See Breakfast & Desserts*
Citrus .. 73
Cloves 16, 30, 31, 53, 54
Cocktail ... 16
Cocoa Butter .. 14
Cocoa Pods .. 15
Coconut 108, 109, 111
Coconut Crunchies (Poloo) 17
Coconut in Caramelized Sugar 108, 109
Coconut Oils 14, 31
Coconut Pie ... 110
Cocoyam (Malanga) 37, 39
Cocoyam (Malanga) Leaves 94

D
Cold Drinks .. 17
Coleslaw .. 50
Corn .. 14, 16
Corned Beef 20, 45, 56-58, 91
Corned Beef Stew 91
Cow's Foot .. 93
Crab 19, 104, 106, 107
Crumble for Pie 111
Cucumber ... 49
Cutters ... 46

D
Darkua .. 116
Desserts 109-121
Dokunu (Fante Kenkey) 69, 83
Domedo (Baked Spicy Pork) 67, 74, 75
Donuts/Doughnuts 17, 41
Drinks 16, 17, 21, 29-31
Drinks & Smoothie 28-33

E
Eba .. 24, 70
Egg in the Middle 44, 80
Eggplant ... 14
Eggs 12, 17, 44, 45, 49, 51, 56
Eko egben ... 22
Eta (Wooden Traditional Spoon) 36, 81
Ewe .. 10

F
Fante ... 10, 11
Fante-Fante Stew 96

INDEX
124

Index

Fante Kenkey 20, 68, 83
Fast Food .. 16
Fig Leaves ... 83
Fish 13, 24, 47, 49, 60, 70, 71, 90
Flour ... 13
Flowers ... 14
Fruit Salad .. 116
Fruits ... 14, 109-121
Fufu .. 20, 24, 83
Fufu Mix .. 83

G
Ga 10, 11, 19, 22, 82
Ga Kenkey ... 24
Garden Eggs .. 14, 15
Gari 17, 20, 21, 27, 87
Gari & Coconut Pudding 112, 113
Gari Foto .. 56, 86
Gari Hot Instant 24, 70, 87
Gari Soakings (Sweet) 24
Ghana ... 10, 12
Ghana Salad 48-50
Ghana Tomato Gravy 60-63
Ghana Tomato Gravy See stews
Ghanaian ... 10, 12
Ginger 14-15, 29, 35, 53-55
Ginger Drink 29, 30
Goat Cheese ... 94
Gravy 19, 61-63, 89
Green Plantain 21, 52, 83

Green Plantain Chips 52
Green Shetor 19, 66
Grits .. 22
Ground Nut .. 14
Ground Nut Soup 102,103
Guava ... 14, 31
Guinea Peppers 14, 16, 53
Guinness .. 16
Gulder ... 16
Gulf of Guinea .. 10

H
Harmattan ... 10
Hausa ... 10, 86
Hausa Koko ... 35
Herbs .. 14
Herring ... 12, 16
Hibiscus .. 14
Horlicks ... 17
Hot Drinks ... 17
Hummus .. 59

I
Ice Cream Scoop 51
Ice Kenkey .. 23
Ice Water .. 16
Ivory Coast ... 10

J
Jollof Rice .. 76-79

INDEX
125

Index

K
Ka (Grinding Mortar & Pestle) 19, 66
Kaa (Crab in Ga) 104
Kaklo 22, 52, 54, 55
Kelewele 21, 25, 52, 53
Kenkey 20, 23, 39, 69, 82
Kippers .. 93
Knee high socks 26, 29
Kobe cake (Shredded Coconut in Caramelized Sugar) 108, 109
Kobi (Salted Tilapia) 16, 19, 61, 91, 93
Kobi Stew .. 91
Koko (Corn Porridge) 23, 35
Kokonte (Lapiiwa) 84
Kokonte Powder 27, 84
Komi (Ga Kenkey) 82
Kontonmire (Cocoyam Leaves) 94
Kose (Akara) 17, 24, 35, 57
Koto (Crab in Fante) 19, 104, 106, 107
Kpakpo Shetor 19, 66
Kumasi .. 9

L
Lapiiwa (Kokonte) 84
Legumes .. 14
Lemon/Lemon Juice 13
Lemon Grass 14, 15, 31
Lentils ... 14
Lettuce .. 14, 49
Light Soup 98-101

L (cont.)
Lingua Franca 10
Lobster .. 18

M
Ma (Corn Dough) 23, 24, 35
Ma Koko (Corn Porridge) 35
Malanga (Cocoyam) 21, 27, 37, 83
Malanga/Cocoyam Leaves 94
Malt ... 17
Mango 16, 31, 50
Meat 13, 18, 37, 47, 90
Meat Balls ... 44
Meat Pie 40, 45-47
Mezzaluna .. 26
Millet ... 17, 35
Millet Leaves .. 86
Minced Beef 44, 47
Minced Turkey 47
Moi Moi .. 57-58
Momoni (Moist Salted Fish) 27
Mpotowpotow 37-38
Muslin Cloth 26, 30
Mussels ... 18

N
Nkate Cake (Peanut Brittle) 110
Nkate Nkwan (Peanut Soup) 102-103
Nkrakra ... 99
Nme daa .. 16, 17
Nuts (Nkate in Fante) 14

Index

O

Oats	17, 111
Octopus	18
Offal	18
Oils	14, 19
Okra	13, 93
Okra Stew	93
Omelets	11, 64, 39
Omo Towu (Rice Balls)	20, 21, 22, 86
Onions - *See relishes, salad, soups & stews*	
Orange	73
Orange Juice	13
Orchids	14
Oto (Mashed Yam with Palm Oil)	12, 51
Oysters	18

P

Palava Sauce	94-95
Palm Kernel	14
Palm Nut	14, 107
Palm Nut Soup	25, 104-105, 107
Palm Oil	14, 51
Palm Wine	16
Pancakes	17
Pantry	26
Pastries	40, 45-47
Paw Paw (Papaya)	14, 31
Peanut	20, 23, 35, 51, 71, 110
Peanut Brittle	110
Peanut Butter/Paste Soup	102-103
Peanut Oil	14
Peanut Paste Sauce	73
Pepper Relishes	64-69
Peppered Mackerel	93
Peppermint	14, 31
Pigs Trotters/Feet	18, 93
Pineapple	15, 29, 35, 36, 50
Pineapple Drink	29
Pineapple Upside Down Ginger Cake	117
Pito	16, 17
Plantain	14, 21, 23, 52-55, 69, 83
Plants	14
Poloo	17, 43
Pop Socks	26, 29
Pork	37
Pork Chops	90
Porridge	11, 17, 22, 35
Potatoes	13, 14, 37, 51
Prawns	37
Protein	18
Puna Yam	51

Q

Quick Cake Desserts	120, 121

R

Raisins	35
Red Kidney Beans	14
Red Lady Fingers Peppers	19
Red-Red (Fried Plantain, Black Eye Beans & Palm Oil	17, 24, 52, 92
Red Shetor	19, 65, 66

Index

R

Relishes ... 16, 19, 61
Rice 14, 17, 22, 84, 85, 80, 91
Rice Balls ... 20, 80, 86
Rice Bread .. 114
Rice Water (Porridge) 22, 36
Ripe Plantain .. 21, 51-55
Rotisserie Chicken 37, 77

S

Salad .. 48-50
Salad Cream .. 48-50
Salmon .. 45, 49
Sardine ... 20
Sausages .. 17, 37
Shea butter ... 14
Shetor 19, 65-67, 88-91
Shrimp 12, 16, 37, 49
Side Dishes ... 48-59
Smoked Chicken ... 49
Smoked Pork ... 37
Smoothie ... 29, 32
Snacks & Appetizers 40-47
Snacks ... 17, 27
Snails ... 18
Sorghum ... 17
Soups .. 16, 17, 98-105
Sour Sop ... 15
Sour Sop Drink ... 31
Spices ... 14, 15
Spinach ... 13, 94, 95

Spirits .. 16
Staples ... 14, 80-87
Star Anise ... 15, 78
Star Beer .. 16
Steamed Carbohydrates 21
Stews ... 16, 19, 88-97
Suya Spice .. 25
Sweet Potatoes ... 14, 21

T

Tatale ... 22, 52, 54, 55
Tea ... 17
Tea Bread ... 17, 49
Tiger Nuts (Atakwe) Milk Drink 114
Tiger Nuts Custard (Atakwe Milkye) 115
Tilapia ... 61, 70
Tinned Milk .. 35, 36
Togo ... 10
Tom Brown ... 22
Tomato Gravy .. 60-62
Tomatoes - *See Relishes, Salad, Soups & Stews*
Towo Safi .. 86
Tripe .. 18
Tropical Fruit Coconut Pie 110
Tropical Fruit Salad 116
Tuna ... 45, 56
Turkey Ham ... 37
Twi ... 10

Index

U
Utensils .. 26

V
Vegetables .. 14, 49, 50

W
Waakye .. 86
Waakye Leaves ... 86
Wele (Pronounced Waylay) 18
West Africa ... 10
White Chocolate .. 14
Wine .. 16

Y
Yam 14, 21, 37, 51, 83
Yucca 14, 21, 24, 83, 84

Printed in Great Britain
by Amazon